# Handmade Art

Explorations in Contemporary Craft

GINGKO PRESS

# Handmade Art

## Explorations in Contemporary Craft

ISBN 978-1-58423-687-0

First Published in the United States of America by
Gingko Press by arrangement with
Sandu Publishing Co., Ltd.

Gingko Press, Inc.
1321 Fifth Street
Berkeley, CA 94710 USA
Tel: (510) 898 1195
Fax: (510) 898 1196
Email: books@gingkopress.com
www.gingkopress.com

Copyright © 2018 by Sandu Publishing
First published in 2018 by Sandu Publishing

Sponsored by Design 360°
–Concept and Design Magazine

Edited and produced by
Sandu Publishing Co., Ltd.

Book design, concepts & art direction by
Sandu Publishing Co., Ltd.
Chief Editor: Wang Shaoqiang
Design Director: Niu Huizhen
Copy Editor: Jason Buchholz

Front cover project by Isti Home.
Back cover projects by Erin Gardner,
Svetlana Kuznetsova, Jessica Benhar, and Kanako Abe.

info@sandupublishing.com
www.sandupublishing.com

Printed and bound in China

# Contents

# Preface

This book is all about spaces. *Handmade Art: Explorations in Contemporary Craft* features 34 artists from all over the world who work in a space that is part art, part design, and part craft.

Many of the showcased pieces touch aspects of an artistic process: an eloquent narrative around a concept that appears as a strong symbol loaded with a specific meaning. And just like contemporary art's self-reference to its own history, some of the pieces convey—through every making gesture—the craft practice tradition as a subject on its own and as a personal obsession.

Then it comes to the space where the artist makes conscious choices on how she wants this process to be experienced by the customer, user, or viewer, just like a designer would do.

The creative process begins with collecting inspiration from many different sources: personal memories, graphic ephemera, material samples, vintage treasures, old photographs, etc. The artist then translates these inputs into drawings. Sketching an idea and refining it until it turns into print patterns, embroidery motifs, paper cut-outs or dolls is fundamentally a graphic design exercise in form, language, iconicity, and synthesis. The coloring process sparks a custom story which is then put into the surface or material.

Over time, the artist walks into a space in which she learns to fine-tune her observations right from the start and so she is capable of listening to each sketch in such an effective way that the outcome emerges naturally in front of her. It is the very same pattern, stitch, or paper crease that gives the artist the cues to shape it as a specific piece or product.

Each artist advocates for the expressive power and capacity of the techniques and materials they work with. They push their boundaries in an ongoing search for meaning and expression, but within the boundaries of design as a framework, to contain the processes of conception and business development.

It is perhaps the craft space that I, as a designer and maker, feel most compelled to describe. I will use hand-embroidery—my area of expertise—to depict the dimension where the crafter dwells.

Embroidery is a space of calm and peace that triggers a unique conversation: the discovery of the interconnection between your body (mainly your eyes, neck, and fingers) with your trade tools and materials (fabric, needle, and threads). I like to think of embroidering as engaging in a deep conversation or learning a new language. When you learn to embroider, all your focus is put into mastering the stitch execution (a precise and guided movement). At the beginning, you only observe and get into this conversation gradually—much like a self-conscious process—making sure you are using the right words and grammar. When you are capable of remembering, without thinking, the right direction, angle, and sequence of the needle passing through the fabric, it is then that you can start a mostly fluid conversation. I also like to see this dialogue as a negotiation, a set of questions, exclamations, and commentaries. The needle and thread have their own ways and you need to learn how to interpret and decode their signs and warnings, their postures and gestures. It is only after you have repeated a single stitch hundreds or thousand times that you can engage in an endless conversation without worrying whether or not you are being precise. It is almost like dancing in full complicity, letting the technique, shapes, and colors become one inspiring story.

Embroidery, as well as printmaking, toy making, and paper art, take so much time, attention, and focus. Sometimes, and depending on the complexity of the technique being employed, an area as small as one square inch can take up to four hours to complete. Using craft as a means to think, experiment, and create implies the re-conception and re-shaping of both the creative and production methodologies so that they can fit and work in today's times. It also makes a statement of appreciating life and design in a slower fashion, where mistakes and corrections have the necessary time and consideration.

*Handmade Art: Explorations in Contemporary Craft* welcomes you into the space of art, design, and making. The curious, sensitive and creative minds, who can read the keys behind each crafted piece, as well as the active minds, who like to create with their own hands, will find in this book loads of visual inspiration and step-by-step guides that will walk them into the space of the makers. Welcome!

**Karen Barbé**
Textile designer, embroiderer and educator.

# Chapter 1: Toys & Dolls

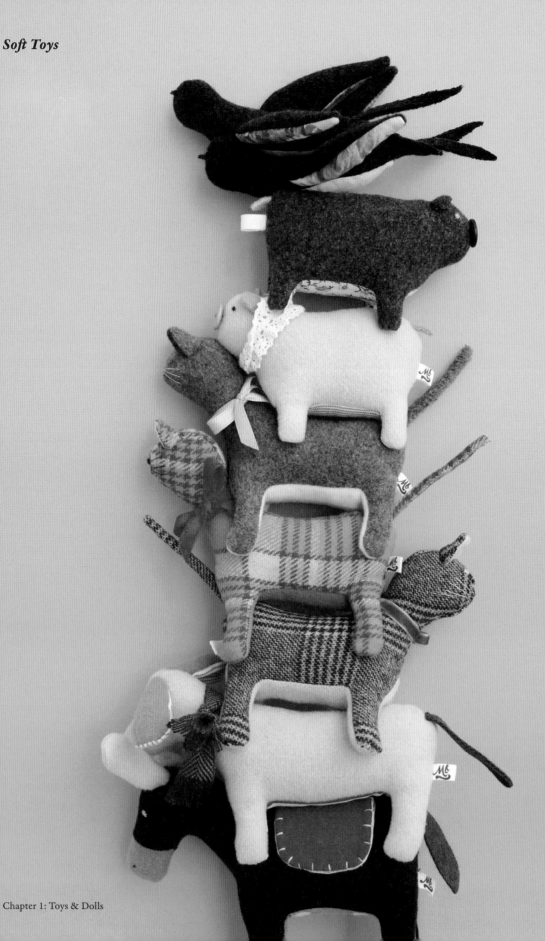

*"I like to work in freestyle, but I also like to work with highly valued techniques. When I make toys, I try to make them beautiful and at the same time suitable for serious play. My motto is: You can play hard; you can get crazy; you can have lots of fun!"*

# *Rita Pinheiro*

Rita Pinheiro graduated with a degree in Fine Arts. In 2003, she established a brand of handmade fabric dolls, soft toys, and many other things. The brand is called Matilde Beldroega, named after her cat Matilde. She enjoys doing manual work using carefully selected materials and natural fibers like wool, linen fabrics, and cotton. All her handmade toys are available in her online store. Rita currently lives in Tomar in Portugal with her husband and daughter.

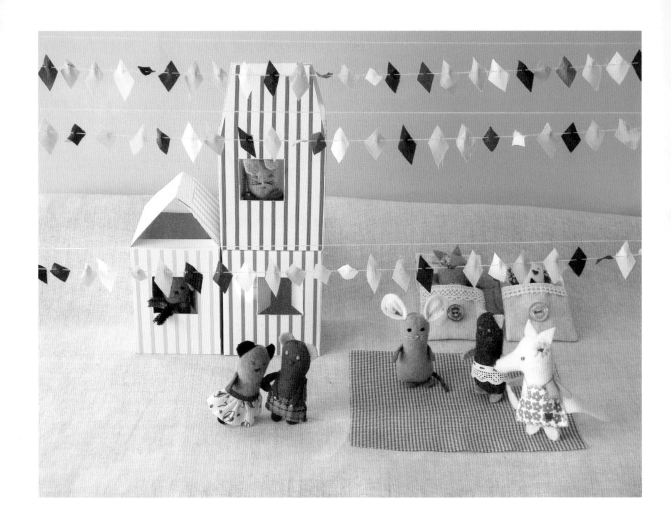

## Beach Party

The idea for this project comes from the word "beddy-byes," a child's word for bed or bedtime. Rita started to imagine a whole universe with cute animals and gave them a beach party scenario to keep the fantastic story going.

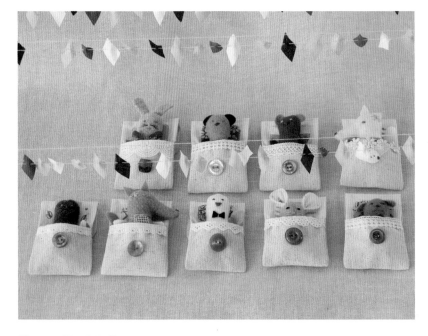

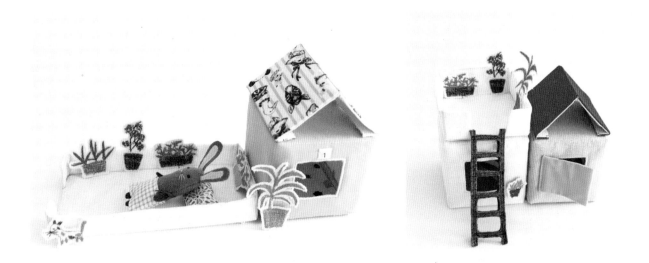

## *Modular Houses: Miniature Play and Build Scenarios*

The houses are created like Lego pieces, allowing the owners to combine the parts as they wish. They can keep a house alone, put another one on top of it, and add a roof or a terrace or a garden. To add more fun and adventure to the series, Rita also embroidered some animals, plants, and vegetables.

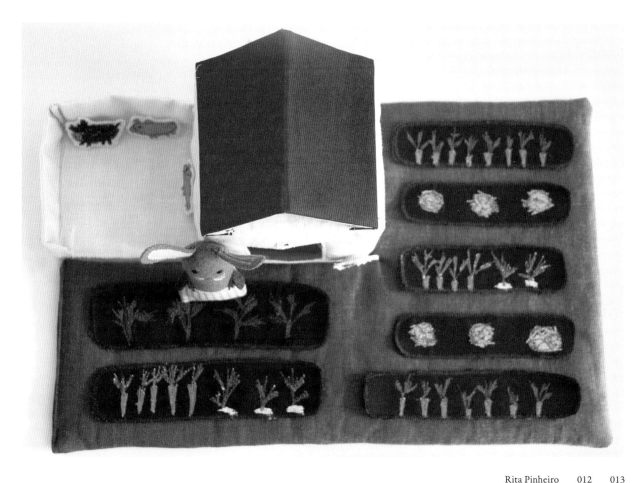

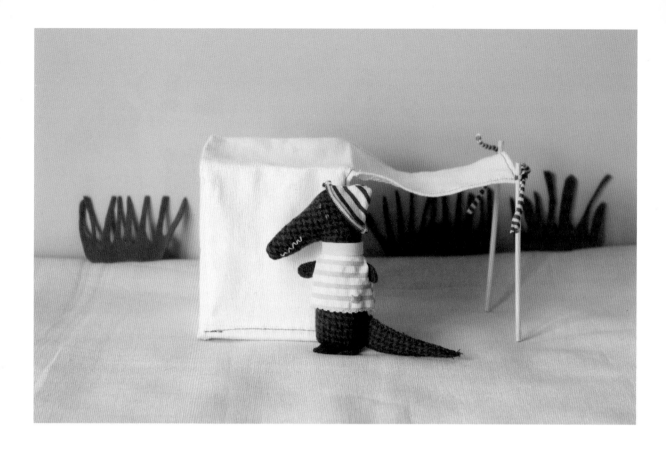

## Beddy-byes

These are tiny little animals sleeping in their sleeping bags. They are very portable. Children can keep them in a pocket or sleep next to them in bed.

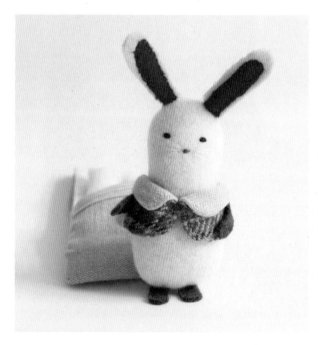

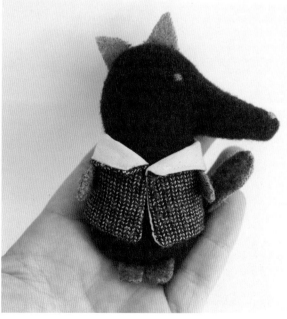

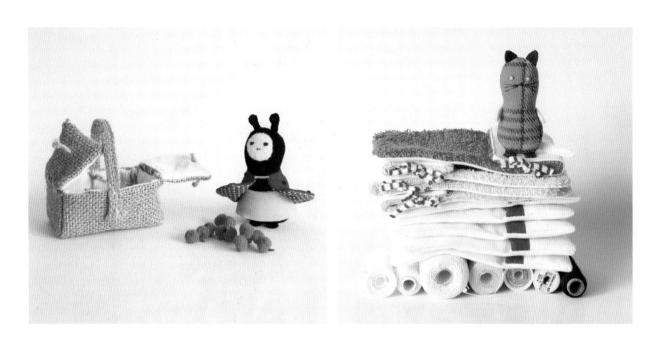

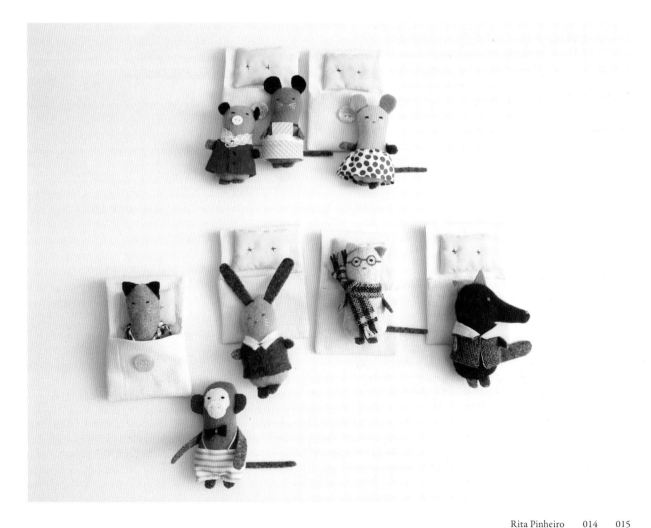

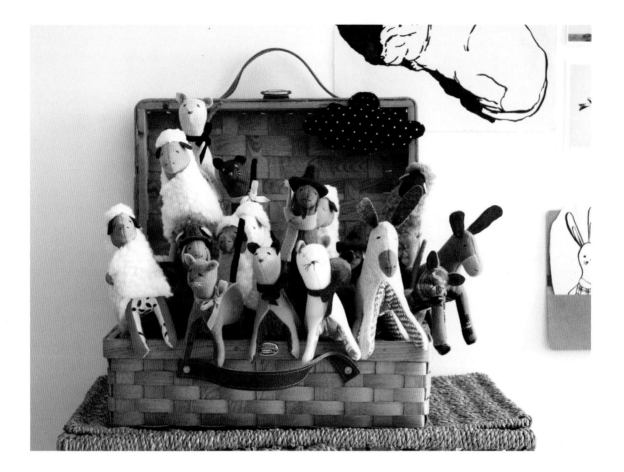

*1. Tell us something about your background. How did you discover toy making?*

As a child, my paternal grandmother taught me many things related to sewing and crafts. She made me the most beautiful rag dolls ever. They were huge and very colorful. I think those dolls were essential to me because they taught me about what I do now: entirely handmade toys.

*2. You named the brand after your cat Matilde. Could you tell us something about your cat?*

Shortly after finishing my degree in arts, my husband and I and our cat Matilde went to live in a small village near the beach in Alentejo. That's where my project started. Matilde was a Siamese cat. Unfortunately, she died a few years ago. For a long time, she was my beautiful workmate. I miss her very much!

*3. For you, what defines a good toy piece?*

If we are talking about children's toys, a good piece must have a fun design, proper construction with high-quality materials, and most of all, they must be durable and playable. And personally, I love colors.

*4. Where do you usually get the materials? Do you make or dye the fabric yourself?*

I buy a lot of materials online, as I live in a small town. Online purchasing makes everything much easier, but I also like to buy in the local haberdashery, whenever possible.

Recently, I started to print my fabrics. My husband and I create the designs, and I print them myself. Instead of dying, I make mostly screen prints. I'm enjoying it so much!

*5. What is the most challenging part of a project?*

Well, I must say that making toys is more serious and complicated than you might think. There are many beautiful toys out there, so it's quite difficult to do anything interesting and original. Thus, I think the challenge for me at the beginning of a project is to clear my mind as much as possible for a strong, direct idea. It's true that I work a lot with somewhat collective memories, like dolls, for instance. But it's essential to be able to hear your own voice in the crowd.

### 6. What is your typical day like? What environment do you prefer to work in?

It's like a common workday: I get up early, take my daughter to school, then stop by my favorite coffee shop, Café Paraíso, a café with a history of over 100 years, to drink my morning coffee, without which I can't get along. After that, I go to work and stay there until late afternoon. My favorite environment to work in is my messy studio.

### 7. In today's world, people can get ready-made stuff easily from physical shops and online. What does craft mean to you?

Craft, for me, means creating in a small scale using good materials. It makes possible a more personal, intimate contact with the public or consumers. I love doing custom orders. Doing things by hand also implies knowing the techniques, knowing how to do.

From the view of a maker, the craft also means a way of sharing. You learn from the knowledgeable and experienced makers, and then you pass down the things you've grasped to the newcomers.

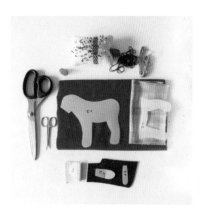
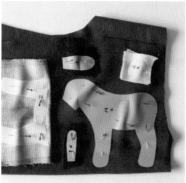
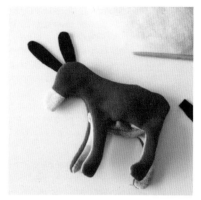
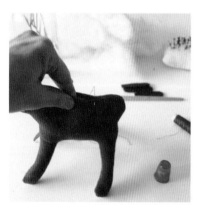
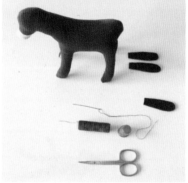
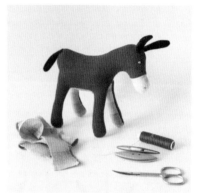

## Materials & Tools

- Original patterns

- Woolen fabrics for the different body pieces, including velvet wool, thick and lightweight wool fabrics, and Burel (a traditional textile originating from Portugal)

- Stuffing, antiallergic required, either 100% natural wool or synthetic

- Pins

- Scissors (large and small)

- Needles for sewing and embroidery

- Thimble

- Sewing threads

- Embroidery lines

## Tutorial

1. Collect all materials.

2. Trace pieces onto appropriate fabric.

3. Cut the pieces.

4. Sew the body pieces together, inside-out. Leave an opening in the middle of the donkey's back large enough for stuffing.

5. Turn work right-side-out and fill with stuffing. You can use the end of a pencil to help turn and fill.

6. Stitch the gap on the donkey's back.

7. Sew the ears and the tail.

8. Finally, embroider the eyes and nostrils on the donkey.

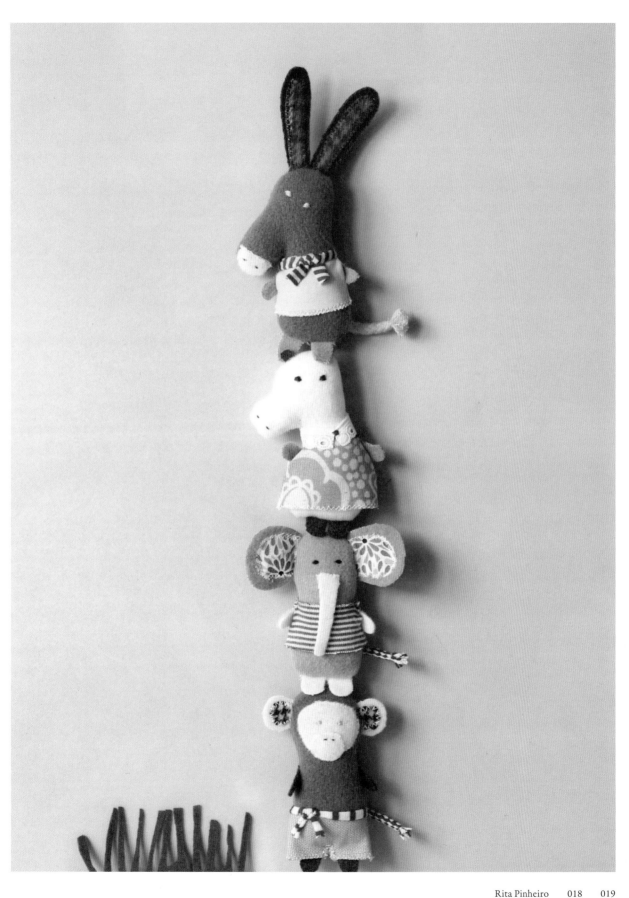

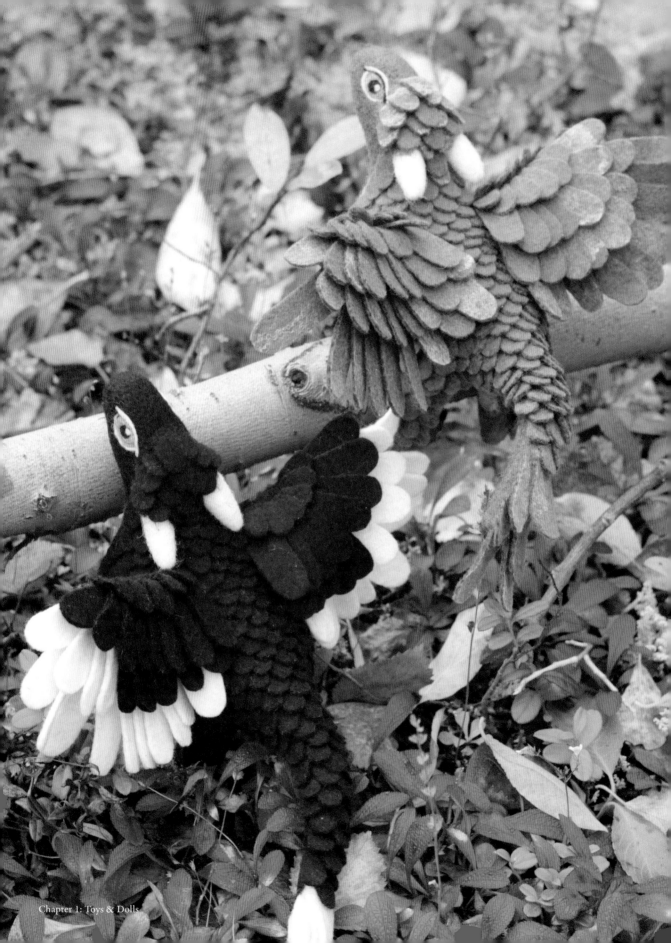

*"I usually use primitive and stylized forms for my dragons' bodies and shapes but decorate them with detailed textures, feathers, and scales. As for color palette, I prefer natural colors, which shine brightly yet go well with the scenes of autumn forests or seasides."*

# *Alena Bobrova*

After graduating with a degree in Graphic Design in 2012, Alena Bobrova did not find actual enjoyment in this field. Since she had always preferred working with her hands and enjoyed working with wool, which for her, is an amazing material with unlimited possibilities, she dedicated herself to the world of felted creatures. She believes that making felted animals is a kind of craft that needs a little bit of skill, a lot of time, and most of all, imagination.

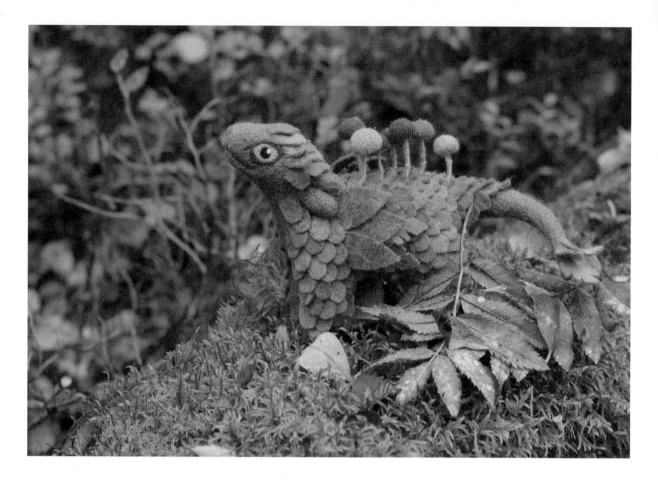

## Dragons and Fairy Creatures

Most of Alena's toys reflect a fantasy about creatures living in remote places far from big crowds. She creates different wyverns and beasts drawn from the old legends and fairy tales. She also makes whimsical plants, trees, stones, mosses, and even diversified landscapes of forest, mountain, and ocean. All these felted creatures together narrate the story of her "imaginary world."

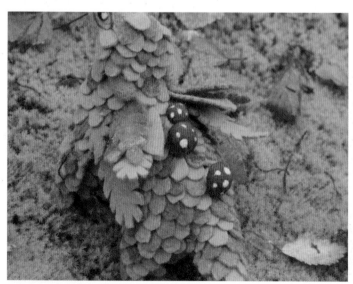

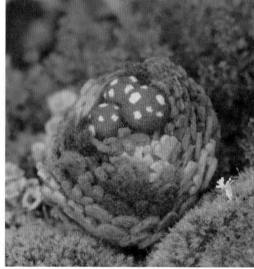

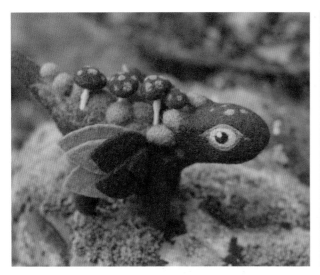

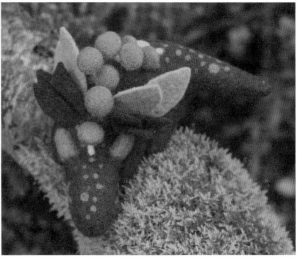

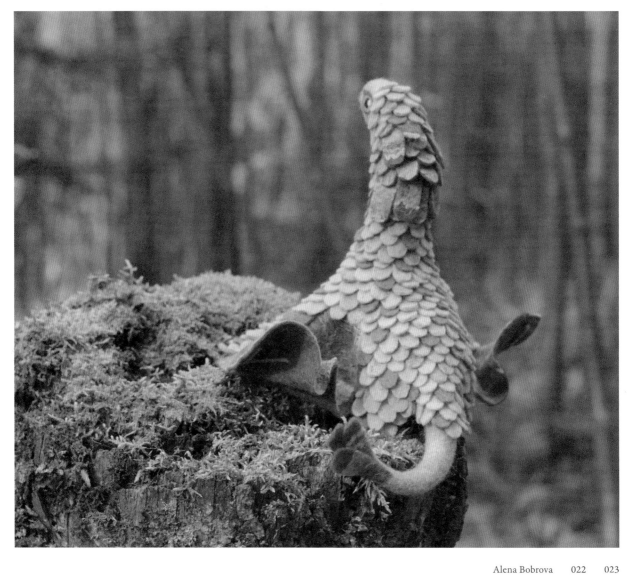

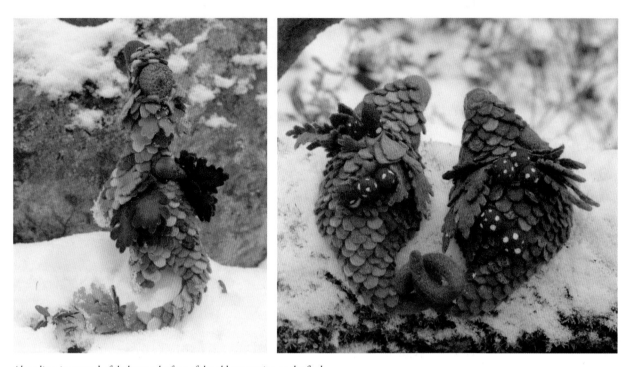

Alena lives in a wonderful place at the foot of the old mountains, so she finds inspiration in everything around her. Her toys are part of her daily walks in the forest or thicket.

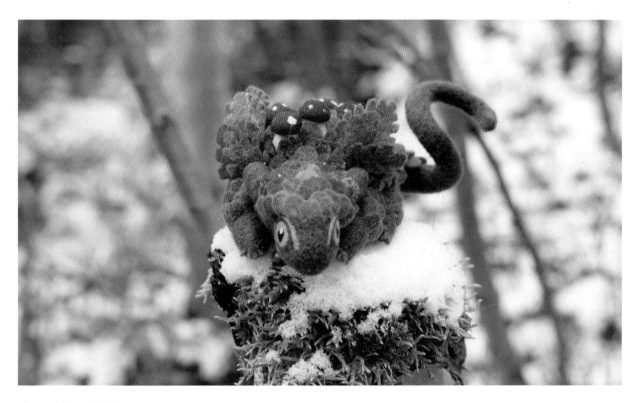

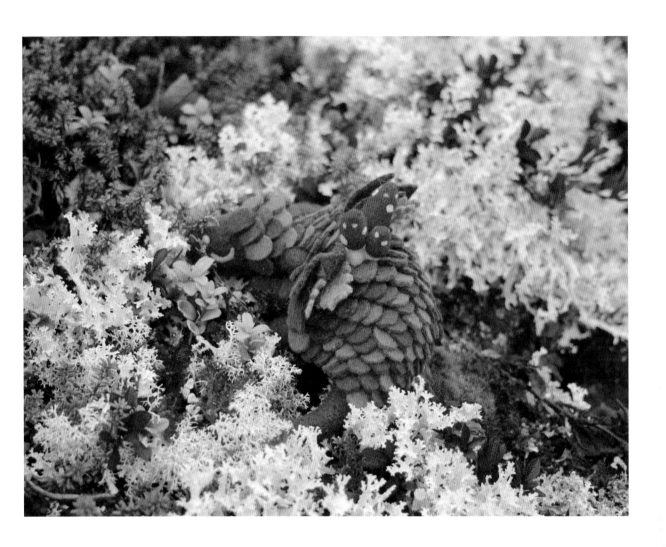

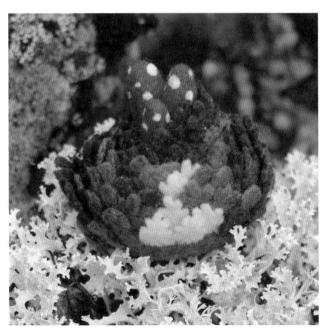

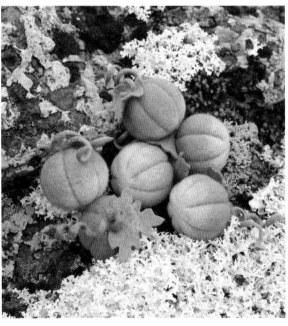

### 1. How did you discover felted toy making?

I graduated from university as a graphic designer, but I knew that this profession didn't attract me at all. By the time I was about to graduate, some new crafts had begun to thrive in Russia, such as quilting, polymer clay, felting, and many others. I tried many of them, but needle felting turned out to be the most interesting and fascinating for me. At that time, this technique was new, and it was somewhat difficult to find lessons, tutorials or any other information. Things about it were like secrets, so I was forced to invent and discover on my own. Now, after making felted toys for seven years, I just can't stop!

### 2. Dragons are the most prominent creatures in your toy collection. Why do you like dragons?

I like reading, and my favorite literary genres since childhood have been fantasy and fairy tales. And dragons, the most famous and popular fantasy characters, were always attractive to me. When I was a kid, my favorite writer was Ursula Le Guin, and I'm sure that her version of dragons has had a great influence on my creative work—the kind, mighty dragons with an ability to change and transform. But to be honest, I can't say that most of my creatures look like "real" dragons. A correct description would be spirit or reflection of a dragon.

### 3. For you, what defines a good toy piece?

As a craftsman, I appreciate interesting ideas. Wool is a great material, and you can make everything that you can ever imagine. And for me, a skillful technique is also important. A well-made felted toy will not lose its shape as time passes because it has to be resistant to any damage. I also collect fantastic creatures from other artists. As a buyer, I define a "good" toy as something you fall in love with at first sight. You see it and understand that you need it immediately.

### 4. Where do you usually get inspiration?

I like traveling and taking long walks with my dog, especially in new places. I keep an eye on every small detail. The area we live in is full of wonders. With a little bit of imagination and boldness, you can turn any commonplace thing into something breathtaking.

### 5. Do you have a favorite dragon? Which one and why?

My favorite dragon is a graceful white doe with brown spots. I grew up in Crimea and my best memory in childhood is from the southern steppe there. This beast is my thoughts about that land and is like a "spirit keeper" of those places.

### 6. Do you make and dye the cloth yourself?

I have a special felt cloth partner: my mom. She shares my interest in felting. She makes very nice and high-quality cloth and felt sheets which I use for making feathers and leaves for my toys. We can create any color combinations we want. In most cases, we use ready-dyed fabric wool but sometimes we dye with white felt sheets by ourselves.

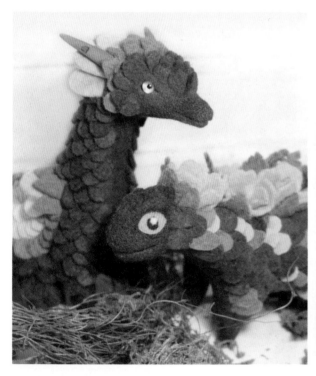

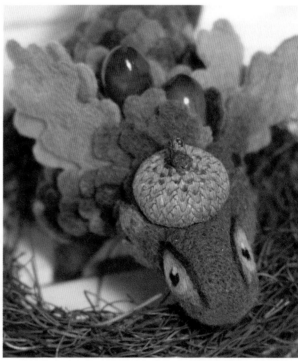

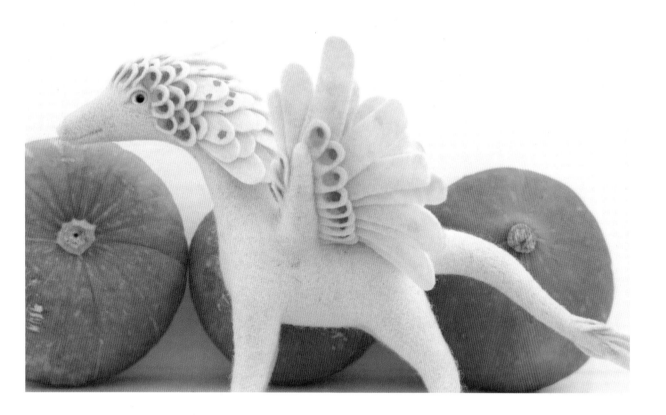

*7. You were born and raised in Russia—how did this country shape who you are today and influence your creations?*

Russia is big and various. Nature here is amazing. It combines almost all types of landscapes and climatic zones. Right now, I'm living in the far north, while my parents live in the south. When I want to visit them, I need to spend more than two days on a train. On the journey, I can see the scenes change from snow-covered lands to blossomed fields.

I believe that each part of our country is full of its special charm and magic. Also, I can't forget about the people living here. Many people from different nations gather here, and they carry with them their own legends and fairy tales.

*8. In today's world, people can get ready-made stuff easily from physical shops and online. What does craft mean to you?*

I think I have to work with my hands. If not needle felting, I would still find some other handmade crafts, for example, ceramic making. I appreciate artisans and support the things they do. Handmade work is a way to self-realization, in the most interesting, comfortable, and pleasant fashion.

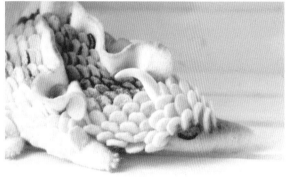

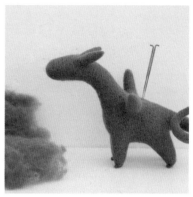

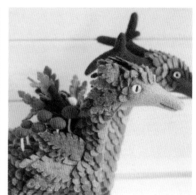

## Materials & Tools

- Wool roving in appropriate colors for needle felting

- Felting needles in various sizes

- Felt sheets made of 100% wool

- Soap, water, felting roller or dowel, bubble wrap, netting or tulle

## Tutorial

1. Sketch the dragon on paper.

2. Collect all materials.

3. Create the dragon's body by poking the roving with the various-sized felting needles to create the desired overall shape.

4. If creating custom felt sheets (wet felting), lay roving in thin wisps on top of the bubble wrap. Continue to add layers, making sure the grain of the fibers in each additional layer is perpendicular to the fibers of the previous layer. Top with netting or tulle and spray with soapy water. Massage gently with your fingertips for about seven minutes to start the felting process. Roll the layers around the dowel or felting roller with bubble wrap on the outside. Agitate fibers by rolling until wool is felted and remove sheet carefully from tulle.

5. Cut and trim pieces in the shape of feathers or leaves from the sheets.

6. Attach scales to the dragon's body with a thin felting needle.

7. Add eyes.

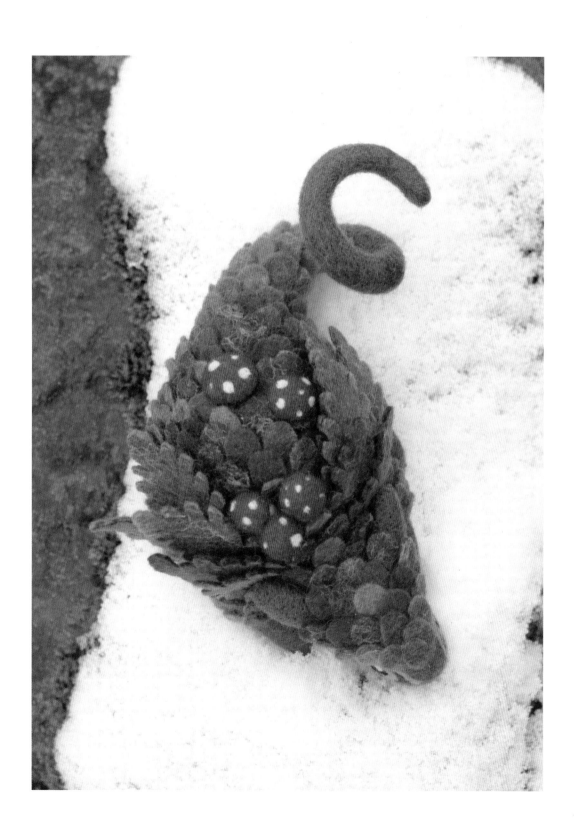

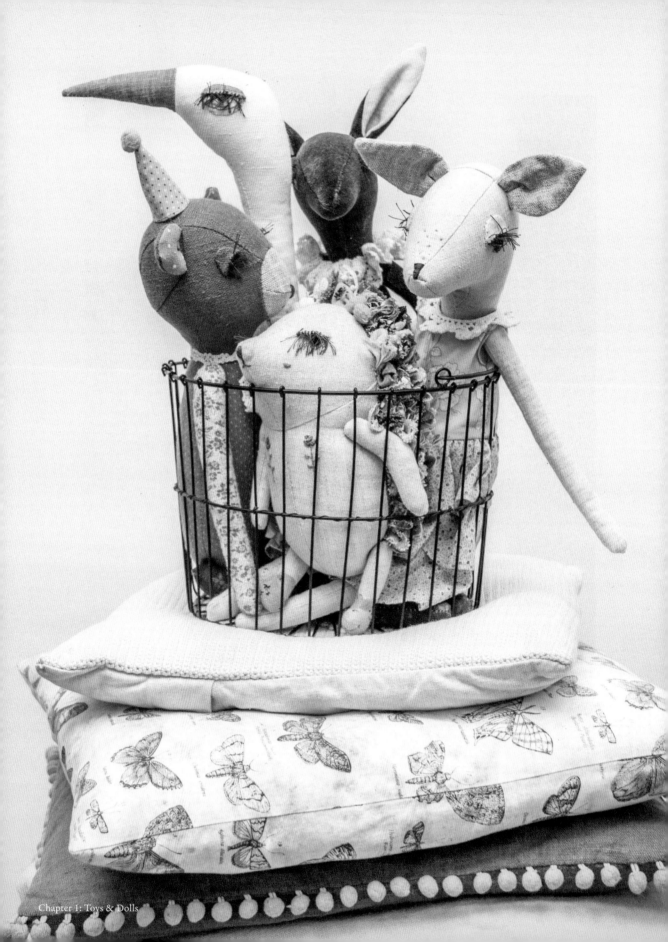

*"I see them as textile heirloom dolls. They are all inspired by woodland animals."*

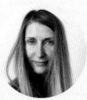

# *Lena Bekh*

Lena Bekh is a textile designer who has been fascinated by doll making since she was a little girl. Each of her whimsical creatures tells a unique story. Lena hand-stitches all the dolls using natural cotton and linen and gives them a vintage touch. They are made for little and grown-up dreamers who are in love with fairy tales and magic.

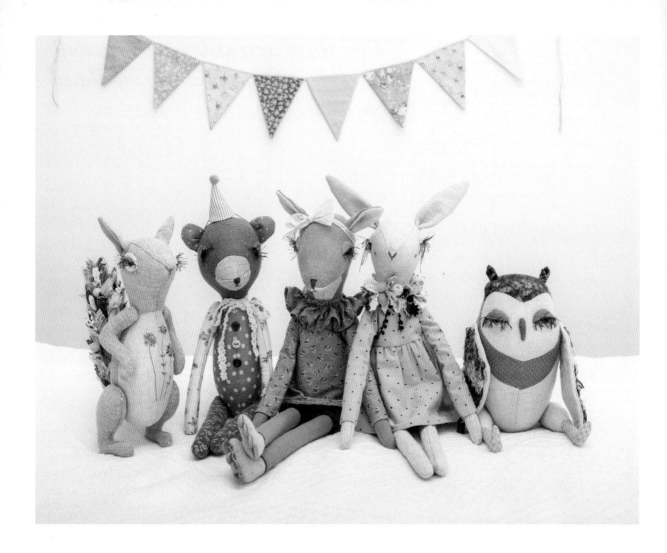

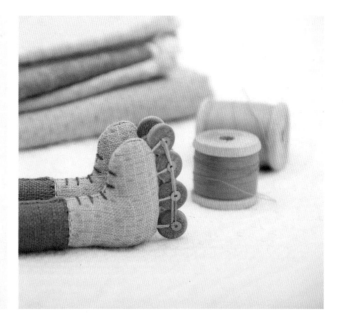

Chapter 1: Toys & Dolls

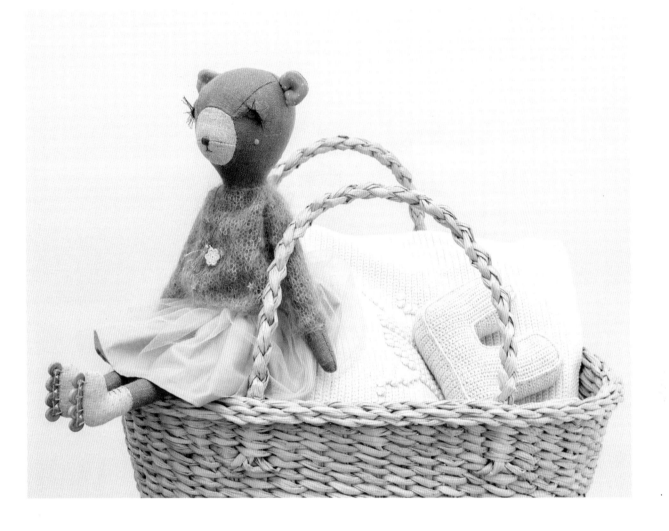

## ◄ Squirrel

The squirrel is made of linen and cotton fabric. Her accent element, of course, is the tail. The tail consists of hundreds of small fabric leaves and lace flowers—all cut and stitched by hand. She has fluffy eyelashes and a body decorated with hand-embroidered flowers.

## ◄ Bear on Roller Skates

Lena is an ardent lover of rollerblading, so she decided to make a doll on skates. The bear is made of linen and cotton fabric. The bear-girl, a fashionable skater, wears a powder-pink tutu, a hand-knitted mohair sweater decorated with golden stars and a necklace with charms. The tiny wooden wheels are specially made by Lena's dad.

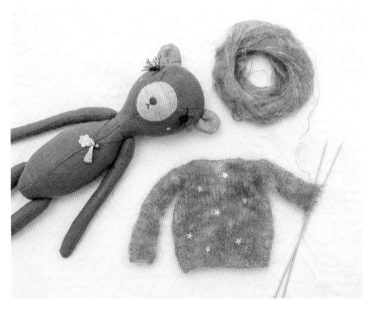

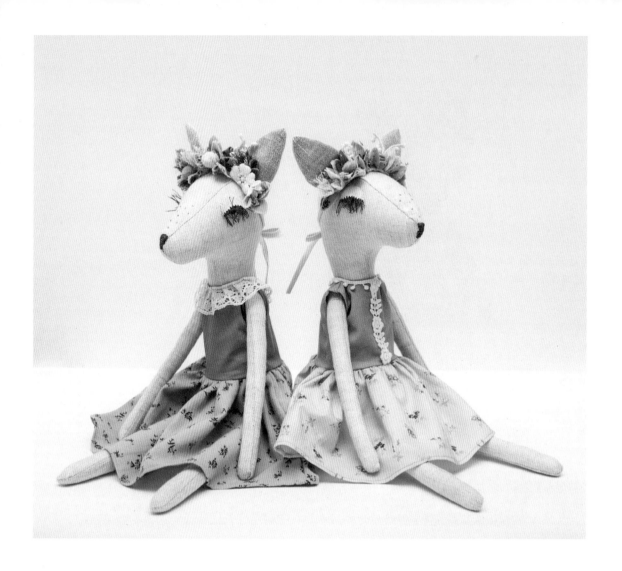

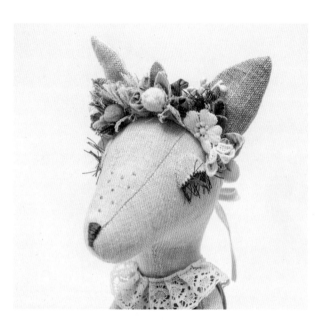

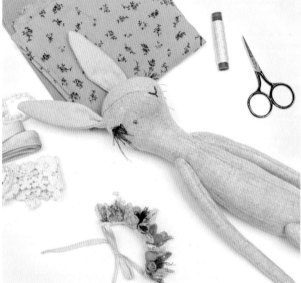

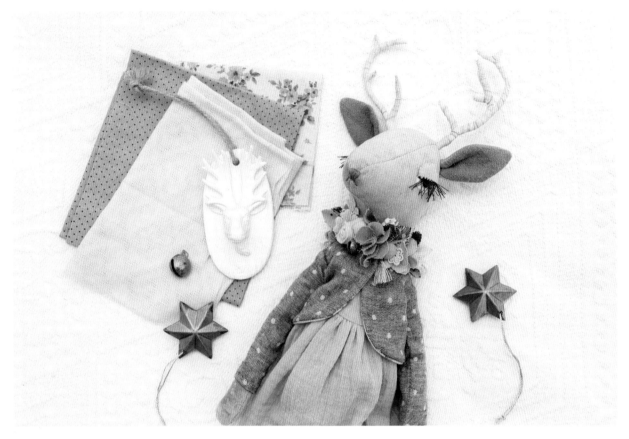

## *Reindeer*

Lena had the idea of making the reindeer heirloom doll for about a year. She has made the antlers, but it was not until she came across this beautiful grey velvet fabric that she got a clear vision for the reindeer doll. She loves the mix of different fabric textures, soft neutral colors, and the hand-stitched flower collar.

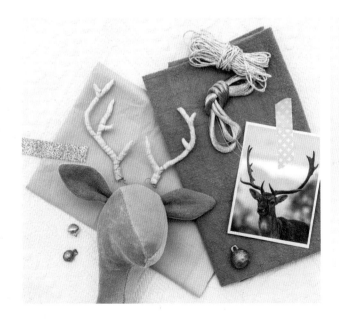

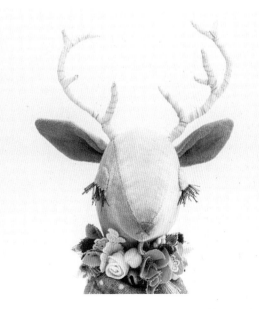

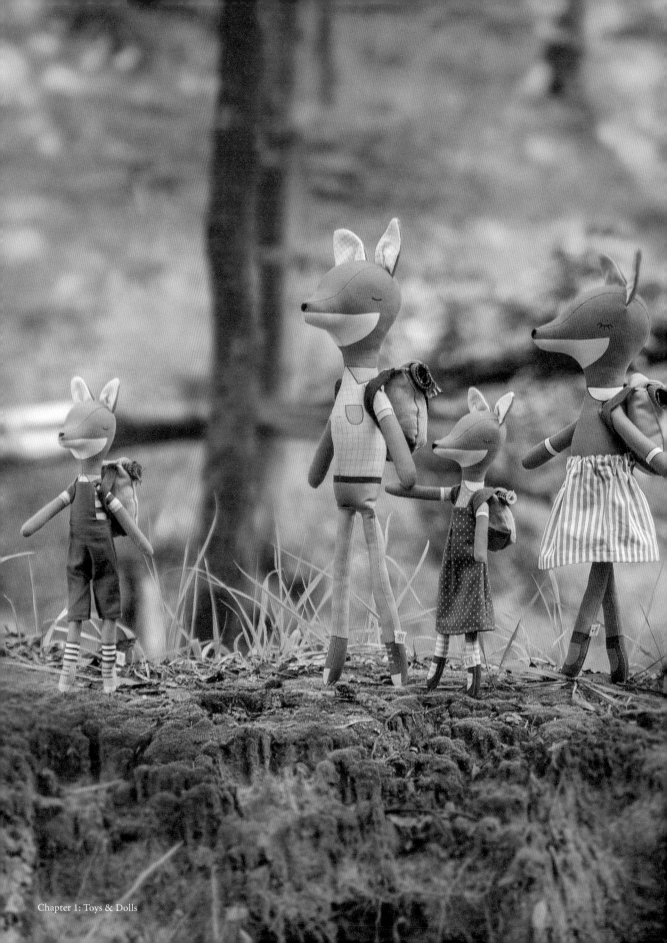

*"Our toys are inspired by nature. They come from a magical forest. They are friendly, colorful, and wild."*

# *Pani Pieska*

Pani Pieska is the creative duo of Marta Lubaszewska and Krzysztof Wykrota. Based in Poland, they make detailed toys and accessories for children, especially handmade stuffed animal toys. They create animal families to show the beauty of nature and the animal world.

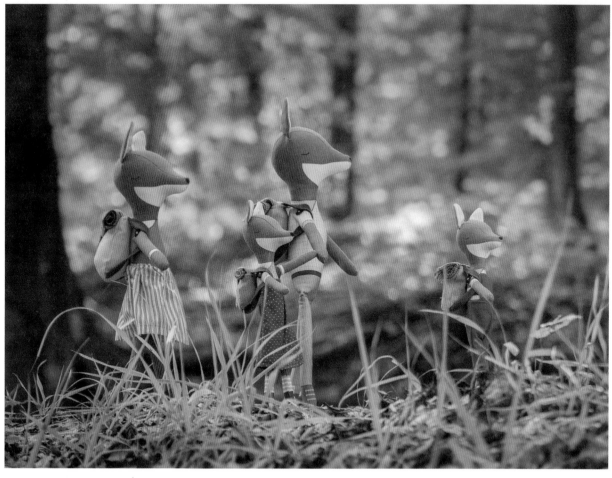

## *Animal Family*

This stuffed animal toy family is made from cotton, partly sewn on a machine and partly by hand. They are made in a small workshop located in the Bieszczady Mountains, the wildest mountain range in Central Europe.

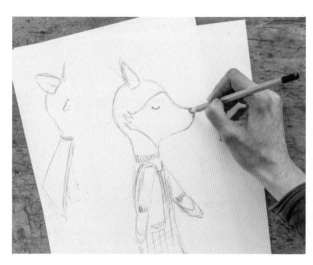

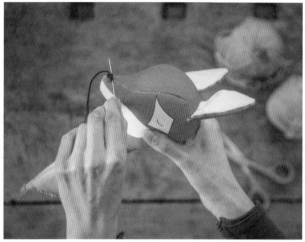

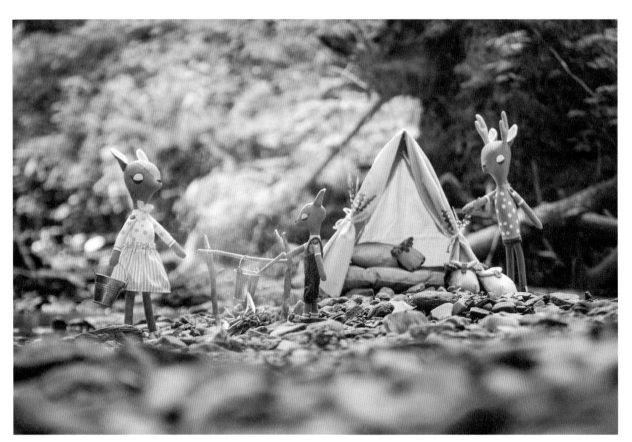

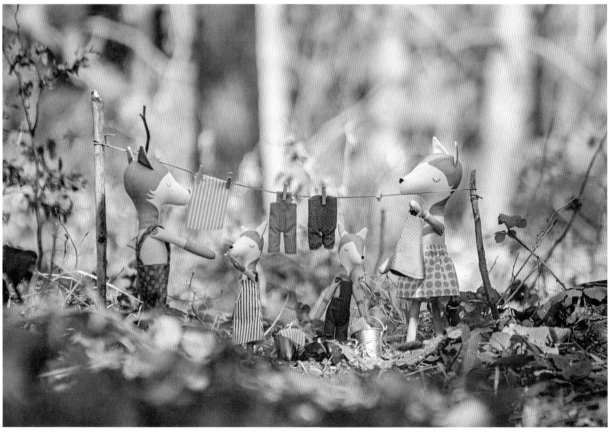

These toys are small and can be taken anywhere, whether the forest, the creek, or the mountains, where they go hiking, camping, gardening, or playing.

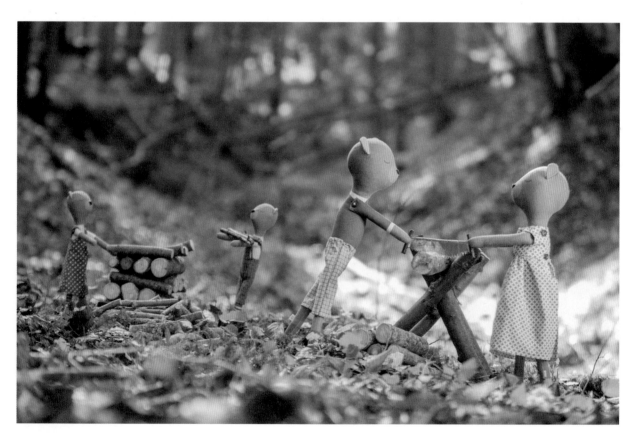

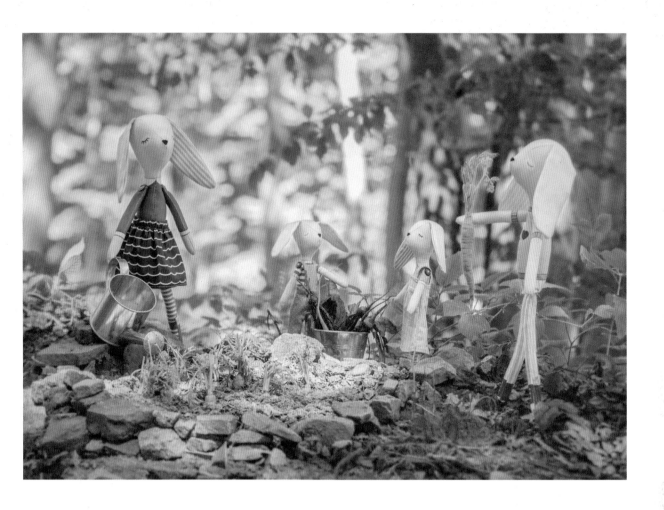

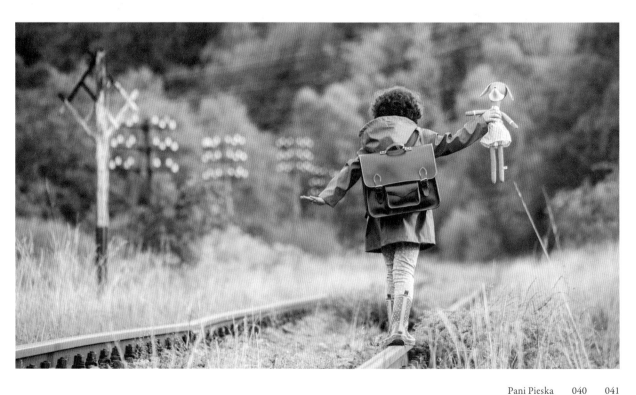

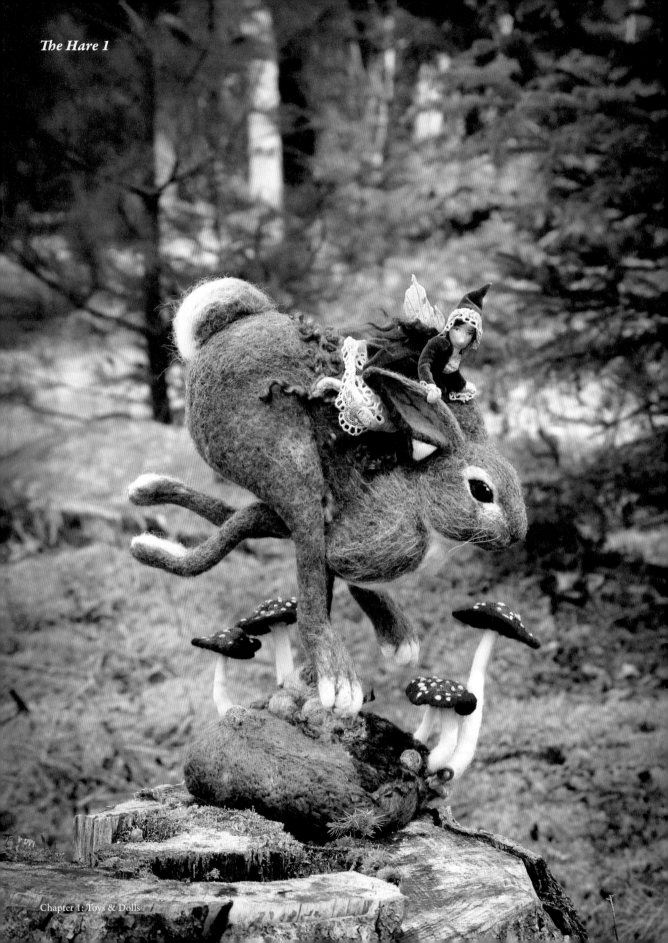

*"I love the transparent quality of old cotton and the beautiful craftsmanship in the details. I never tire of seeing how a scattered pile of fabric, thread, and roving can come together into little creatures, each with such distinct personalities."*

# Phoebe Capelle

Phoebe Capelle is the artist behind Lavender & Lark. She works with natural fibers—wool, silk, and recycled antique garments—to create felted animals and art dolls. Her inspiration comes from the natural world, folklore, and fairytales.

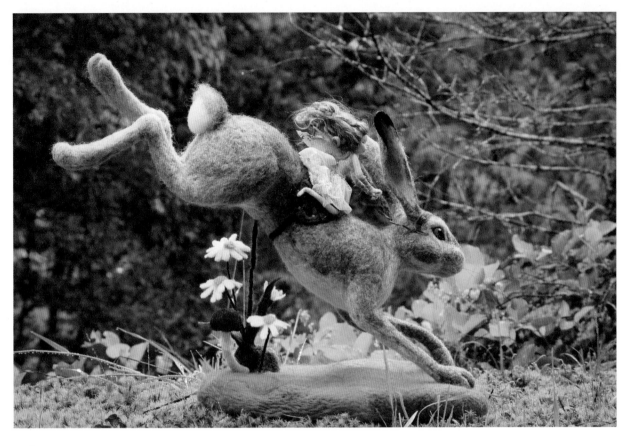

▴ *The Hare 2*

▾ *A Troupe of Faeries*

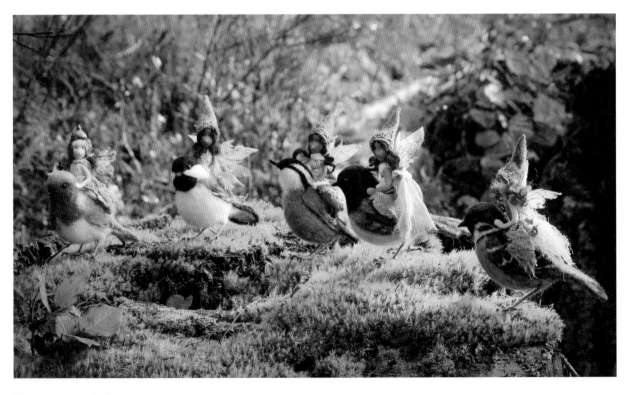

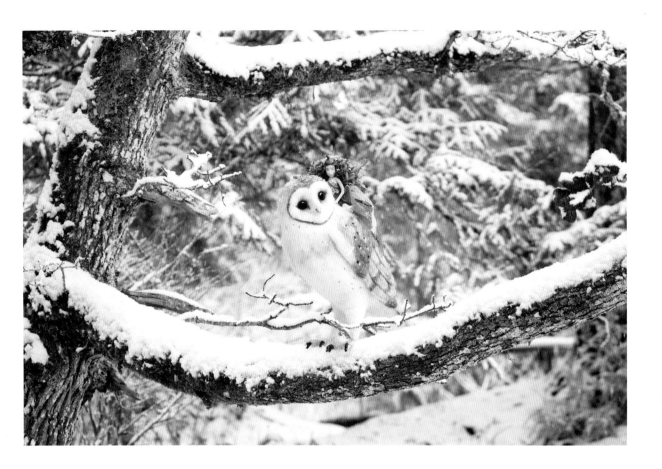

### ◂ Aoife & Finvarra

Aoife, the Faerie Queen, is hand-sewn over a wire armature. Her dress is made from scraps of hand-dyed silk and lace. The Owl King, Finvarra, is needle-felted from a mixture of wools over a wire armature.

### ▸ Winter's Children

In the still quiet of mid-winter, wee folk travel unseen on bird and hare through the sleeping wood. They are gathering twigs and hollow seed heads for their faerie hearths, and wintergreen and bayberry for table and feast. If you wait, crouching un-stirring beneath the cedars for long enough, you may hear little whoops of laughter rising in the wind as they swoop and dart amongst the forest brush.

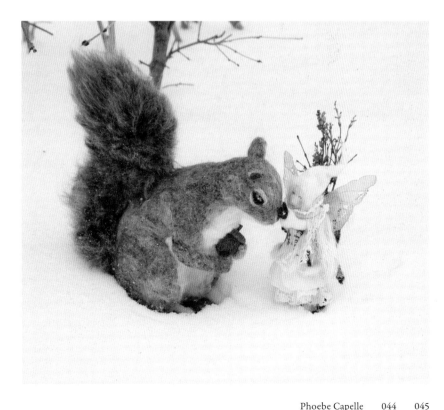

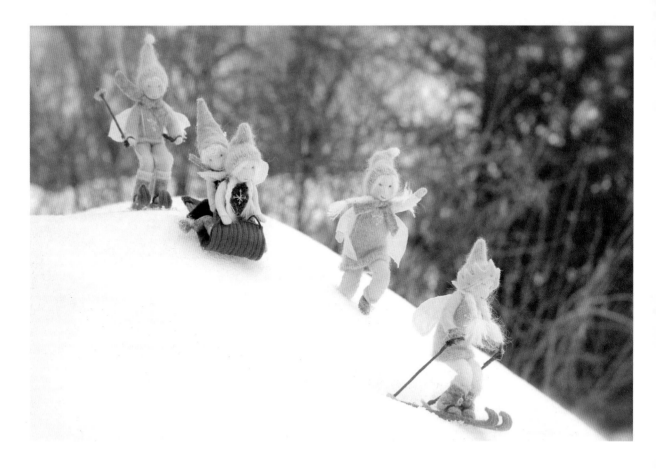

▲ *Winterland*
▼ *Briar and the Hare*

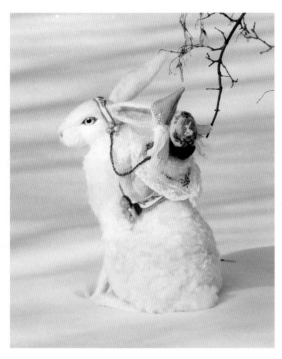
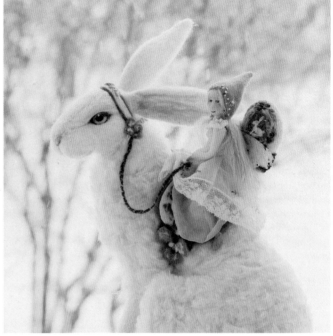

### ▾ *Niamh the Huntress*

Niamh glides above the trees on Gawen, her red-tailed hawk. She is the guardian of the forest and all its creatures. If you are fortunate enough to catch a glimpse of her, walk with care through her wood. Niamh is hand-sewn over a wire armature. The hawk is needle-felted from a mixture of wools over a wire armature.

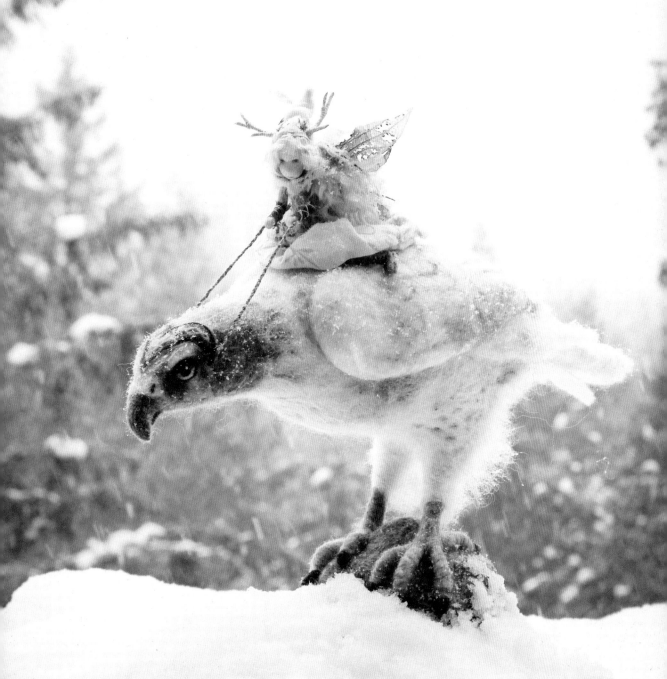

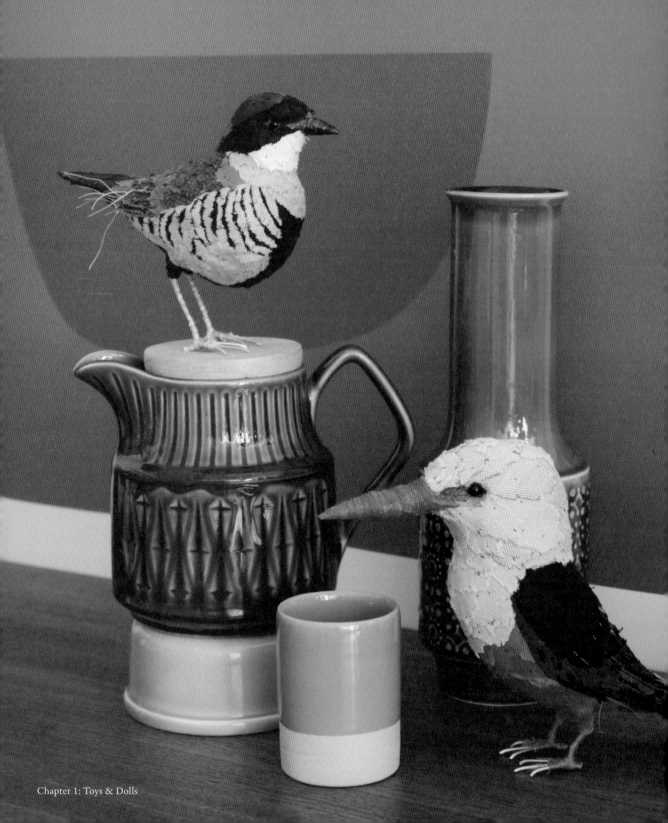

*"I am excited by the opportunity to create life from cloth, working with its weave to mold shapes, form feathered breasts, hind legs, and snouts. With the final placing of the eyes, a new life is born!"*

# Abigail Brown

Abigail Brown is an artist and illustrator based in London, England. Working from her studio at Cockpit Arts, an award-winning social enterprise and business incubator for craftspeople in central London, she makes each animal herself by hand with fabric or papier-mâché. She has already made over 100 species of birdlife to date for her Fabric Birds series, each crafted from fabric, wire, and thread. Each bird is created using a mix of newly sourced and pre-loved fabrics, painstakingly cut and layered to form feathers, and finished with tiny hand-stitched details.

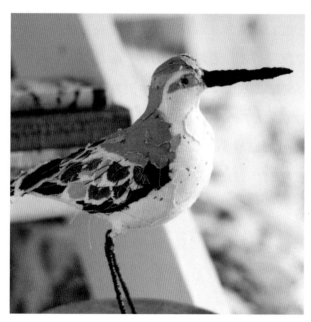

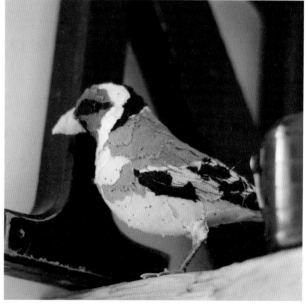

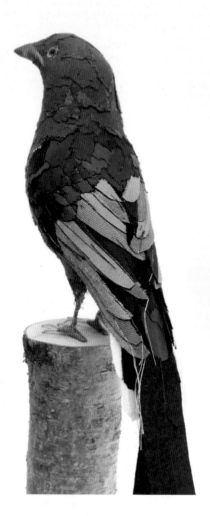

*‹ Sanderling*
*‹ Goldfinch*
*‹ Sri Lanka Blue Magpie*

- *Great Green Macaw
and Parakeets*
- *Saffron-crowned Tanager*
- *Lilac-breasted Roller*

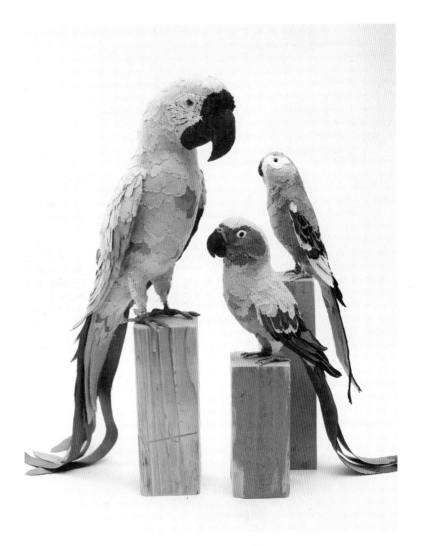

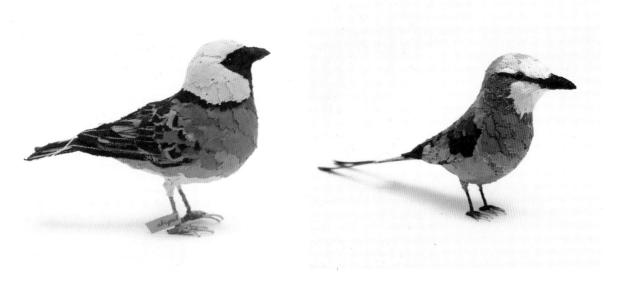

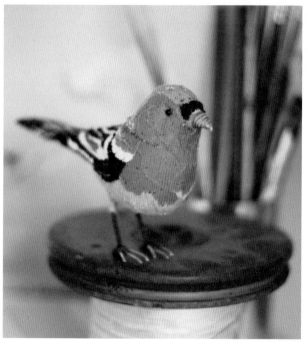
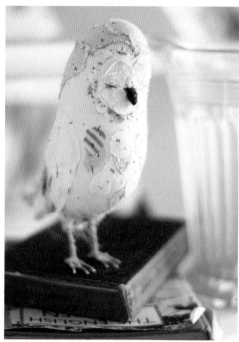

▴ *Chaffinch*
▴ *Cream Ponsenby*
▾ *Flamingo*

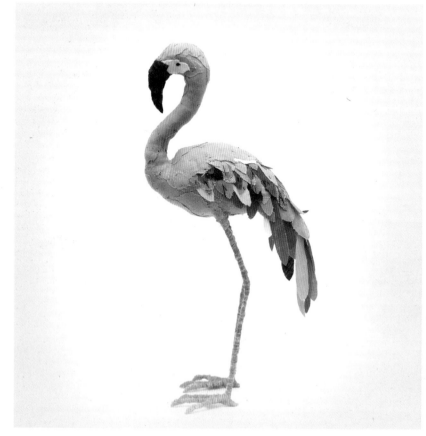

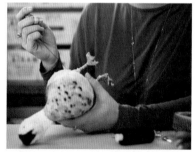
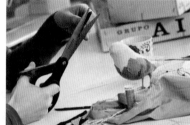
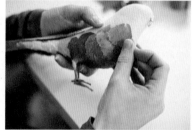

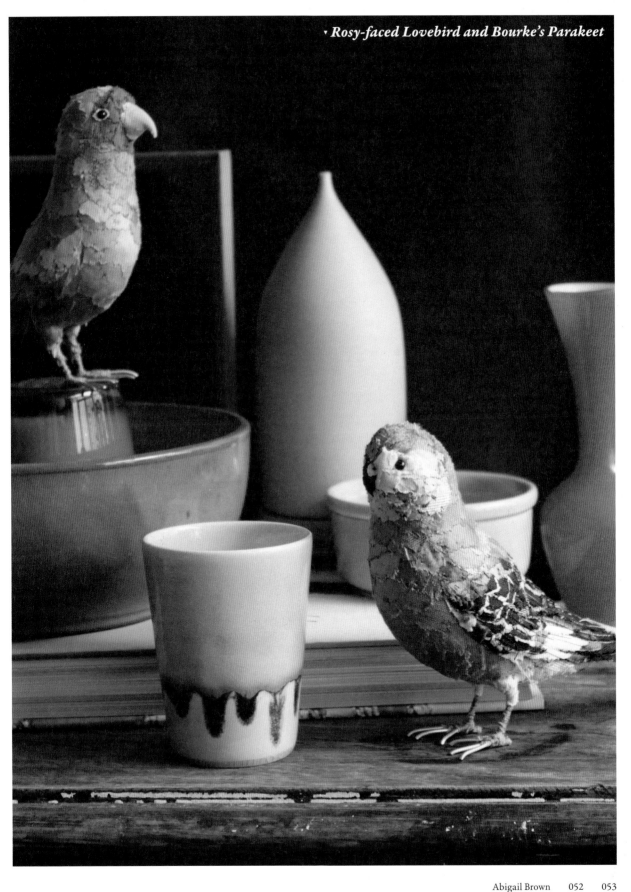

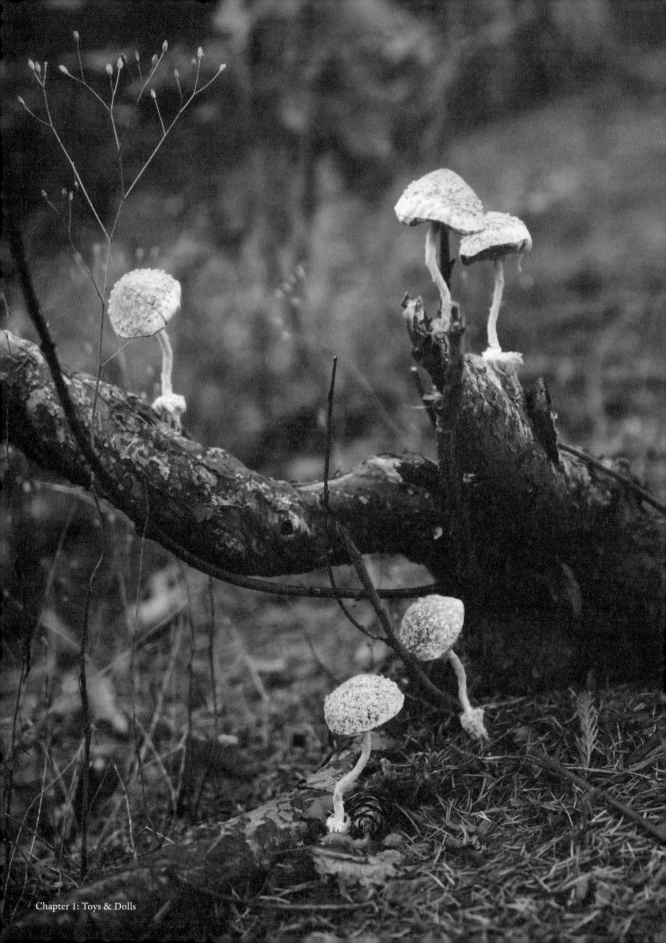

Chapter 1: Toys & Dolls

*"I make nature-inspired, custom art dolls and accessories crafted with clay, naturally dyed fabrics, recycled materials, and love."*

# Maria Danshin

Maria Danshin, originally from Russia, creates all of her art in her home studio in Vancouver, Canada. She draws inspiration from the rich nature of British Columbia. The shapes, textures, colors, and patterns of her work reflect the stunning rainforests and creatures of the Pacific Coast.

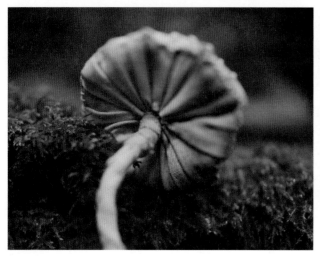 

## Textile Mushrooms

These mushrooms are crafted from wires, recycled fabric, embroidery floss, polyester fiber, laces, glass and wooden beads. To make yourself a lovely mushroom, you first form the desired shape of mushroom out of the wire. Then you will need some fabric to create the mushroom's cap, ring, volva or mycelium. Stitch the parts one-by-one to the mushroom base. When attaching the cup to the gill, you should leave an opening through which you can stuff the mushroom cap with polyester fiber, and after that, you can sew up the opening. Lastly, you come to the styling and decorating stage. When embellishing your mushrooms with beads, decorative threads, and embroidery flosses, try to be as creative as you can and experiment with different techniques and styles.

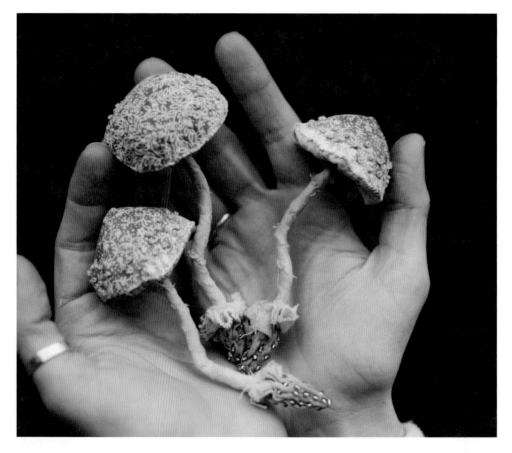

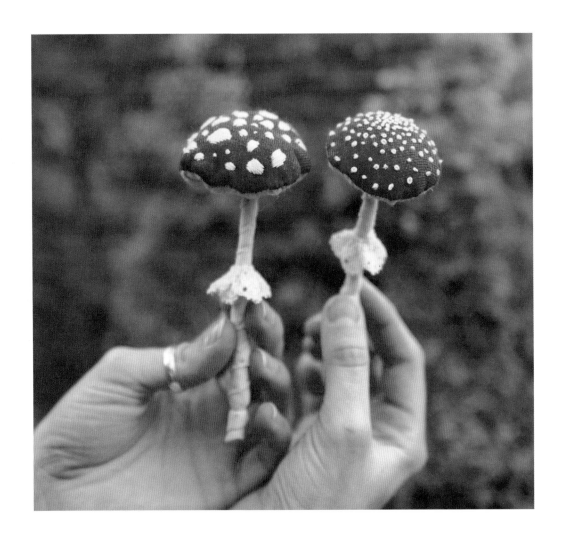

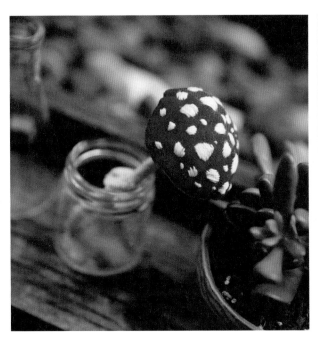

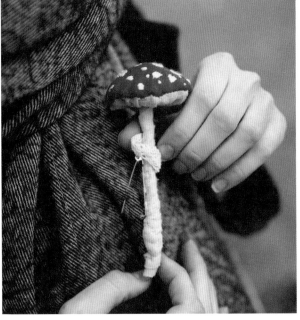

Chapter 1: Toys & Dolls

## Wool Acorns

These cute baby acorns are made with natural materials
and recycled fabrics. The acorn head is real and
collected from the forest nearby.

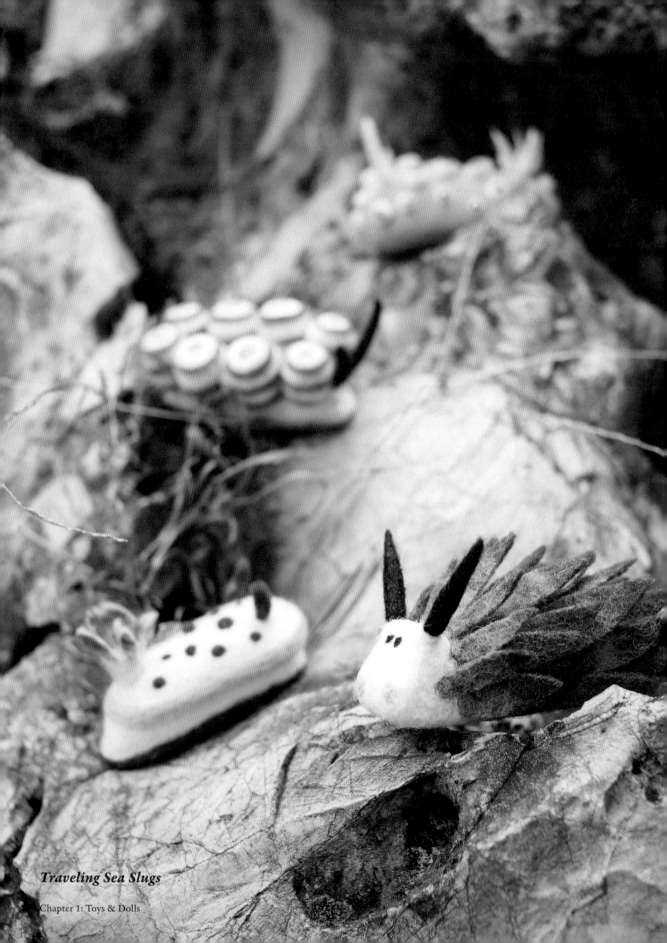

*Traveling Sea Slugs*

Chapter 1: Toys & Dolls

*"Needle felting lets you make wool in almost any shape you can imagine. I usually spend 6–12 hours to make a three-inch-long sea slug. Wet felting enables you to combine different types and colors of wool in amazing ways. It takes me roughly 1–3 hours to make a medium-size jellyfish."*

## *Arina Borevich*

Arina Borevich is a photographer from Moscow, Russia. There are three things in the world that she loves and values most: her family, traveling, and all kinds of crafts. Her favorite type of handmade work is needle felting and wet felting of wool.

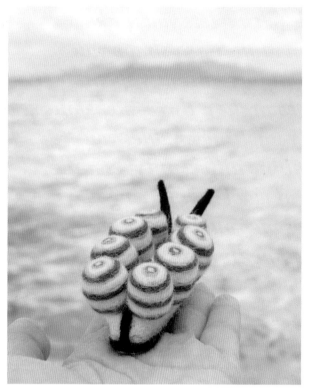
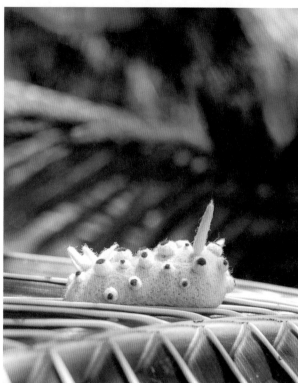

*⁖ Sea Slugs Traveling*
*▸ Sea Slugs at Home*

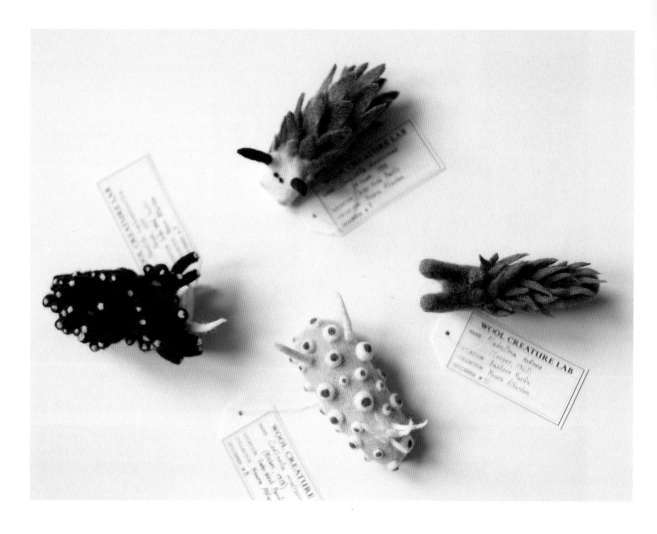

## Sea Slugs and Mollusks

Arina's craze for sea slugs and mollusks started in 2015, when she went to the White Sea Biological Station (in Russia) to visit some friends who were working there as biologists. There she saw nudibranchs for the first time and instantly fell in love with the cute, tiny creatures. She decided to make some as gifts for the station's scientists and was delighted at how they turned out.

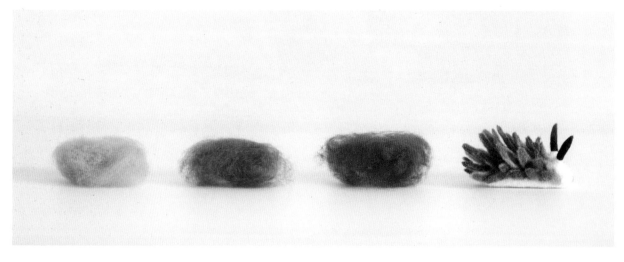

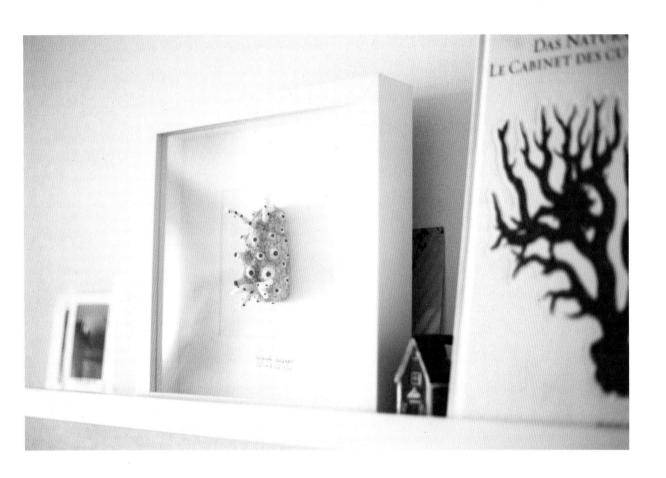

Das Natur...
Le Cabinet des cu...

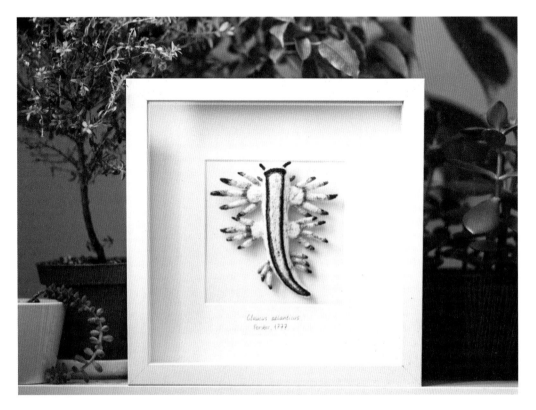

Glaucus atlanticus
Forster, 1777

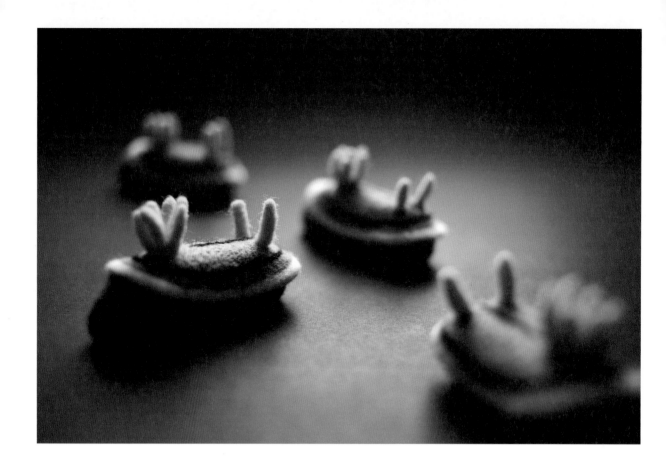

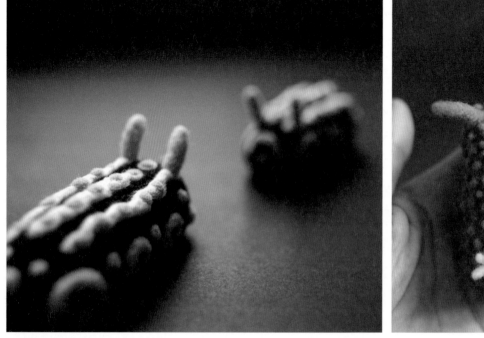

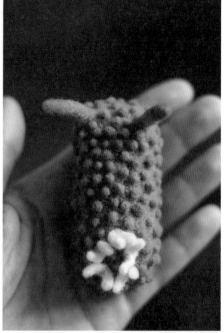

Chapter 1: Toys & Dolls

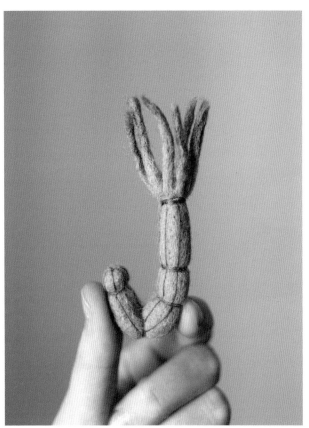
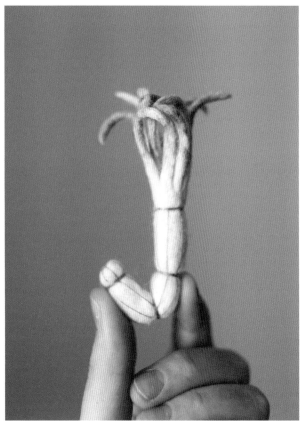

## *Starlet Sea Anemone*

Arina crafts a series of miniature needle-felted starlet
sea anemone sculptures, brooches, and gifts for marine
biologists and marine life lovers.

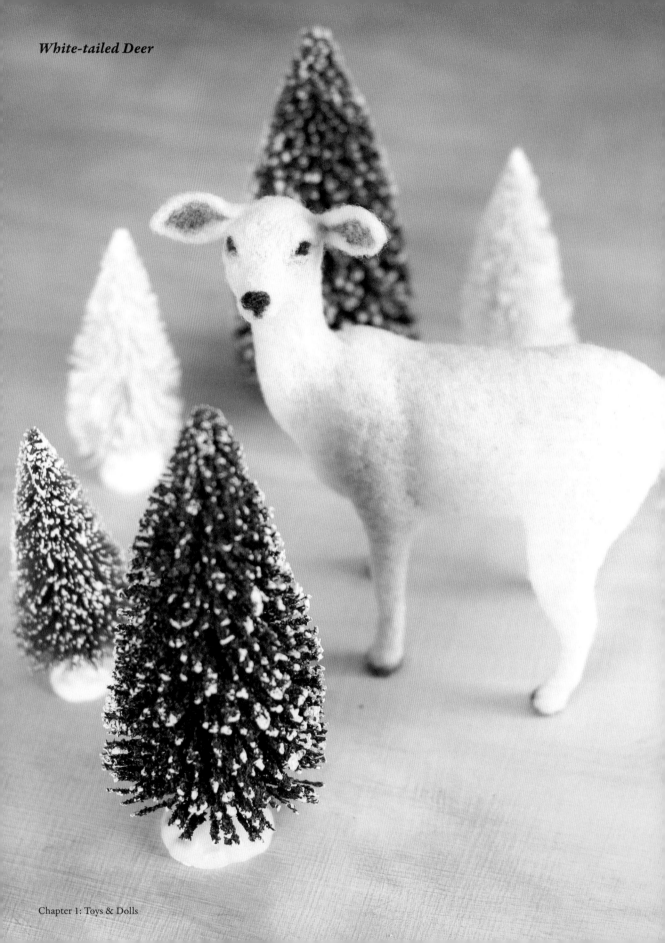

> *"Thousands of jabs with the needle shape the wool. A visual and tactile narrative is created through the addition of each layer and color. Botanical elements are detailed on the surface of chosen animals to continue the narrative."*

# *Erin Gardner*

Erin Gardner is an American fiber artist from New York. She received her MFA in 2009 from the University of North Carolina, Chapel Hill, with a focus on painting. She is self-taught in the craft of needle felting—an art form she learned about while living in Vermont after graduation.

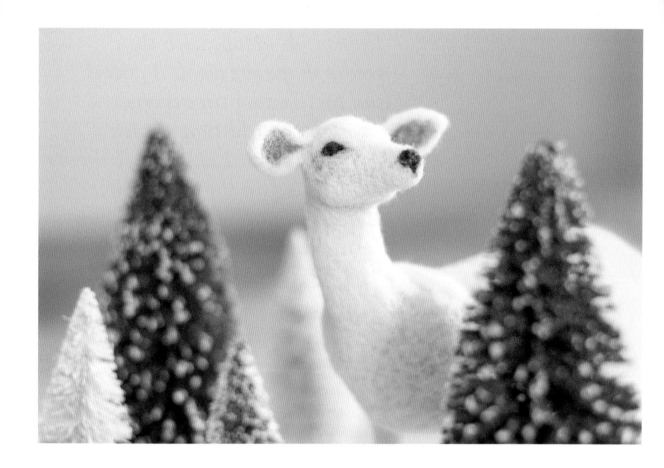

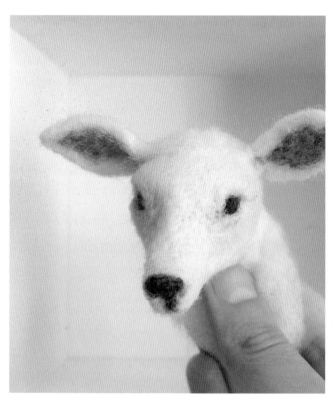

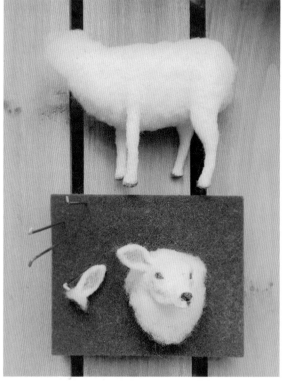

### ‹ White-tailed Deer

One summer afternoon, Erin witnessed a white deer grazing by the side of the road in upstate New York while driving. She arrived home in a state of fascination and learned about leucism, a condition that results in pale or white skin, hair, feathers, or scales. She then created a needle-felted likeness of this beautiful, ghostly creature.

### ‹ Sea Wolf with Rockweed

The sea wolf is a subspecies of the gray wolf that resides on the coasts of southern Alaska and Vancouver Island. Sea wolves often search for food in the water. The rockweed pattern on the wolf is an aquatic plant native to the coastal waters in which the sea wolf swims.

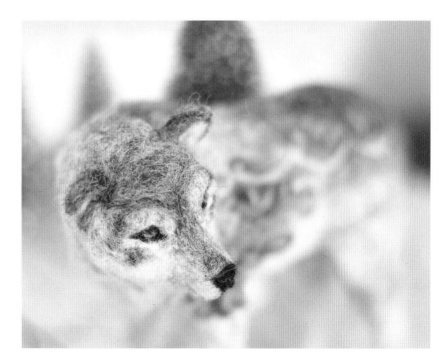

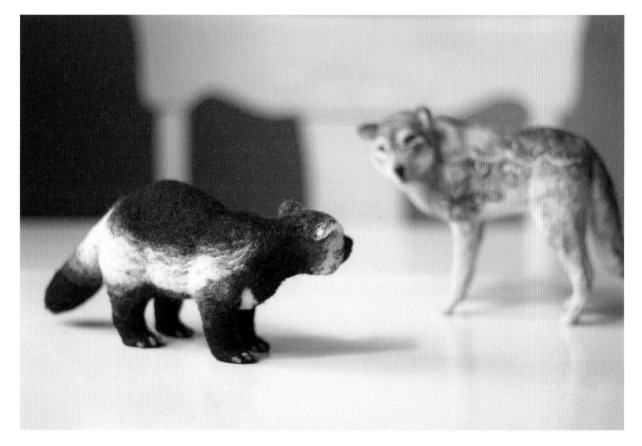

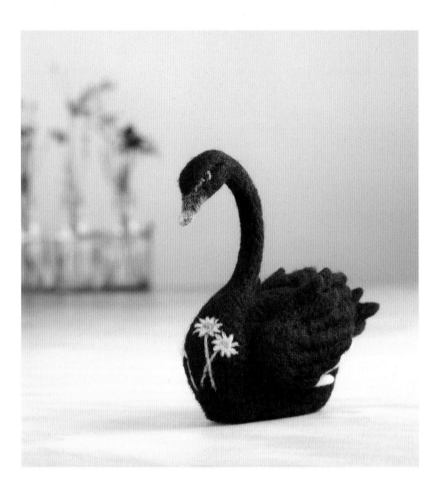

### ◂ Black Swan with Flannel Flowers

The black swan is a native to Australia. According to Aboriginal Dreamtime, the creation stories of indigenous Australia, all swans were once white. One day, two swans landed on a lagoon inhabited by eagles, who picked up the swans, flew them to the southern coast of Australia, pulled their feathers out, and dropped them along the way. The swans were saved by crows who kindly offered the swans some of their black feathers. The swans' white feathers later sprouted as delicate flannel flowers.

### ▸ Western Meadowlark with Marigolds

This felted western meadowlark, the state bird of Nebraska, was made for an auction to benefit the victims of Hurricane Harvey. The bird was detailed with marigolds, a cheerful flower associated with the sun, to send a bit of light from the Midwest.

### ▸ Woodland Trio

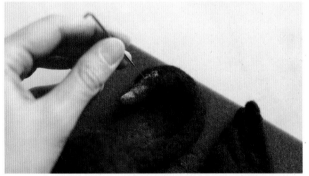

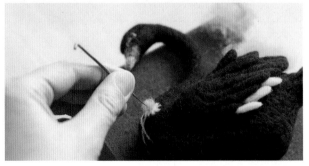

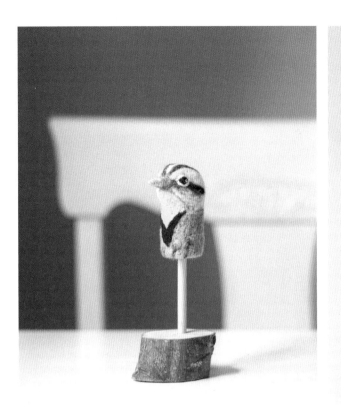

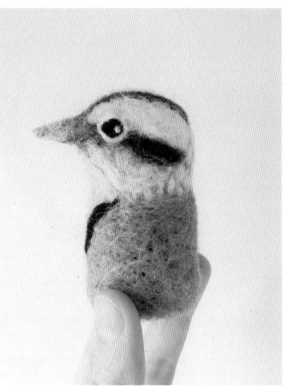

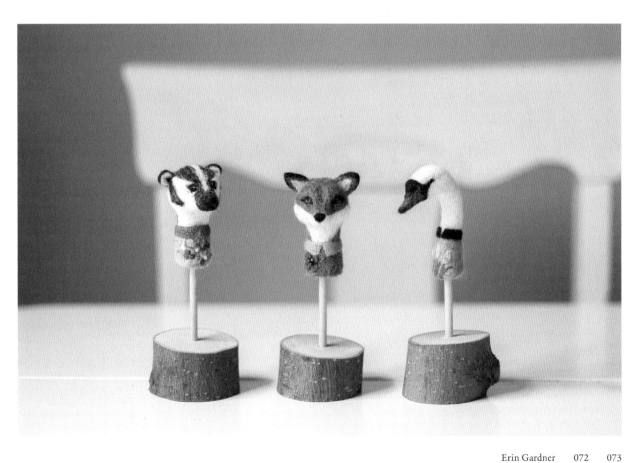

*Friends*

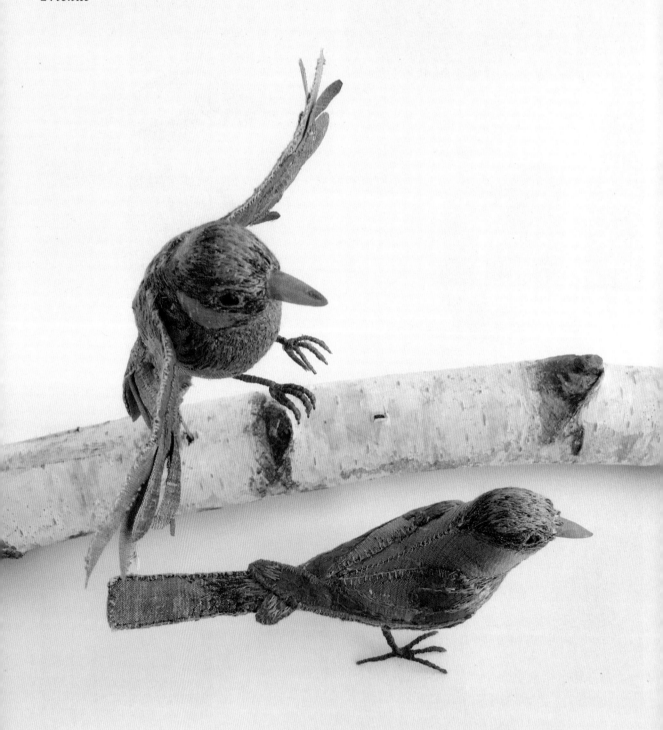

> *"I don't consider myself to be a needle-artist, but an illustrator with a love for birds and their character and behaviors. I translate my illustration style into three dimensions, and think of 'slow-stitching' as a newfound, delicate way to draw and mold each bird, without sketches or plans."*

# *Justien van der Winkel*

Justien van der Winkel graduated with a Bachelor Degree in Fine Arts and worked as an illustrator for children's books. In 2016, Justien decided to replace pencil and pen with needle and thread and become a bird-maker based in Amsterdam. She sources vintage fabrics from local markets and makes each bird by hand.

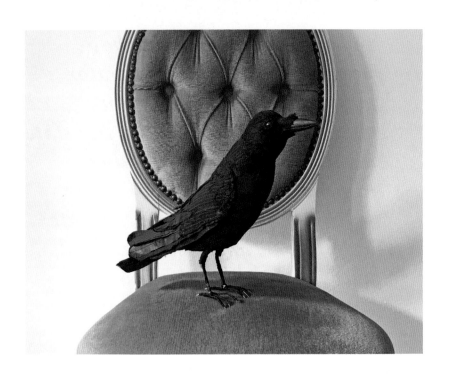

### ◂ Crow

The Crow is a life-size bird made of pinstripe wool fabric and black and dark-blue cotton. The crow's head and its beak are covered with little blue, black-grey, and purple stitches. Her wings and tail are made of lots of feathers stitched together. She measures approximately 40 cm from beak to tail.

### ▸ Blue Pink Bird

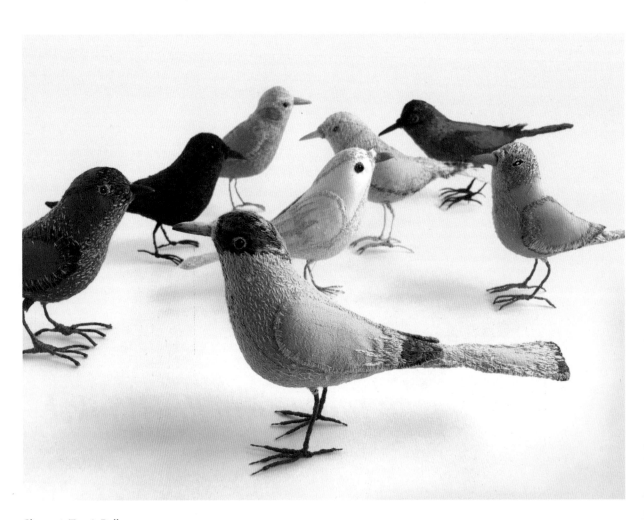

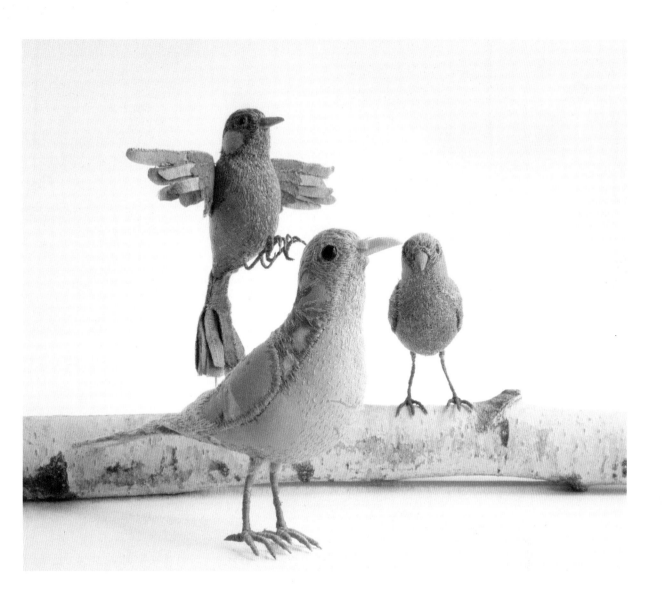

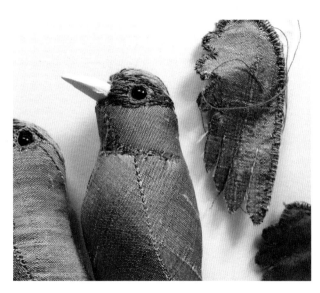

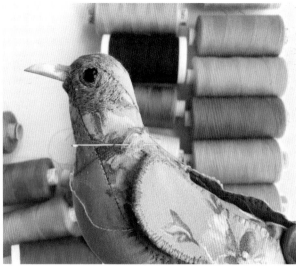

*"From a young age, creating has been an integral part of my life. My childhood was spent with a group of women makers in a small Midwest town. With them, I learned the things that I still love most in life—making jam and pies, weaving baskets, embroidering, sewing, baking desserts, and playing gin rummy."*

# *Erika Barratt*

Erika Barratt fell in love with creating when she was a child. She graduated with a BFA in Textile Arts. Currently, she works as a textile artist, designer, and maker based in New York. She makes heirloom-quality handcrafted dolls and animals from carefully sourced sustainable materials and antiques she finds.

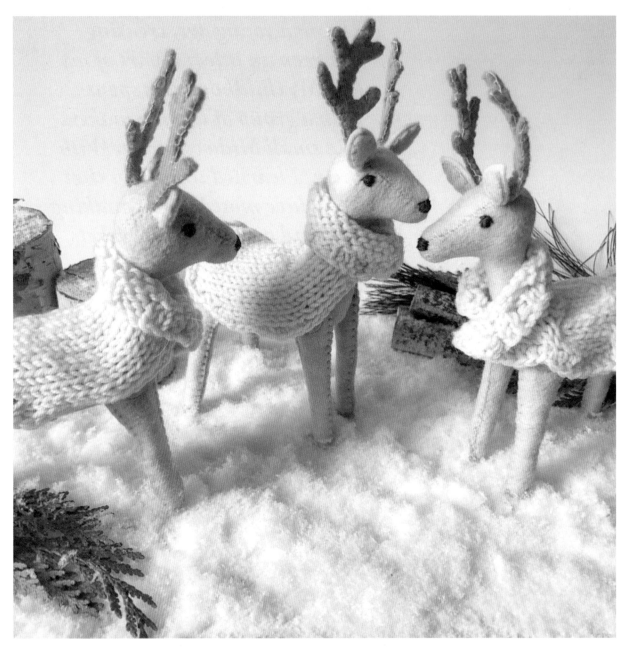

‹ *Reindeer Friends*
› *Rabbit Family*

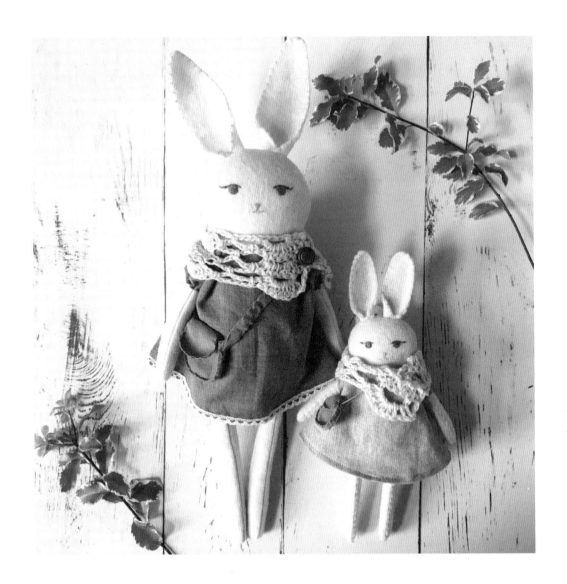

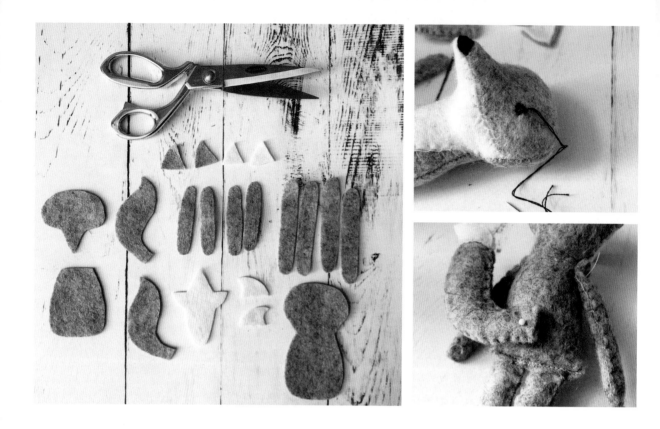

## Lady Fox

This little fox fits perfectly in the palm of your hand. She loves to collect wildflowers and to fill her basket with homemade cookies to share with her friends at the creek.

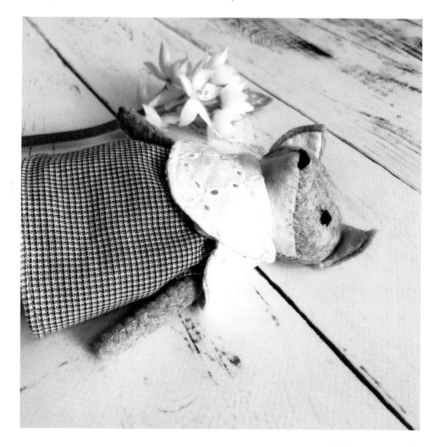

# Chapter 2: Embroidery

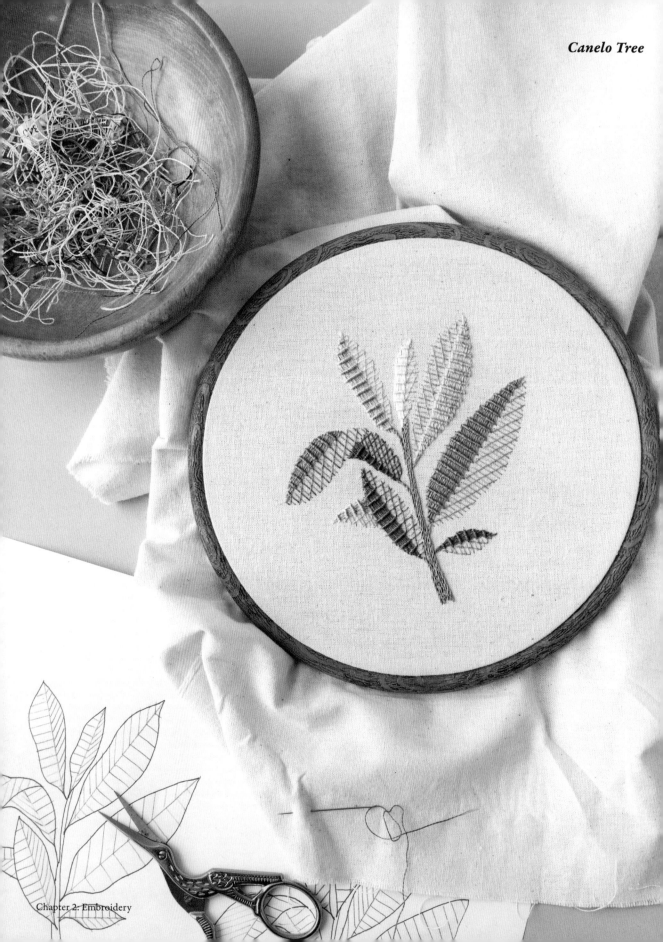

*"My work is usually described as contemporary, sometimes with a Scandinavian feel to it. I always strive to make it warm, clean and fun."*

# *Karen Barbé*

Karen Barbé is a designer, embroiderer, and educator based between Santiago (Chile) and Chicago (US). Her first book, *Colour Confident Stitching* (Pimpernel Press, 2017), presents a simple and hands-on method for understanding color and creating palettes for stitch projects.

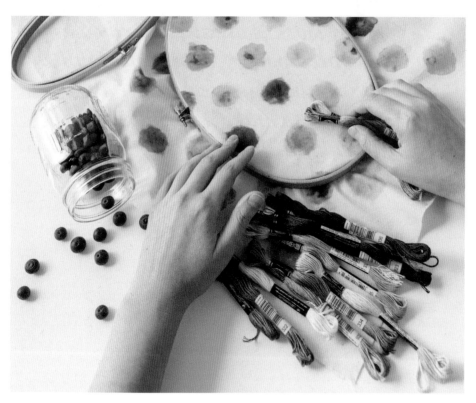

## *Woven Stitch Sampler*

Inspired by hand-printing with fresh blueberries, this sampler explores the use of woven stitches to render different textures and color intensities. To make this project, you will need embroidery floss and hand-woven textile.

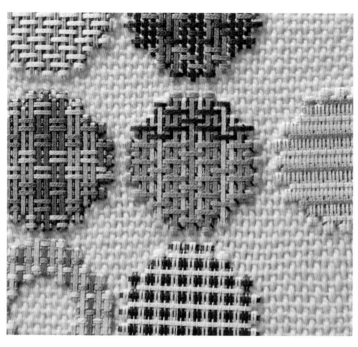

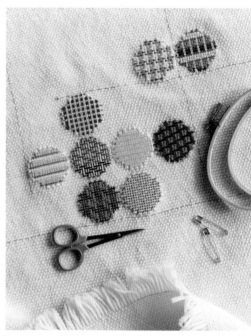

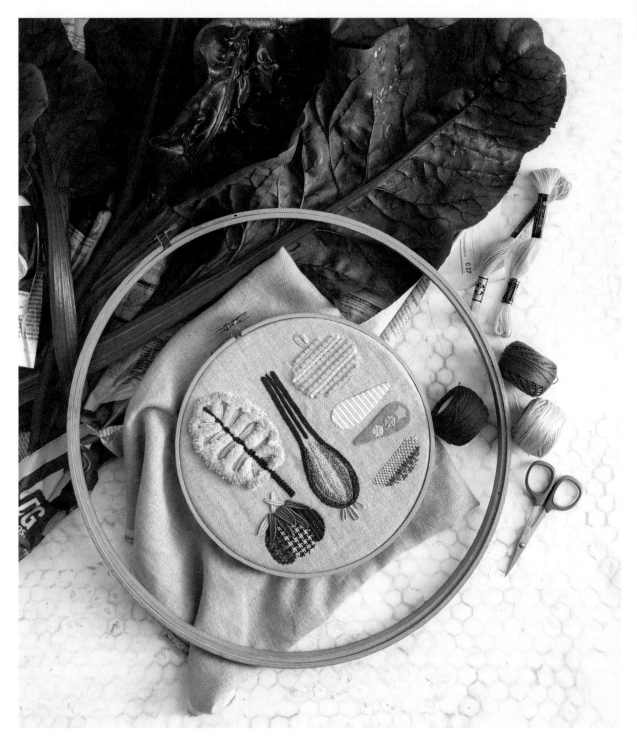

## *Veggie Sampler*

This sampler features different fruits and vegetables in brilliant colors. Karen offers embroidery lessons in her workshop, and this sampler is for intermediate students. It features both basic and more complex stitches to let students practice their techniques and expressive abilities.

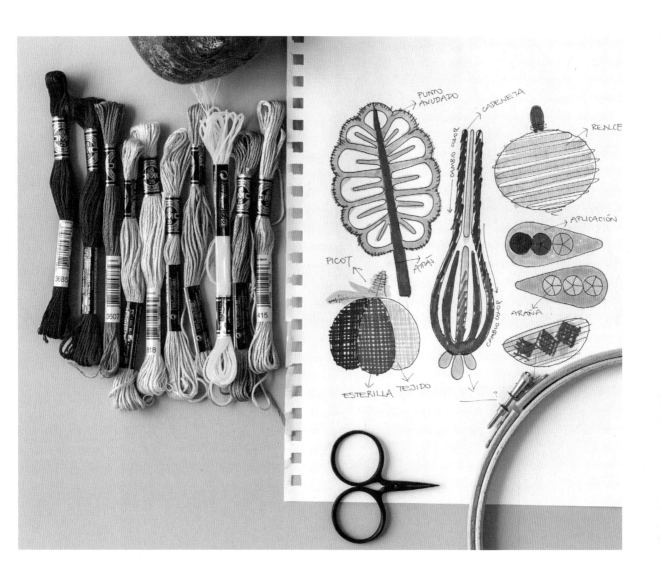

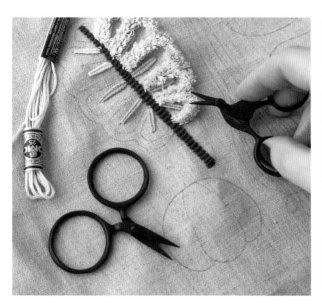

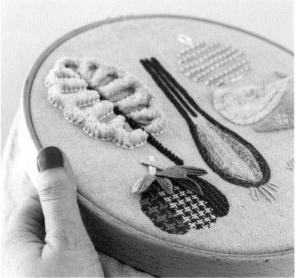

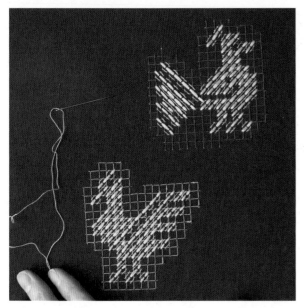

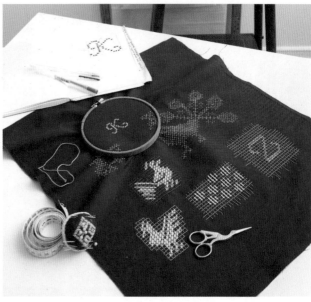

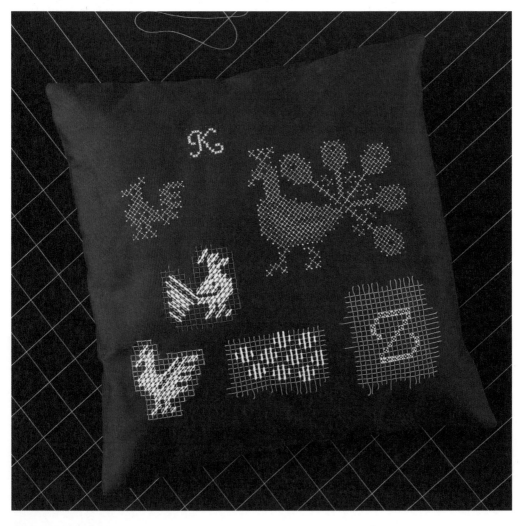

Chapter 2: Embroidery

## ◂ Cross-stitch Pillow

Invited by *KOEL Magazine* (Issue 2),
Karen created a pattern that would
spark a new understanding of cross-
stitch motifs. The original bird designs
were collected from magazines about
old crafts.

*1. Tell us something about your background and how you started your journey with embroidery.*

I'm a trained designer with a background in textiles and graphic design. During the early stages of my career, I worked in the corporate world. In 2008, I decided that I would pursue my passion for textiles when I realized they were a natural extension from a family tradition of domestic crafts. Becoming a trained designer enlightened this long-cultivated family practice with new tools, both conceptual and technical.

*2. For you, what defines a good embroidery piece?*

Embroidery crosses from artistic expression to the pure technicalities preserved in traditional embroidery schools and includes every space in between. Everyone has his or her own definition and aspirations in regards to "good" embroidery. As a designer, I stand in a place where I care a lot about the graphic quality, colors, and productive systems of embroidery.

*3. What is the most difficult part of a project? What about the most refreshing part?*

Embroidering takes so much time, attention, and focus. Sometimes, an area as small as one square inch can take up to four hours to complete, depending on the stitches

being employed. This is difficult not because of the stitch per se but it forces me to re-frame the whole project and practice based on this time scope. I guess the word "refreshing" takes me to that part of the process where the project is still open and can go in many different ways. So it is that creative exploration that opens new possibilities, which is invigorating to me and keeps me pushing my stitches forward.

*4. The color schemes of your works are stunning. What suggestions would you give to beginners on color combinations?*

I think what makes my palettes shine is the consistent concept of my work as a whole. All my work revolves around the idea of home. Color comes as a "tool" to express this concept. I use lots of warm neutrals like off-white, beige, and shades of brown to bring in the feeling of coziness at home. And then, to avoid a flat or boring outcome, I like to add pops of bright colors such as blue, pink, and orange which immediately infuse a joyful tone to the mix.

As for suggestions for beginners, may I recommend my own book, *Colour Confident Stitching*? First, you should train your eyes to spot beautiful color combinations everywhere you go (ideally, you should make note of them in a color journal). Then, it comes to actually

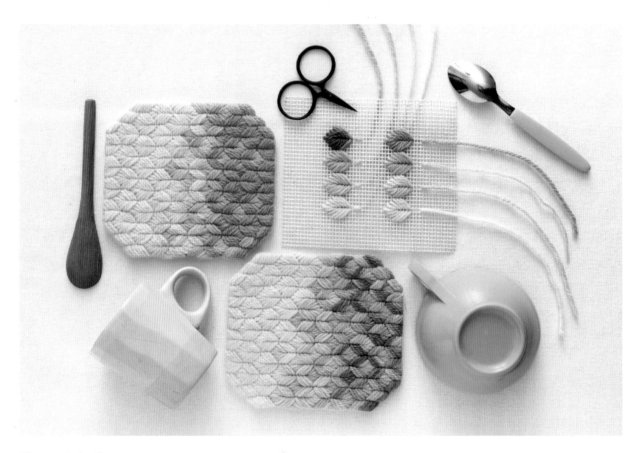

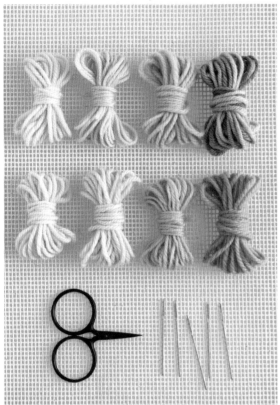

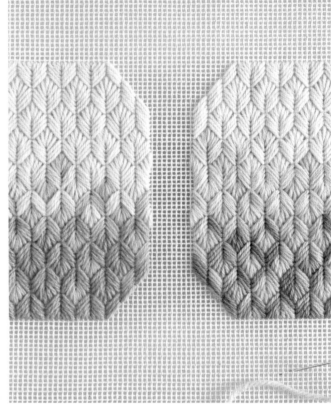

knowing what you want to convey with your colors. There are no right or wrong colors—all that matters is what kind of mood you want to build with that palette. Choose the shades accordingly.

*5. You have published a book called* Colour Confident Stitching: How to Create Beautiful Colour Palettes. *What inspired you to publish this book?*

In 2013, I started teaching embroidery and I soon realized that one of the most common complaints among my students was about the colors used in their samplers. Though they were able to get the stitches right, they still felt disappointed with the palette they had chosen. I also discovered that choosing colors for them was challenging not only in embroidery but in other yarn crafts as well. It was then that I decided to run a workshop about creating beautiful color palettes—a class in which I explain in an easy way the concepts of color theory and how to work with them in order to train our eyes in matters of color. We then discussed this idea with my editor at Pimpernel Press, Anna Sanderson, and that was how *Colour Confident Stitching* came to life.

*6. In today's world, people can get ready-made stuff easily from physical shops and online. What do you think defines the charm of handmade art?*

The best connection between a customer and a handmade object happens when the customer really knows about the story and work behind the piece. And by this I don't mean learning about the story from a website or leaflet; it's about a connection built in time, whether by following the maker in her process or by actually trying that craft technique. My approach to design is through embroidery. It shapes my thinking, experimentation, and creation process. It is also a declaration of principles about appreciating life and design in a slower fashion, where mistakes and corrections have the necessary time and consideration. People who find charm in handmade objects can relate to this dimension and cadence of work.

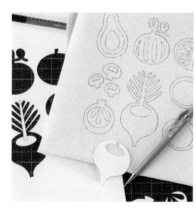
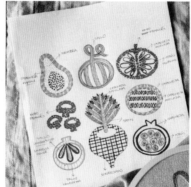
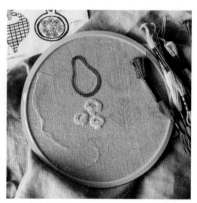

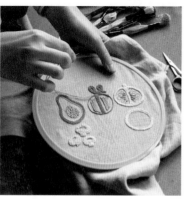
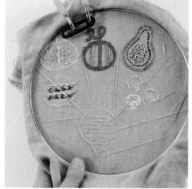
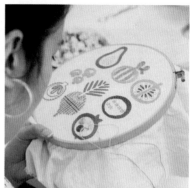

## Materials & Tools

- Linen fabric
- Cotton embroidery floss
- Pearl cotton
- Embroidery needle
- Small, sharp scissors
- 5-inch embroidery hoop

## Tutorial

1. Sketch the motif on a piece of paper..

2. Use a color palette that ranges from very light to very dark colors to achieve contrast.

3. Trace the motif on the linen fabric using a water-soluble fabric pen or a mechanical pencil and mount the hoop on the fabric.

4. Take care that the fruit to be embroidered is placed in the center of it or slightly to one side. (Avoid embroidering too close to the edges of the hoop.)

5. Stitch using mostly one or two strands of floss and pearl cotton. You can use more strands for a bolder, more textured look.

6. Fill in the shapes using the following stitches: laced backstitch, seed stitch, chain stitch, French knot, satin, stem stitch, trellis, and woven wheel.

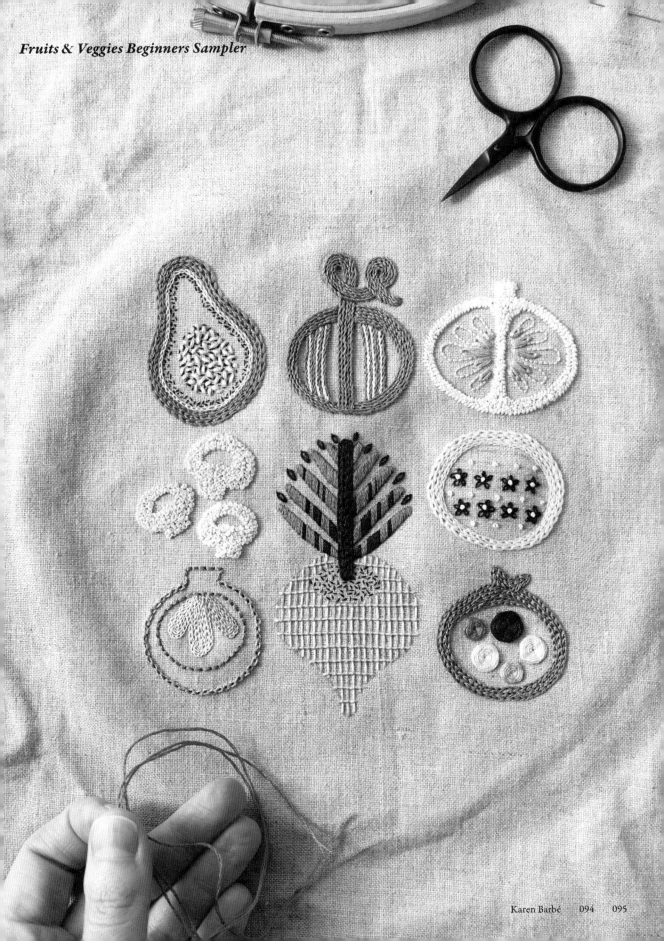

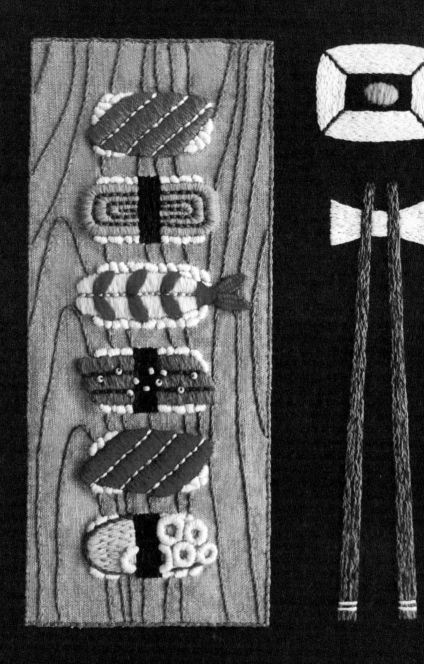

*"My embroidery work is intense and sensual in both colors and forms. I like applying them to small objects that we use in daily life."*

# *Atelier Hola*

Atelier Hola, a.k.a. Hwa-young Lee, is an artist based in South Korea. Inspired by the intense and enthusiastic colors that she saw during her trip to Spain, Hwa-young created her artisan atelier after she returned and named it Atelier Hola, in memory of the trip. Atelier Hola mainly makes fashionable and fun small embroidery works using the techniques of French embroidery and bead embroidery, and she also offers embroidery classes.

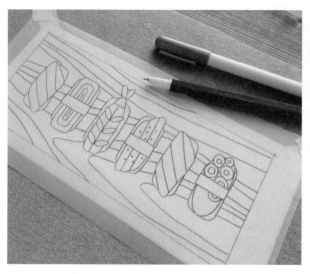
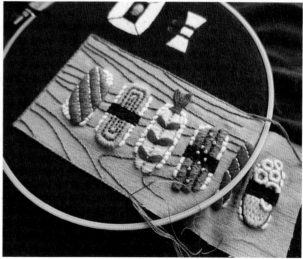

## ▾ Sushi Embroidery Platter

This sophisticated work features embroidered sushi with strong colors and delicate shapes.

## ▸ Food Embroidery Magnets

A set of food embroidery with attached magnets.

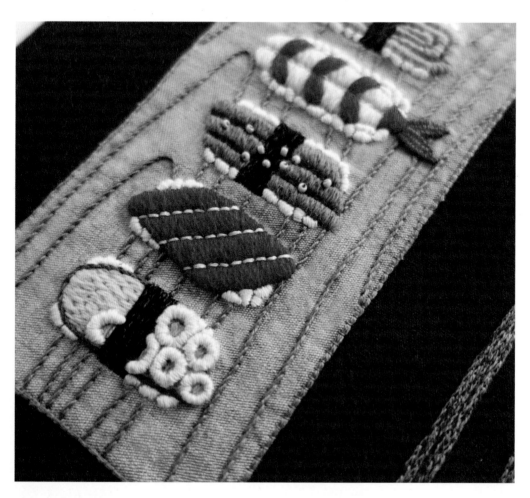

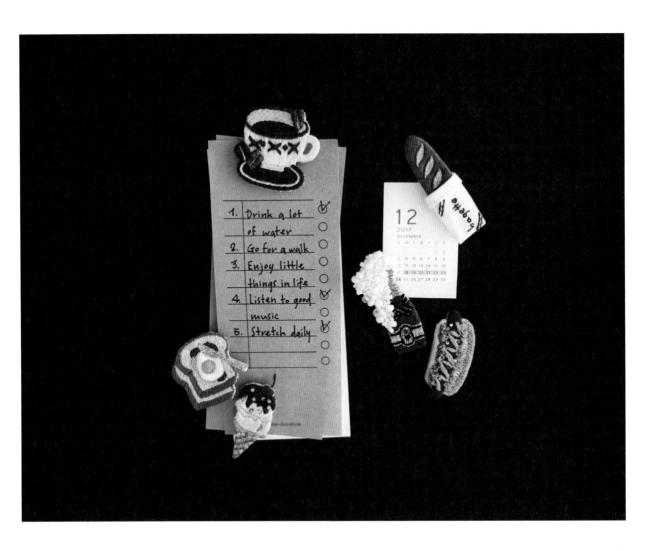

1. Drink a lot of water
2. Go for a walk
3. Enjoy little things in life
4. Listen to good music
5. Stretch daily

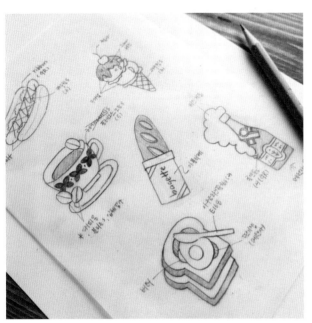

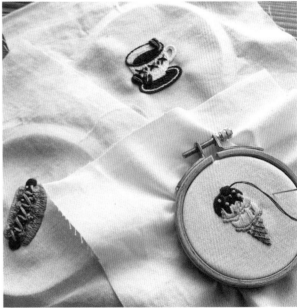

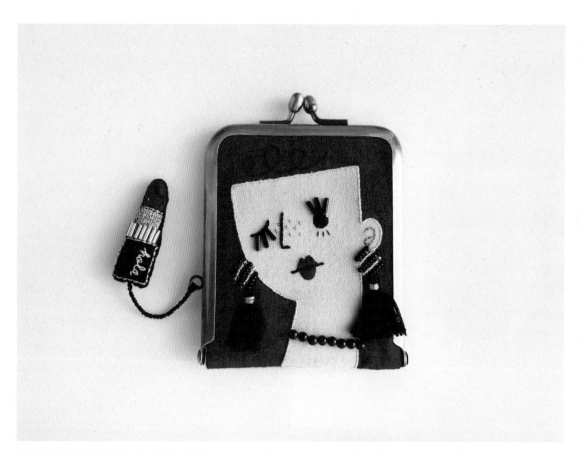

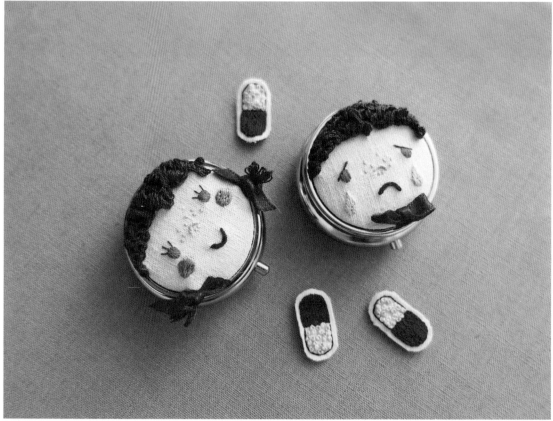

Chapter 2: Embroidery

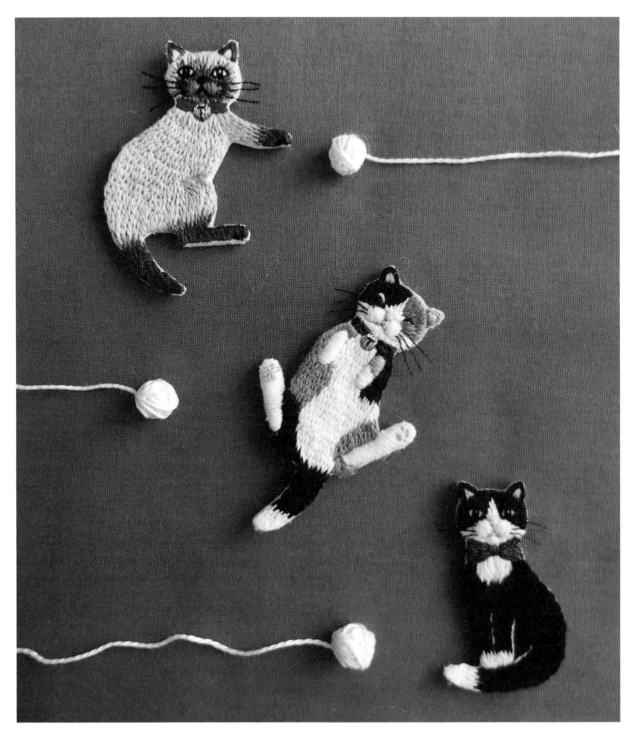

◂ *Mademoiselle Needle Case and Lipstick Pincushion*
◂ *Olive & Oliver Pill Case*
▴ *Cats*

*1. Tell us something about your background and how you started your journey with embroidery.*

One day, when I was looking for something to make my monotonous routine special, I saw a piece of flower embroidery on the Internet and became interested in handmade embroidery. Then I bought a Japanese embroidery book and started to embroider bit by bit, although I didn't know much about it. I made gifts for my friends and family and received some good comments. I find my daily life is becoming special with my embroidery work.

*2. You said the trip to Spain inspired you to establish Atelier Hola. Can you tell us more about it?*

During the trip, I was deeply impressed by the intense atmosphere and the traditional culture of this country, which became the driving force for me to start the atelier. Everything I saw on the trip fit well with my taste, especially the flamenco performance and the unique buildings of Gaudi. When I came back to Korea, Spain was always calling me back. Thus, I created my embroidery atelier based on the vibrancy and colors of the Spanish culture and named it "Hola."

*3. For you, what defines a good embroidery piece?*

The work that moves a viewer is probably the best embroidery piece. But personally, I think a good piece of embroidery is always the one that combines the appropriate color with the ideal stitching, proper design, and good material.

*4. What is the most challenging part of a project? What about the most refreshing part?*

The most difficult part is to experience the trials and errors while working. I usually spend a lot of time creating my works, so when they fail, I lose a lot of strength. Ironically, the funny thing is that it's very fun to go through trials and errors and lead the situation to better results.

*5. What is the best comment you have received so far?*

The best comment is when people tell me that they are becoming more interested in embroidery because of my work. I'm glad and thankful that I can make such an impact.

*6. Your works look adorable. Where do you usually get inspiration?*

Thank you! I like small adorable items and pictures. I usually like to turn my inspirations into pieces of embroidery, so I often visit various exhibitions to get inspired. These days I'm inspired by seasonal materials.

*7. What's your favorite piece so far? Why?*

My favorite works are framed coin purses, needle cases, stamp pouches, small magnets, and brooches. These works are also taught in my embroidery lessons. The reason I like them is that they reflect my personal style and taste. I choose the right materials and express my feelings with them. They are the things that make me who I am right now.

*8. What is your typical day like? What environment do you prefer to work in?*

I have been almost buried in embroidery since I started the atelier. In other words, embroidery has become my

life. Even when I don't embroider, I still look for pictures or materials that can inspire me on embroidery. When I embroider, I like to stay stress-free, play my favorite music, or drink tea with my cat. The best thing is I do what I want, rather than being ordered or assigned to work.

*9. In today's world, people can get ready-made stuff easily from physical shops and online. What do you think defines the charm of handmade art?*

Unlike ready-made products, handmade items are filled with a lot of thought, heart, and time. They express details made by hand, which a ready-made product can never imitate. They take a lot of sincerity and time, so they can only be made in small quantities. With a lot of consideration from the artist, a handmade object carries meaning and soul. Perhaps this is why people love looking for handmade items.

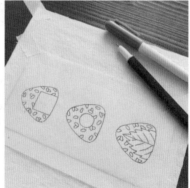
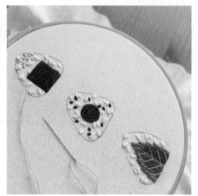

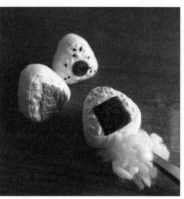

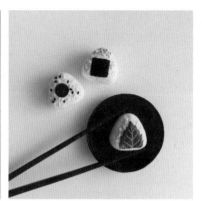

## Materials & Tools

- Embroidery thread
- White fabric
- Cotton
- Embroidery needle
- Embroidery hoop
- Scissors
- Tracing paper
- Chalk
- Pen

## Tutorial

1. Sketch ideas on paper.

2. Transfer the pattern to the fabric using tracing paper, chalk, and pens.

3. Secure the drawn fabric on an embroidery hoop and start to embroider the pattern on the fabric.

4. Sew up the back face, front face, and side surface of the rice ball, but leave an opening at the bottom. Stuff with cotton and then stitch the opening.

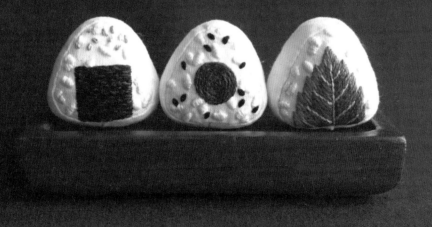

## Snow White

This scene, from the fairy tale *Snow White*, depicts the lovely princess in
a graceful dress. This embroidery illustrates Annas' themes and values:
animals, plants, and fairy tale heroines.

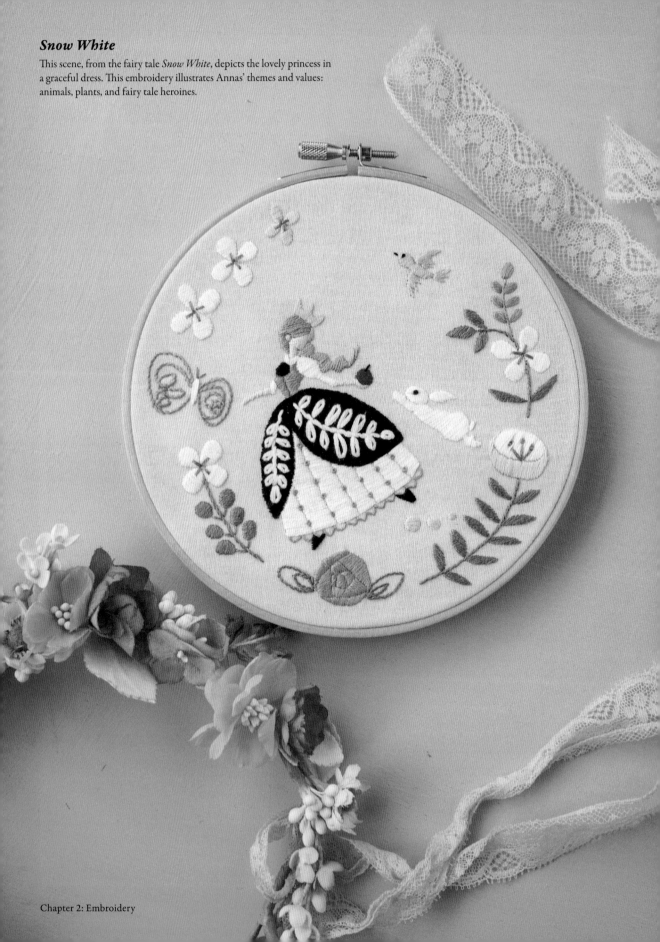

*"With children's tales as a theme, I recreate through French embroidery the details in plants and animals as if I was drawing."*

# *Annas*

Born in Osaka, Japan, Annas worked as a kindergarten teacher before she started a career as an embroidery artist in 2006. Her work is published in print and the Internet, and is well-received by both children and adults. She also creates artwork for book covers and advertisements. She now presides over the "Atelier Anna & Lapin" embroidery school, and her books are sold in Japan, China, and Korea.

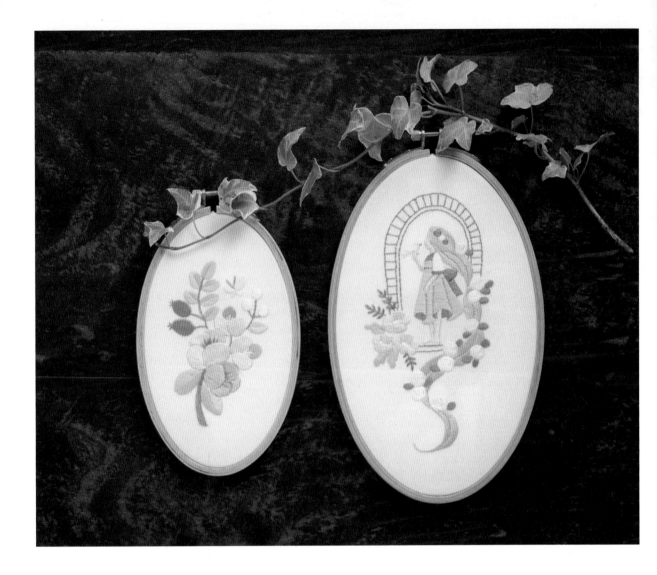

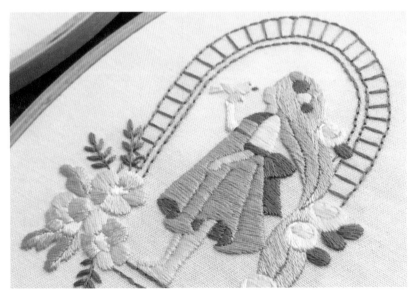

### ▸ *Rapunzel*

Spring is approaching and flowers are blooming in the garden. The beautiful girl with long hair, Rapunzel, stays in the tower with the birds.

### ▸ *Little Red Riding Hood*
### ▸ *Alice in Wonderland*

This features a scene from *Alice in Wonderland*. The card soldiers, at the Queen's command, are setting out to paint all the roses red.

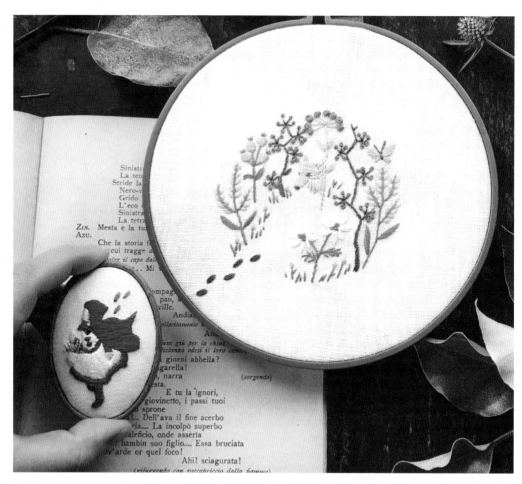

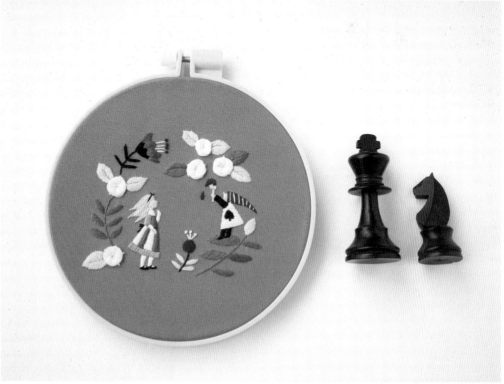

*▾ Embroidery on a T-shirt*

*▸ A Cardigan with Embroideries of Hydrangea Flowers*

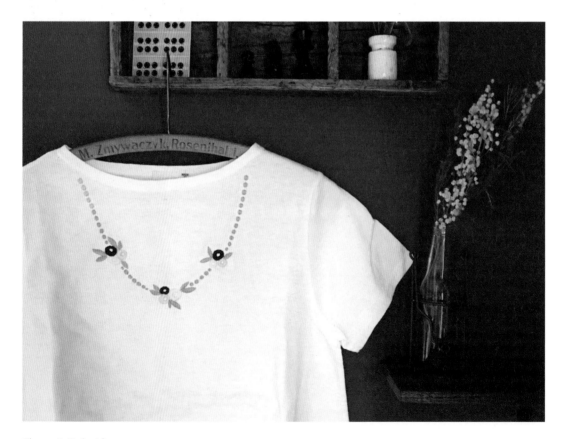

Chapter 2: Embroidery

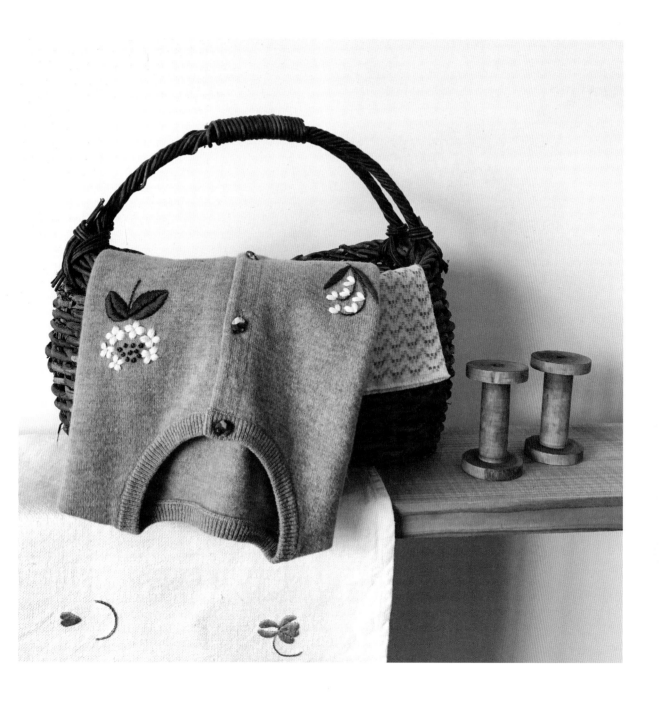

## *Father's Day & Mother's Day*

Annas created gifts for Father's Day and Mother's Day that express one's love and respect for his or her parents.

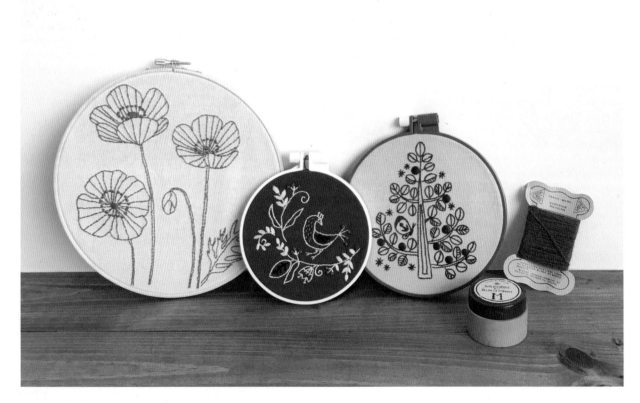

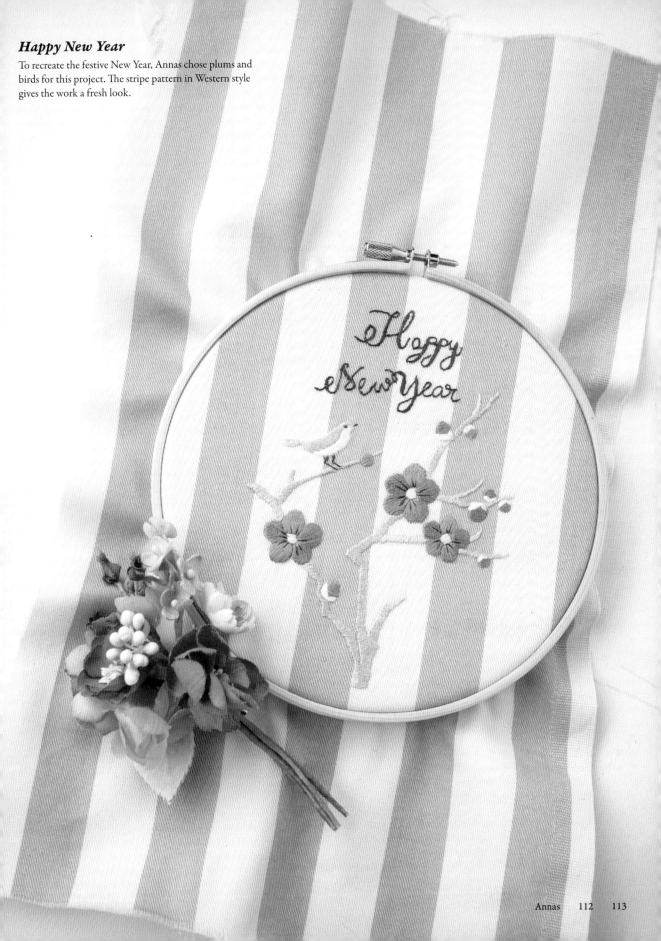

## Happy New Year

To recreate the festive New Year, Annas chose plums and
birds for this project. The stripe pattern in Western style
gives the work a fresh look.

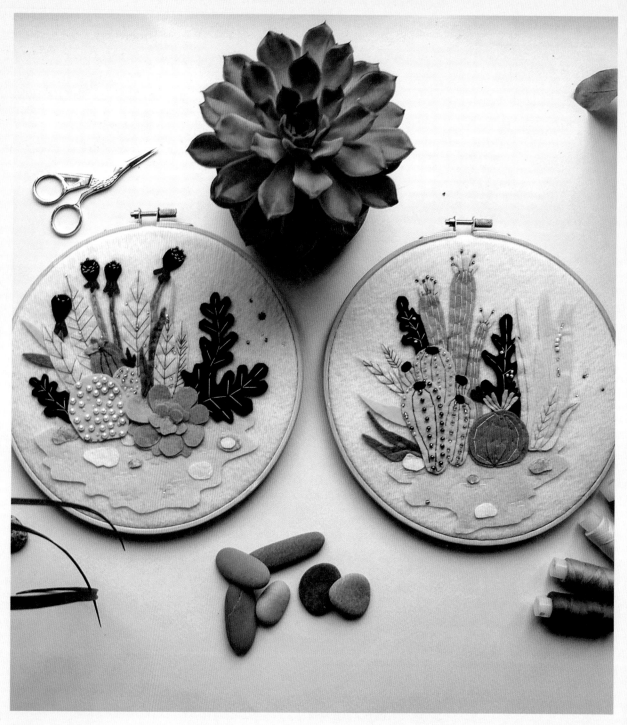

**Warm Botany**

*"My goal is to bring fabric to life, so I use multiple layers, add small or even microscopic details to my work, and always try to find new ways of working with familiar materials."*

# Svetlana Kuznetsova

Svetlana Kuznetsova, a.k.a. Art_Mart, creates cozy gifts to bring joy and warm emotions to people. For Svetlana, felting fabric is the best material to work with because of its softness and special texture. She likes to find inspiration in beautiful stories of friendship and love of her clients.

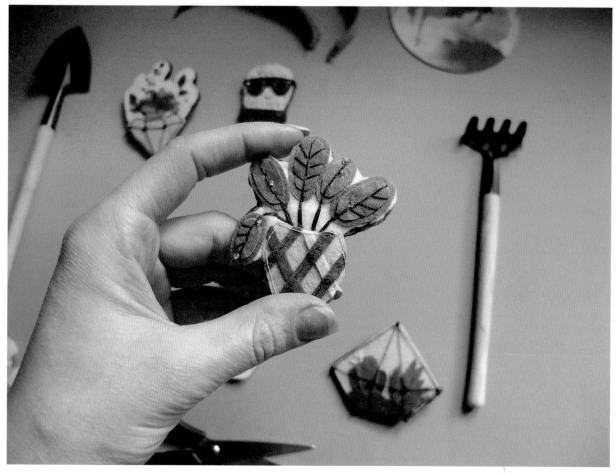

*Fit-in-your-palm Brooches (Plants Series)*

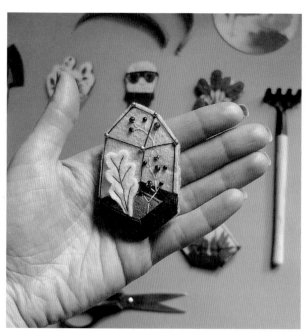

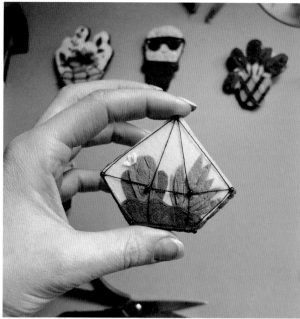

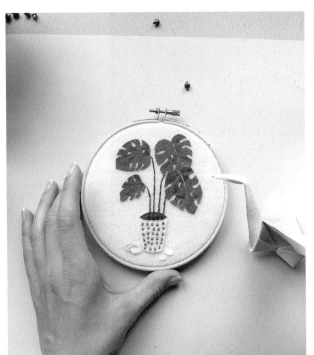

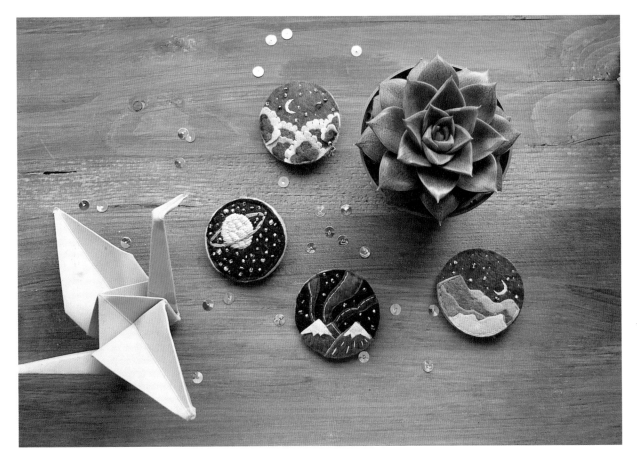

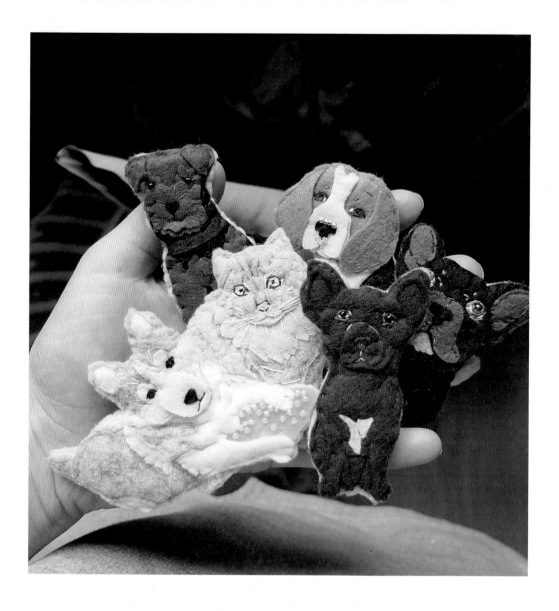

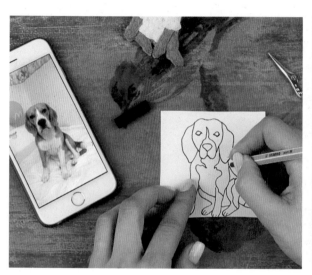

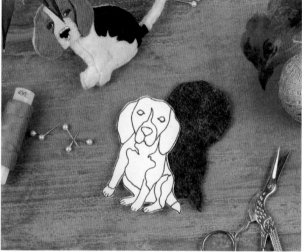

Chapter 2: Embroidery

## *Fit-in-your-palm Brooches (Pets Series)*

In everyday life, it is hard to spend every minute with your furry
creatures. Svetlana creates these brooches so that even if you are not
with your pets, you can still hold them to your heart all day long.

### Warm Portraits

These are the brightest and coolest gifts for your friends, family members, and everyone you care about.

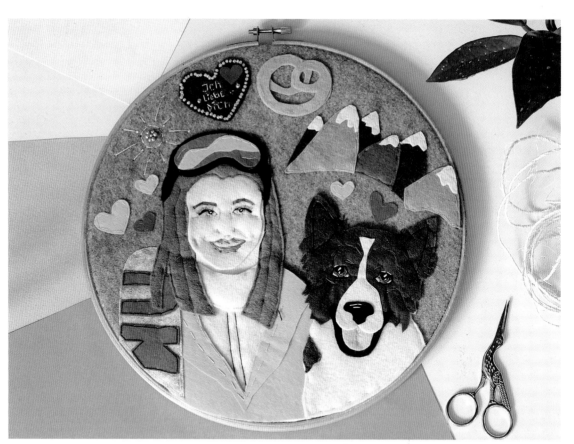

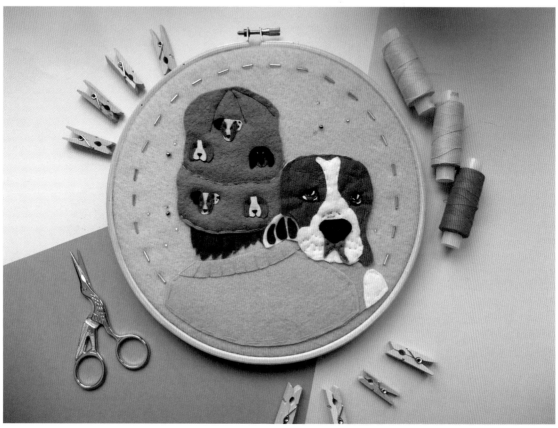

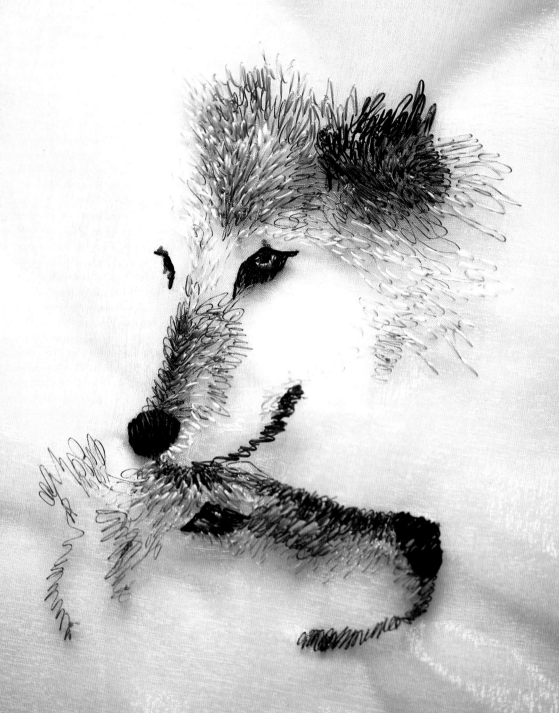

Photos of pages 122–127 by Junichi Miyazaki.

*"I learned embroidery by myself. I enjoy matching my favorite threads with different materials to create something fresh and unexpected."*

# *Yuri Miyazaki*

Yuri Miyazaki is a self-taught embroidery artist born in Kanazawa, Japan. She graduated from Kanazawa College of Art with a degree in Graphic Design. She uses threads as her pen and draws in freestyle on different materials, regardless of the size. She has already held several solo exhibitions.

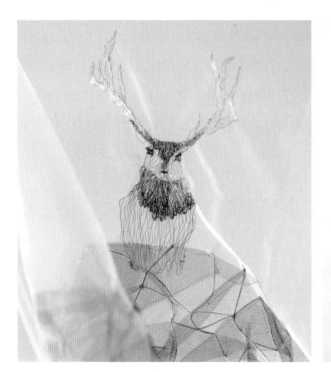
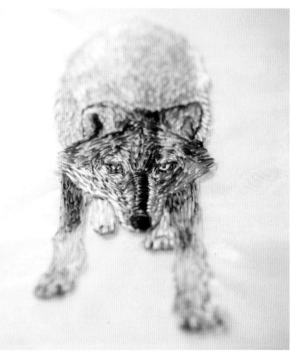
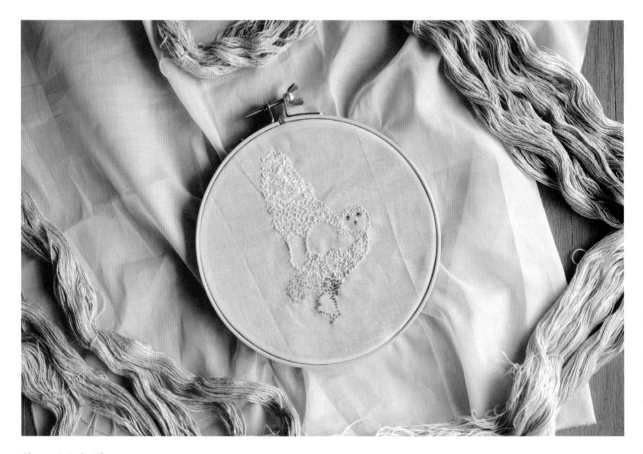

Chapter 2: Embroidery

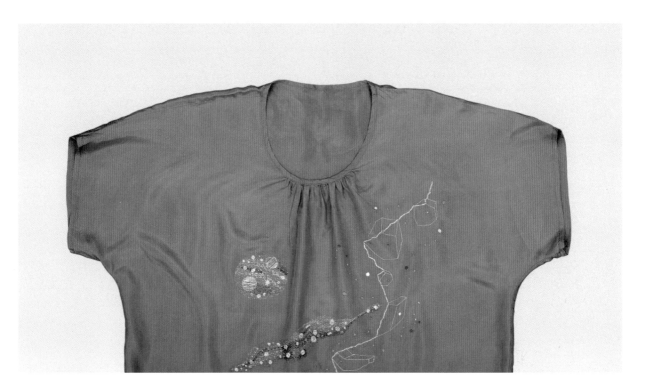

### ◄ Animals

Yuri did this series for her first exhibition at a shop that sold clothes and accessories. She collaborated with a fashion designer and embroidered various animals on the skirts, which were made of transparent materials such as organdy. The animals show a wide variety of facial expressions. When Yuri imagined a colorful bird living in the Southern country, she picked vivid threads and drew a fictitious animal. She even changed the embroidery methods to imitate the furs of different types of animals.

### ✢ Stars and Mythology

These are part of the works that Yuri made for one of her solo exhibitions titled "Stars and Mythology."

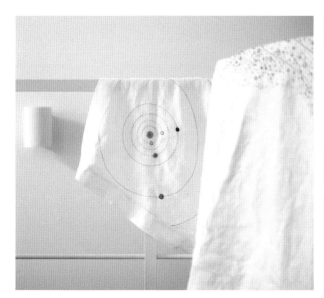

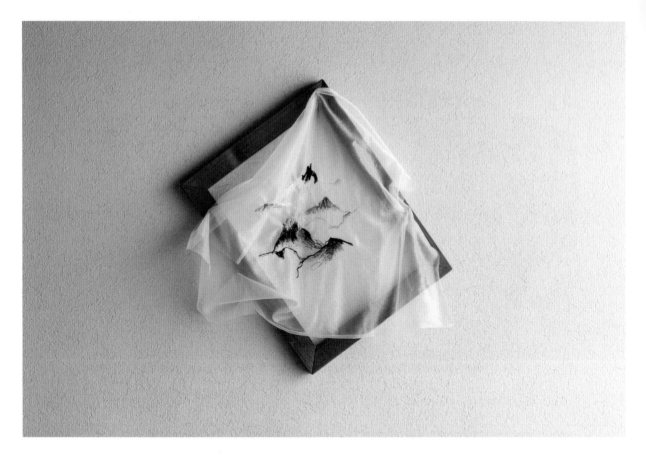

## *Mountain*

When Yuri thought of drawing a picture with threads, she often visited her friends who lived in the beautiful mountainous area. The sky there was always sunny and clear. She could see the ridges clearly, as if she could almost touch them. Yuri has since left Tokyo and has come to live among the mountains herself, but before her moved, she always dreamt about the mountainous scenery, the beautiful shadows of the rolling mountains. The mountain embroidery series is now one of Yuri's signature works.

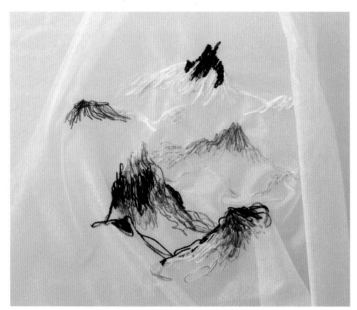

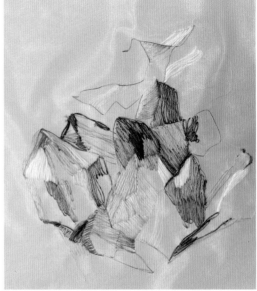

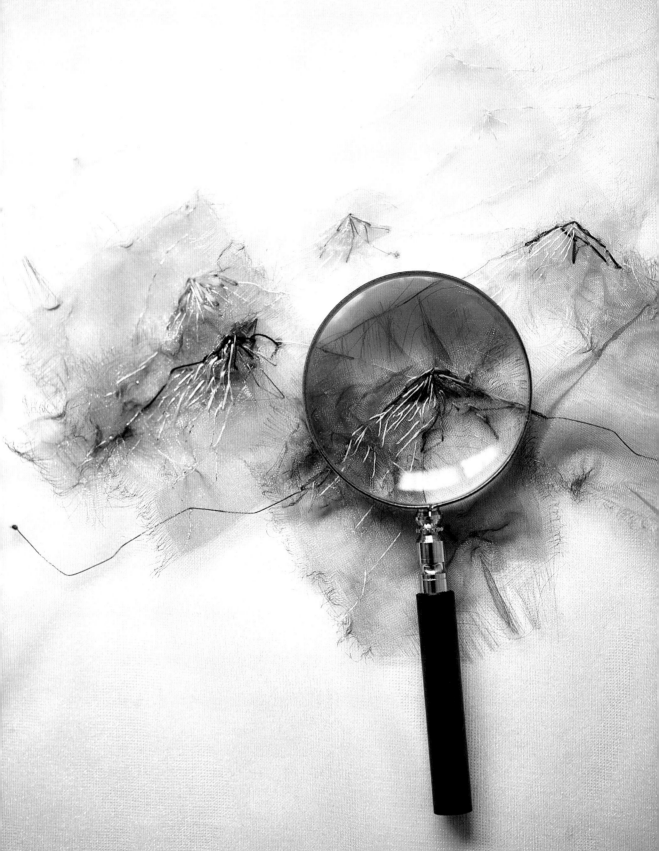

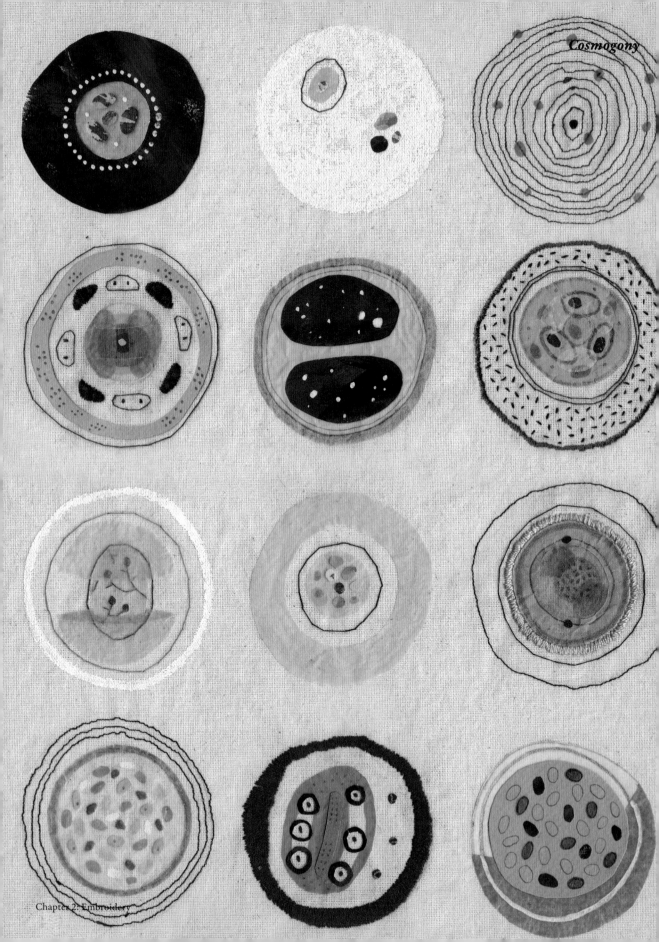

> *"I make embroidery on canvas or collages of collected or handmade pieces of paper."*

# *Annalisa Bollini*

After obtaining a degree in History of Art, Annalisa Bollini got a BA degree in Illustration from Turin (IED, European Institute of Design) and Milwaukee (MIAD, Milwaukee Institute of Art and Design). Her illustrations have been selected in international competitions, such as ILLUSTRARTE (2012), CJ Picture Book Awards (2012), Society of Illustrators Annual Exhibition (2015), Bologna Children's Book Fair (2016), and NAMI Concours (2017). Her first book, *Qui a Volé le Savon*, was released in October 2015 in Paris by Gallimard Jeunesse.

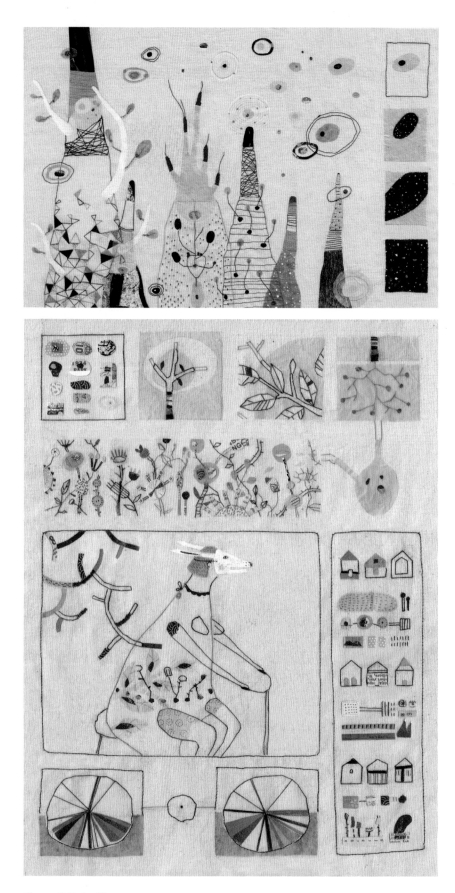

Chapter 2: Embroidery

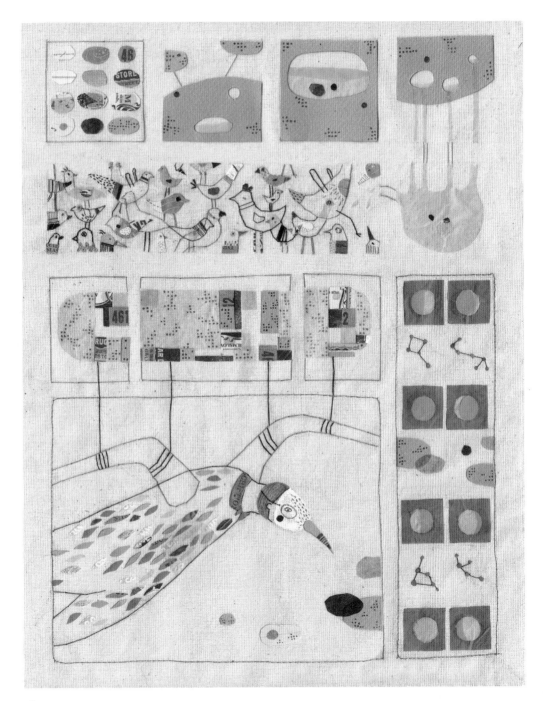

## *Cosmogony*

These pieces are interpretations of how everything was born. Two entities—the Earth and the Sky, choose the perfect place to live in the entire silent universe. After the separation between the heavy and light elements, everything starts to join in a harmonious way to create every single creature.

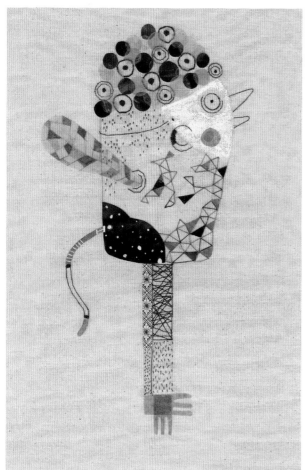

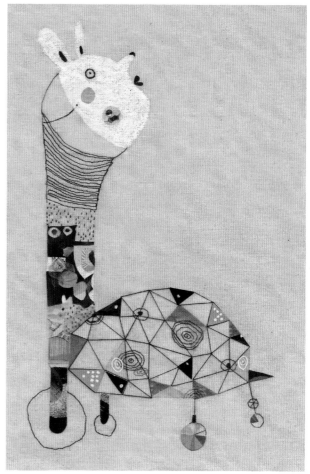

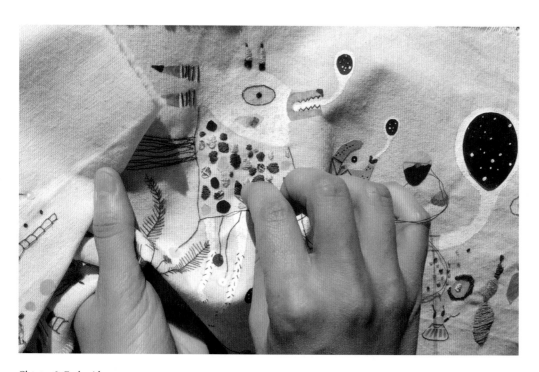

Chapter 2: Embroidery

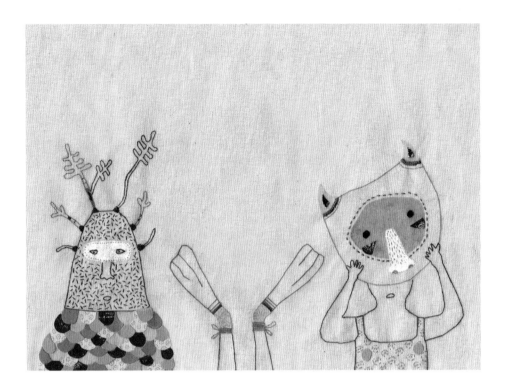

### ◄ *Imaginary Bestiary*

This is a calendar commissioned by the San Zeno Foundation in Italy. Every month is represented by an imaginary beast, created from a mix of two animals.

### ▾ *Who Has Taken the Soap?*

This series is for Annalisa's first children's book, titled *Qui a Volé le Savon,* published by Gallimard Jeunesse. The story is about the Barban family and the mysterious disappearance of the soap in their house. It is a story of friendship and freedom.

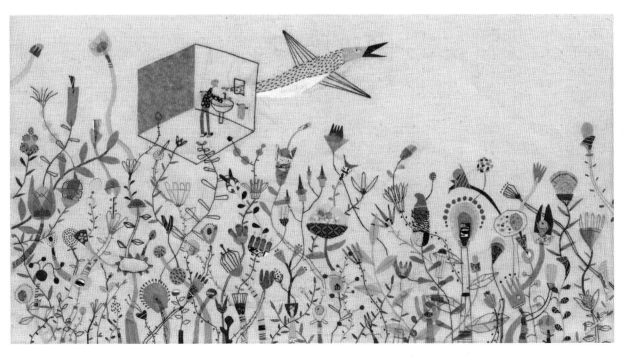

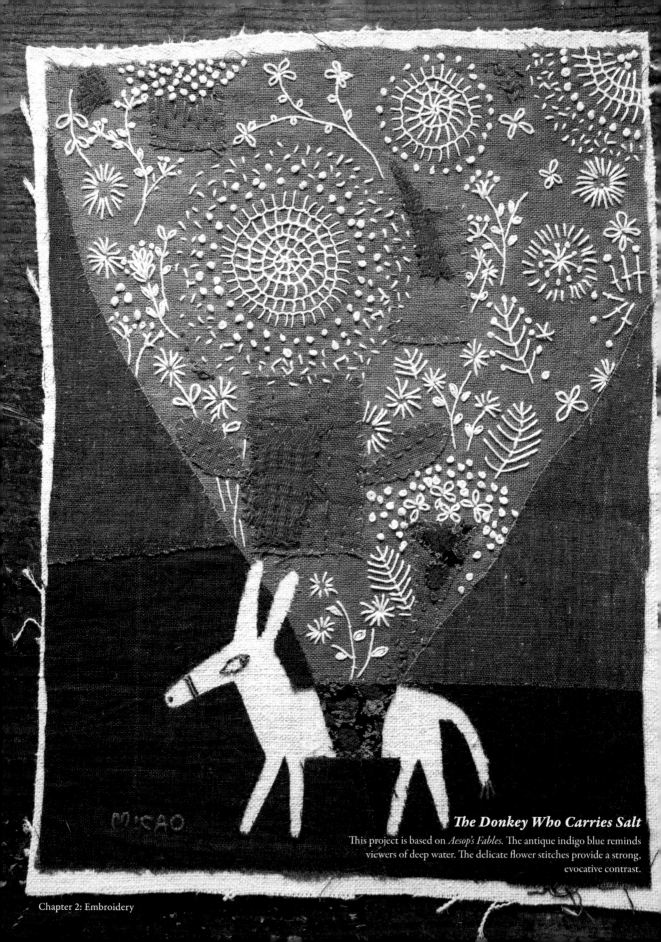

### The Donkey Who Carries Salt

This project is based on *Aesop's Fables*. The antique indigo blue reminds
viewers of deep water. The delicate flower stitches provide a strong,
evocative contrast.

*"I make artworks with textile materials such as embroidery thread, antique laces, used clothes, etc. I draw lines with the sewing machine, then I use paints, dyes, and hand stitches to enrich my drawing's expression."*

# MICAO

Born in 1967, MICAO graduated from Kobe University with a degree in Business Administration. Her work ranges from cover art for magazines to collaborative projects with stationary manufacturers. She participates in both solo and group exhibitions in Japan every year.

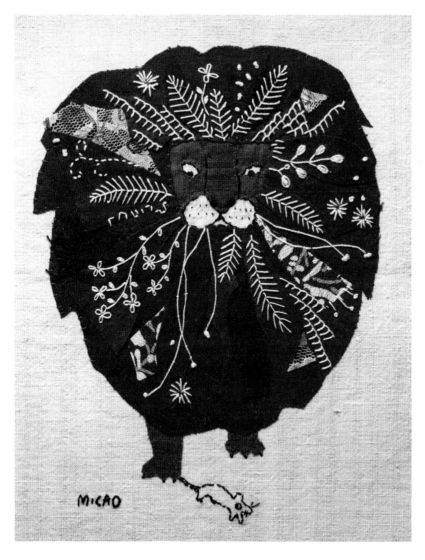

## The Lion and the Mouse

This is another project based on *Aesop's Fables*. The most important thing in drawing pictures with textiles is to use materials effectively. The rough edge of the fabric and the irregular stitches give the work a gentle and warm feeling. The proper use of the colors leaves an impact and adds elegance.

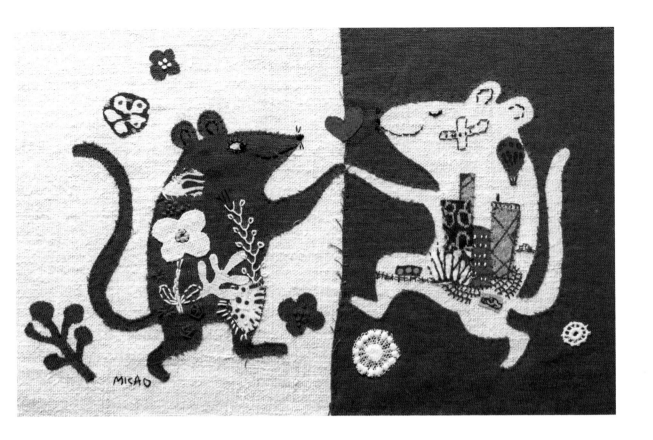

## The Town Mouse and the Country Mouse

The contrast of color emphasizes the difference between the town mouse and the country mouse.

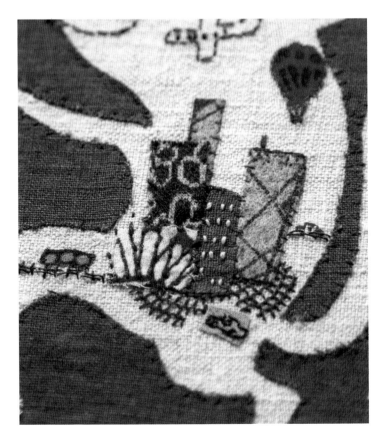

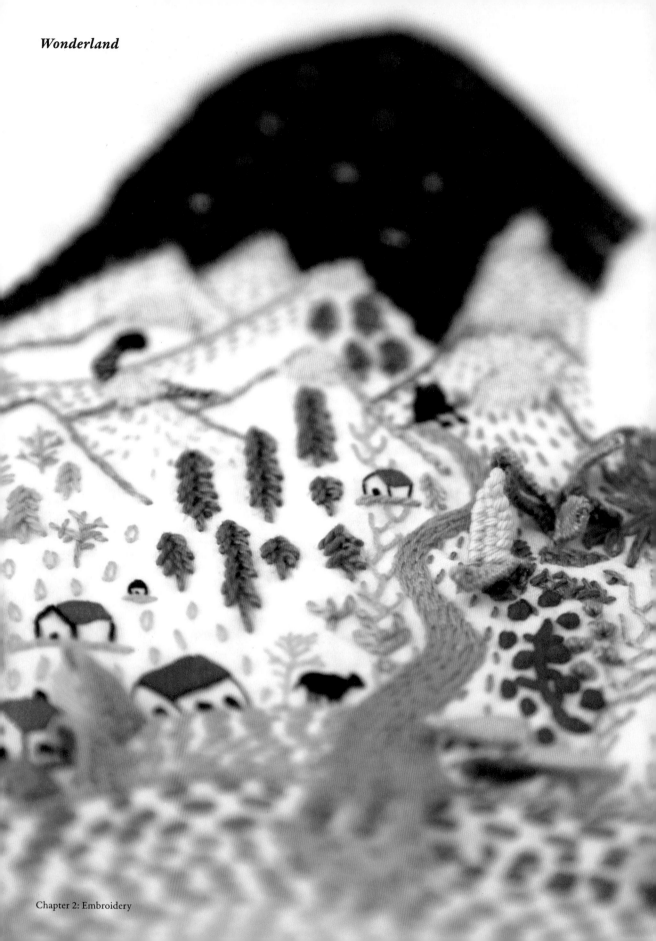

*"Embroidery endows me with patience, originality, and playfulness. I use it to interpret different objects or scenes of my history and everyday life."*

# *Loly Ghirardi*

Loly Ghirardi, a.k.a. Srta. Lylo, creates unique pieces and experiments whenever she can with all her hoops, threads, and needles. For each project, whether it is a collaboration with a magazine/book or an embroidery for wine labels, she is driven by the way she perceives this world. Each stitch of her work is connected to anecdotes or personal stories.

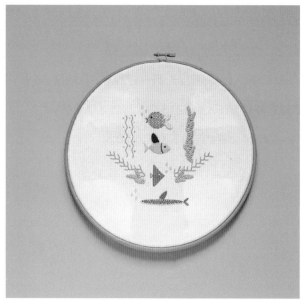

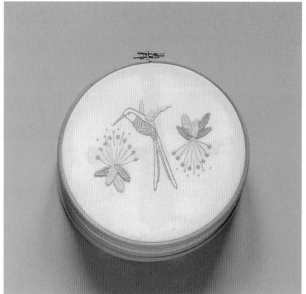

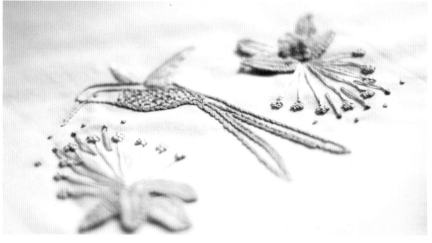

### ⌃ Happy Fish

Happy Fish is part of the ten designs of Srta. Lylo's collection for DMC Threads. It is inspired by the imagery of games, popular among children and adults. She finds it to be a fun and nostalgic experience to select the proper thread and style to mimic the texture of the water, flowers, and fishes.

### ⌃ Colibri & Flowers

Colibri & Flowers is another part of the ten designs of the DMC Threads collection. Users can apply the embroidery on any clothes or objects.

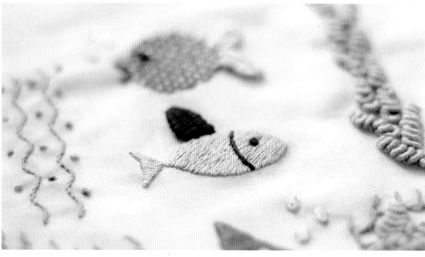

## ► *Embroidery Collar*

This project comes from the idea of creating a story on this unconventional space, the collar. The collars are full of tiny, abstract patterns—some look tactile, while the others smaller and intricate. They are one-of-a-kind.

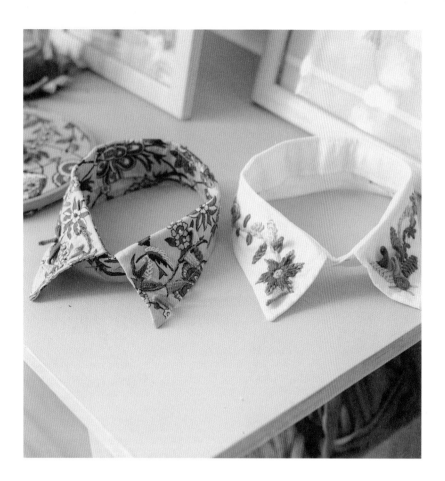

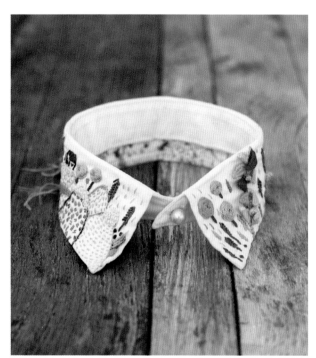

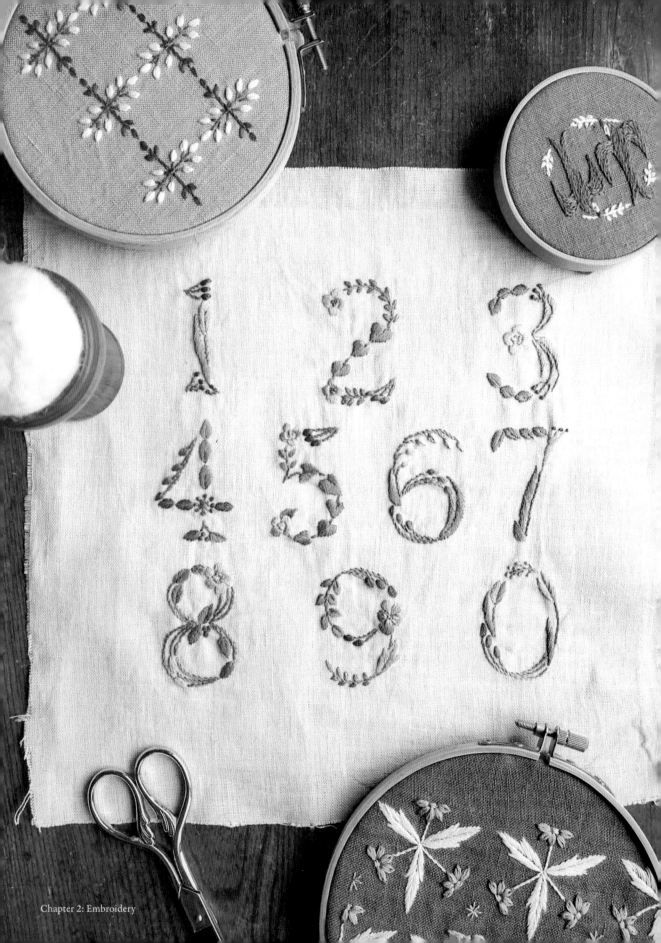

*"Every day I'm working with my needles and I can feel the small yet pleasant changes of the seasons."*

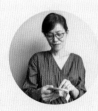

# Alice Makabe

Alice Makabe is an embroidery artist based in Japan. Through embroidery, she conveys the warmth of handmade art. Her work is seen in magazines and solo or group exhibitions.

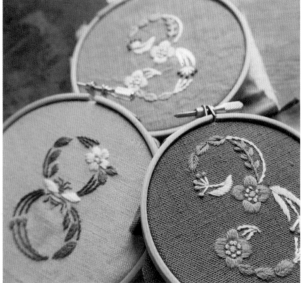

Chapter 2: Embroidery

### ◂ Mini Cosmetic Pouches

Alice designed a number typeface with threads and applied it on mini cosmetic pouches. She chose linen cloth for the outside fabric and cotton cloth for the lining.

### ▸ Glasses Cases
### ▾ Tiny Tote Bags

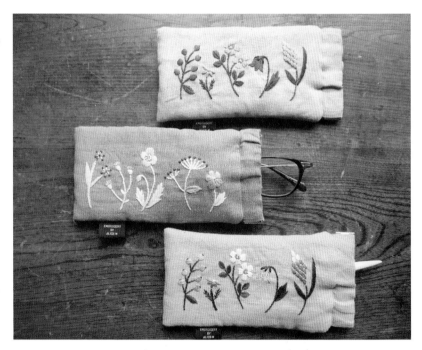

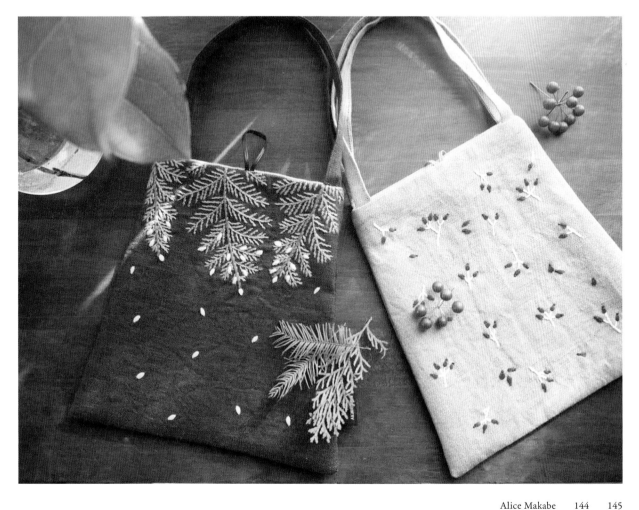

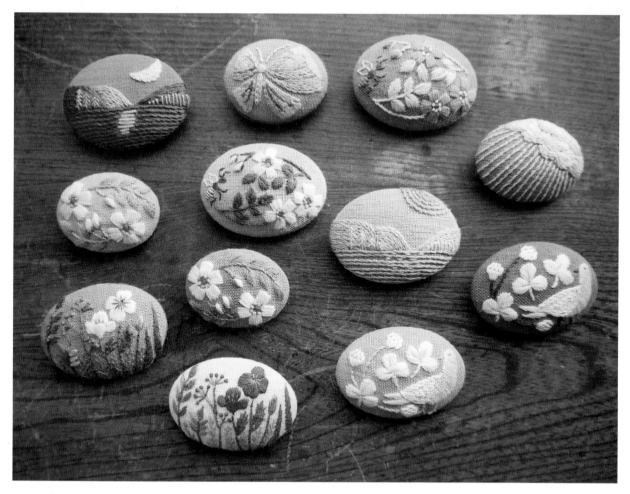

## *Brooch Pins*

This is one of Alice's main projects. The brooch pins can go with clothes and bags.

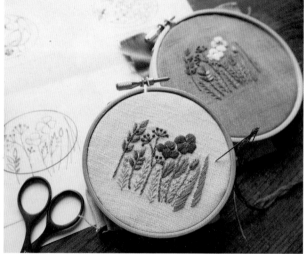

# Chapter 3: Printmaking

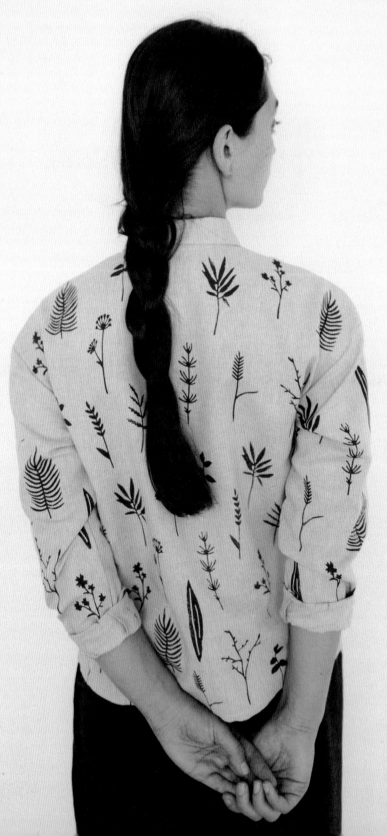

Chapter 3: Printmaking

*"Isti Home brings authenticity into the modern world. Using ancient methods of textile decorating, we create modern items. Though our style is still forming, we'd like to add more natural colors and to preserve minimalism in our prints."*

# *Isti Home*

Isti Home, which means "warm home," was founded by Ukrainian artist Iana Godenko. Its mission is to bring authenticity into modernity. Iana and the other designers create clothes and home textiles with handmade botanical prints using a block printing technique.

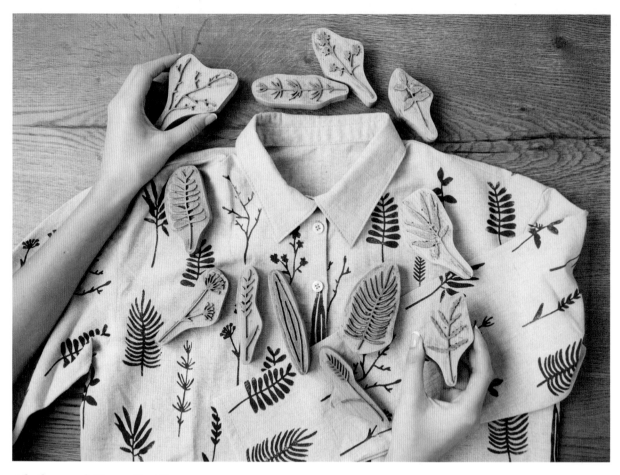

## Clothes and Home Textiles

Isti Home designs and sews clothes using natural fabrics and simple cuts. The prints are created by hand with the wood stamps they make. Their clothes series includes dresses with geometric prints, shirts with botanical patterns, pants, and jackets.

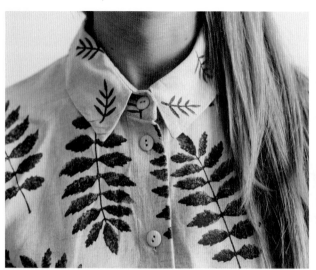

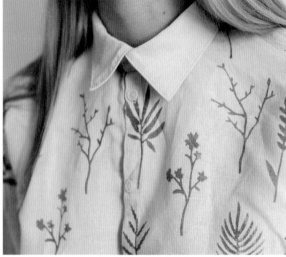

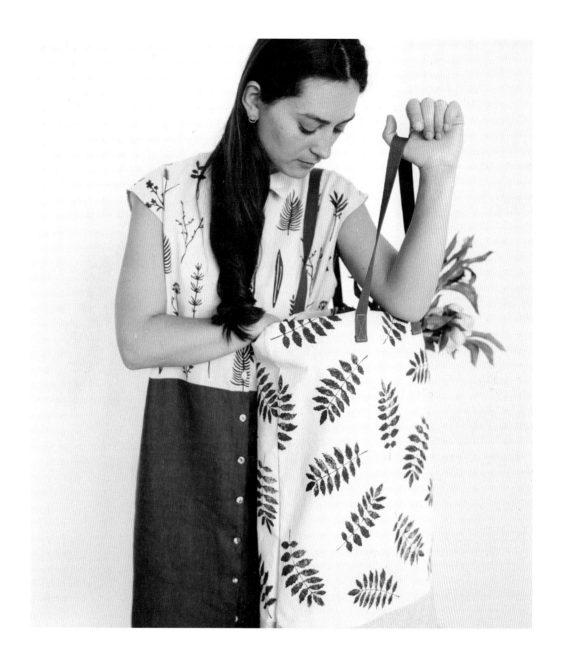

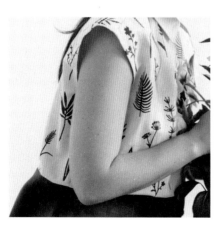

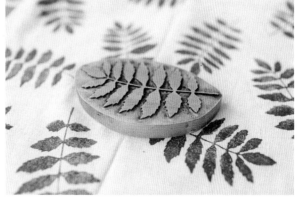

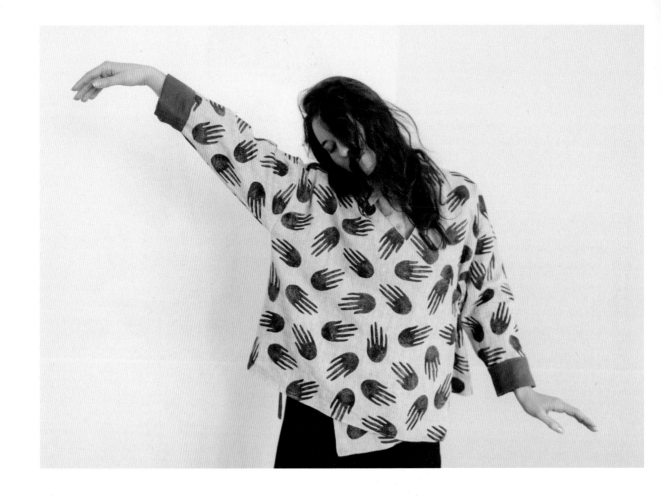

The home textiles series includes pillows, tablecloths, napkins, towels, and aprons. Isti Home chooses linen fabric for these items and decorates them with the custom stamps they make.

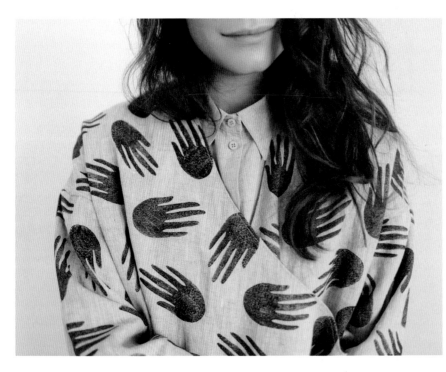

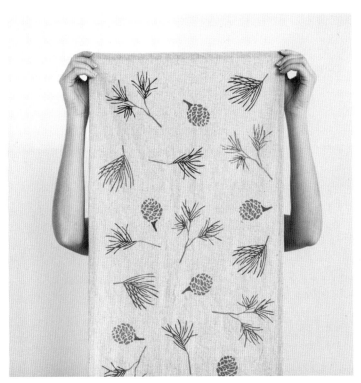

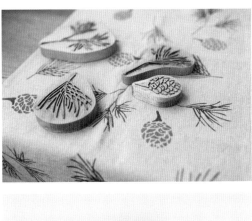

*1. Tell us something about your background. How did you discover printmaking?*

I was born in Kyiv. For a long time, I was working as a family and wedding photographer. I love photography and I'm not going to stop taking photos, although now I spend less time doing this. Since childhood, I have loved making things with my hands. Several years ago, I bought a sewing machine and started making toys. Later I discovered block printing, a technique of decorating textiles with the help of wooden stamps. In Ukraine, there wasn't a place where I could learn this technique or buy any stamps, so I decided to learn and make them by myself. My first stamps came from my uncle and he carved them for me by hand.

*2. You said "Isti Home" can be translated into English as "Warm Home." How did you come up with this name? What is your vision for this studio?*

Handcrafted things are full of warmth the creator puts in. I wish the things I make will bring coziness and warmth to my clients' homes. As for the choice of linen fabric, I'd like my clients to feel relaxed and natural. Wearing our

linen clothes, they can feel as if they're at home with the closest people wherever they are. This is what Isti Home is about.

*3. For you, what defines a good print piece?*

For me, a successful product is the one that I wish to wear myself or use to decorate my home. Of course, a good print should be created in good quality. Speaking of our works, I really love the shirt "Botanica" and our pillows. I've got several pillows with botanical prints sitting on my yellow sofa at home.

*4. Where do you usually get inspiration?*

Inspiration is everywhere. I get inspired by the colors and sounds of nature, communication with nice people, and my home, a place that always inspires me.

*5. What is the most challenging part of a project? What about the most refreshing part?*

The most challenging parts of my work are promotion and bookkeeping. These processes are lagging behind.

We need professionals to join our team. I love focusing on creation, working with my hands. Most of all, I love making the prints. It's a sort of meditation. One of the monotonous things is preparing the textiles—washing and ironing them—which is not very interesting but rather important.

*6. What are the necessary materials and tools for printmaking? Do you have any tips to share with beginners?*

For block printing, you need some textile, acrylic paint for fabric, hammer, sponges, and an iron for fixing the print. My piece of advice for beginners is simple: patience. Making prints with a stamp isn't difficult, however, if you want to make them neatly, you need to be composed and concentrated.

*7. You were born and raised in the Ukraine. How did this country shape who you are today and influence your creations?*

I was born in Kyiv, Ukraine. I really love my city. It's got an unhurried rhythm. Compared to other capitals,

it's more relaxed. Also, I love Lviv and the Carpathian Mountains, which inspire me a lot, and the same with Ukrainian music. The music is such a powerful energy source that it can drive me to tears.

Being raised in Ukraine influenced me a lot. Ukrainians are open and credulous. They follow their passions more than business. I think I am a Ukrainian deep inside. Many years ago, I decided that I'm going to do only the things that will bring me happiness. That's why Isti Home is growing more slowly than I want it to. I'm growing and developing with it together.

*8. In today's world, people can get ready-made stuff easily from physical shops and online. What does craft mean to you?*

Fast fashion has spoiled customers. Many people seldom imagine how things are produced. Handcrafted things aren't valued nowadays. However, I do what I love. And I'm happy that there are people out there who also enjoy the results of my work.

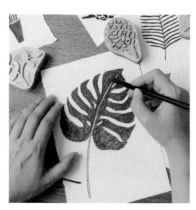
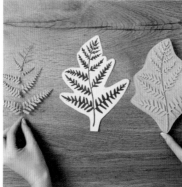
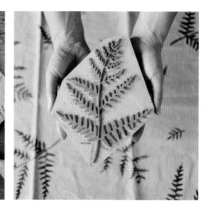
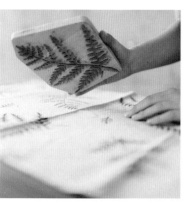

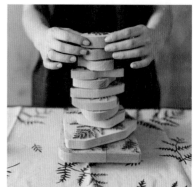

## Materials & Tools

- Natural fabrics
- Acrylic paint
- Wooden stamps
- Cutters and scissors
- Hammer
- Roller

## Tutorial

1. Create a sketch on a piece of paper.

2. Convert the sketch to an outline, transfer to wood, and carve a wooden stamp with a cutter.

3. Prepare the fabric. Spread ink on a large plate with a spatula. Ink the roller and use the roller to ink the stamp.

4. Press the wooden stamp to the fabric.

5. Hammer the stamp to fix the pattern. In some cases, you can fix the pattern by ironing.

6. Sew the fabric and finish the item.

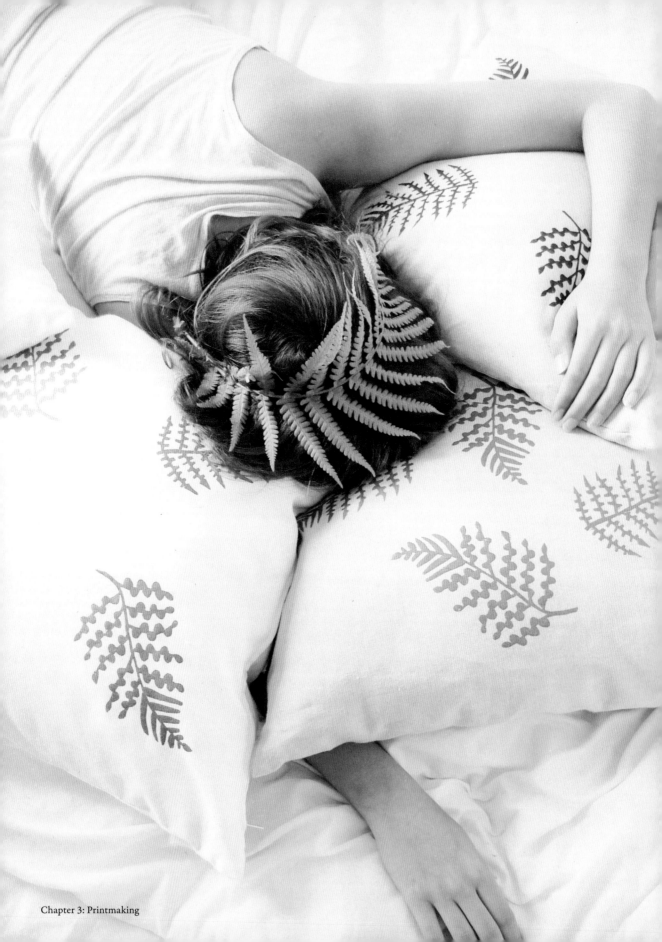

Chapter 3: Printmaking

*"Surrounded by the landscapes of Brittany, we imagine and shape our collections with inspiration, respect, and a desire for the lowest impact on the environment."*

# *Atelier Pataplume*

Atelier Pataplume was created by a mother-and-daughter duo, Christine Salabert and Léna Salabert. Atelier Pataplume explores the values of contemporary craftsmanship and slow design, especially through the practice of textile printing. They create all their designs by drawing and engraving stamps on a natural linoleum surface. Their work highlights an art of living oriented towards essence and poetry, the aesthetics of minimalism, and craft.

## *Bringing Nature Home*

This collection explores the shapes and patterns that Christine and Léna
have found during their casual walks in the countryside, celebrates the joy of
collecting fragments of wilderness, and tries to share the feeling of bringing
nature home. It is gradually becoming a herbarium which is growing bit by bit
over time. With traditional lino printing techniques, each piece is one-of-a-kind
and has its own imperfect yet authentic look.

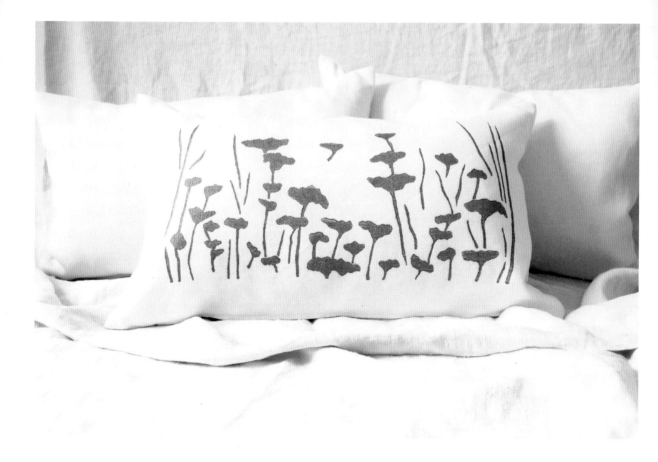

**1. Tell us something about your background. How did you discover printmaking?**

**Christine**: I completed a degree in Fine Arts at the University of Aix en Provence in 1990. I spent five years to complete the degree and discovered engraving on metal, linoleum, wood, and other mediums. From there, I adapted and applied these techniques to printing textiles with an emphasis on organic mediums like linen.

**Léna**: I have a degree in Management and Marketing but I've always been deeply interested in art and craft. After working some years in fashion and interior design, I decided to dedicate my time to a more personal project that would allow me to combine ethics and aesthetics. I tend to think that handmade objects are fragments of their makers' sensitivity. I wanted to create goods for a home with artistic value. Pataplume was born with such desire. We explore lino printing and use this technique to transcribe our artistic universe into everyday life objects.

**2. A mother-daughter creative duo is not often seen. What drove you to start Atelier Pataplume together? Does Pataplume carry any special meaning?**

**Christine**: I noticed that even as a small child, Léna showed intrinsic artistic tendencies. Over the last ten years or so, Léna and I have often collaborated on certain artistic expositions: her photography and my poetry are presented together in art galleries, cafés, and certain public events. We realized that we really shared a kind of artistic balance and the same life values. At the beginning of 2014, we decided to create Pataplume in order to propose a line of products that embody our artistic sensibilities and our life ethics. We both find that sharing an artistic business venture together as adults is something rare and precious.

**Léna**: Pataplume is a nod to our family history. It is what we called the action of blowing dandelion seeds.

**3. Do you each have a separate role in the studio? What do you do if you disagree with each other when working on a project?**

**Christine:** In practice, Léna is more at ease with the communication, marketing, and commercial side of things. She also really enjoys working on visual identity and photography. Whereas I am more involved in running the production and the actual printing of our pieces. I think this collaboration is working because we both share the same overall vision and our differences are complementary.

**Léna:** Running a creative business is really multitasking and for almost everything, we are just the two of us. So, we kind of split the work between us two according to our preferences and strong points. But we always discuss and brainstorm together to choose the designs, styles, and messages. Quite often, during these in-depth discussions on our artistic direction, we have different

propositions and points of view. Actually, this helps us to organize our ideas and shape the final project.

We also try to listen more and more to what each of us wants to do and feels happy doing, knowing that it can change with time. It is really important that it is not frozen. For example, recently, I've been dedicating more time to carving stamps because I felt a need to focus on manual activities.

## 4. For you, what defines a good print piece?

**Christine**: A good print for us is a print that is technically satisfying in terms of clean lines, good ink, and fine textile, and that reflects our tendency toward nature and the universally shared values of simplicity and style.

**Léna**: A good print piece would be a good mix of simplicity and poetry. Of course, this is for us, because printmaking can be developed in many different amazing styles!

## 5. Where do you usually get inspiration?

**Christine**: We get our inspiration often from long walks outdoors on the seaside or in the forest. We are also inspired by memories of a summer, a picnic in a field of wildflowers, or the seaweed waving in the water, as you can see in our last collection *"Champs"* ("Field").

**Léna**: My grandfather was an herbalist and Christine has always encouraged me since my childhood to hone my eye, to pay attention to details, vegetal shapes, etc. I am also very inspired by the work of many artists and makers from all over the world.

## 6. What are the necessary materials and tools for printingmaking? Do you have any tips to share with beginners?

**Christine**: Our materials are all chosen out of natural qualities and respect for the environment. For the materials, I would advise makers to use natural linoleum for the print block and paper, linen or any other finely weaved textile to print on to. For the tools, one needs a simple ballpoint pen to draw the design, then special linoleum chisels to carve the design onto the linoleum. You will also need printing ink, best without solvent or heavy metals, to print with and linseed oil to clean the printing plate. Finally, depending on the result you want to achieve, you will need to invest in a press but you can start without. I advise the beginners to try the best they can and to be careful not to cut themselves with the chisels!

## 7. In today's world, people can get ready-made stuff easily from physical shops and online. What does craft mean to you?

**Léna**: We think that today people are more and more interested in how products are made and that "handmade" has a real meaning compared to manufactured goods and anonymous mass production. Not only does it have to do with ethics but it has become our aesthetics and lifestyle. As a reaction to a mass market, simple living and inspiration can be pursued through craft.

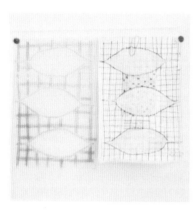 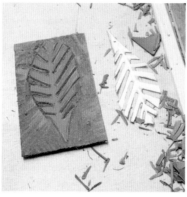 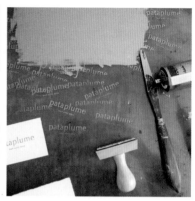

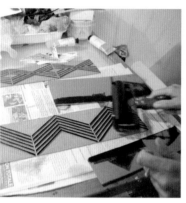  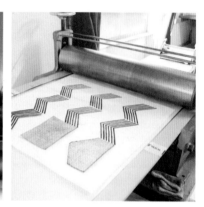

## Materials & Tools

- Linoleum sheet

- Ink

- Gouges of different sizes

- Spatula

- Roller

## Tutorial

1. Choose a pattern that you like and draw its outline on the tracing paper.

2. Trace the pattern on the linoleum sheet. In this step, you need to choose which part of your drawing you want to be blank and which part to receive the ink. Then engrave the linoleum with a gouge. Use a gouge with a thin blade to cut the outline and finish it with a larger one.

3. Put your ink on a large plate (glass plate is preferable) and use a spatula to spread the ink lightly.

4. Ink the roller and transfer the ink to the carved linoleum pattern.

5. Put the pattern on cloth or paper and put pressure on it with a small wooden hammer or roller.

6. Remove the linoleum plate and let the pattern dry.

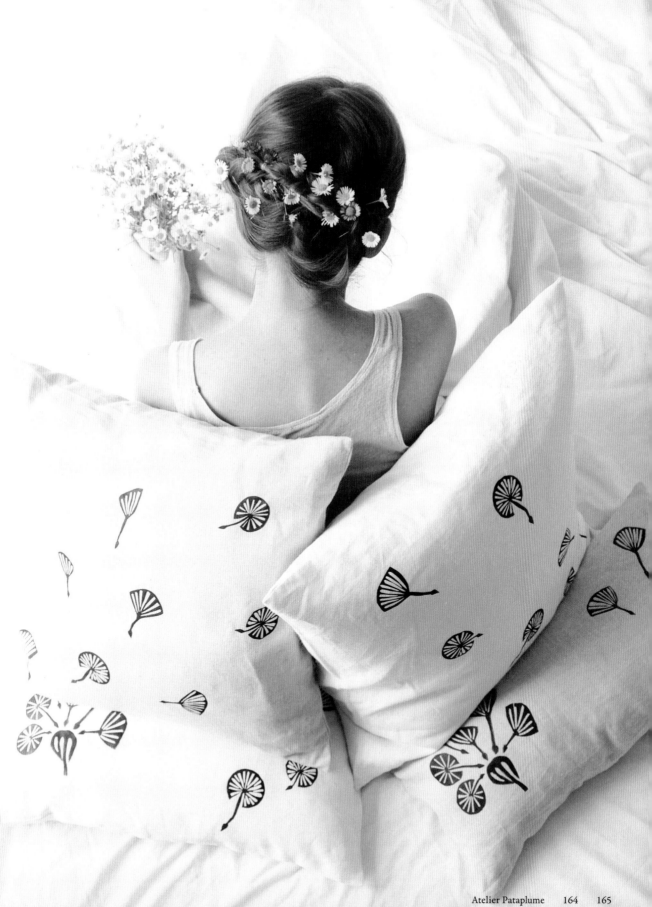

### Invitations to a Greek-Russian Wedding

The invitation features a female matryoshka in Russian ornamental style and a male figure in Greek costume. A blue-and-red color palette signifies the blend of the two countries.

Chapter 3: Printmaking

*"I'm inspired by ethnic motives, funny animals, good films, and delicious food. The main thing in my work is the mood."*

# Iya Gaas

Iya Gaas is an illustrator from St. Petersburg, Russia, who likes to mix techniques. She creates illustrations using the technique of linocut, together with her husband Misha. Iya draws and cuts out the images; while Misha prints them out on a press. Iya usually collects the linocut prints and creates digital versions for future printing.

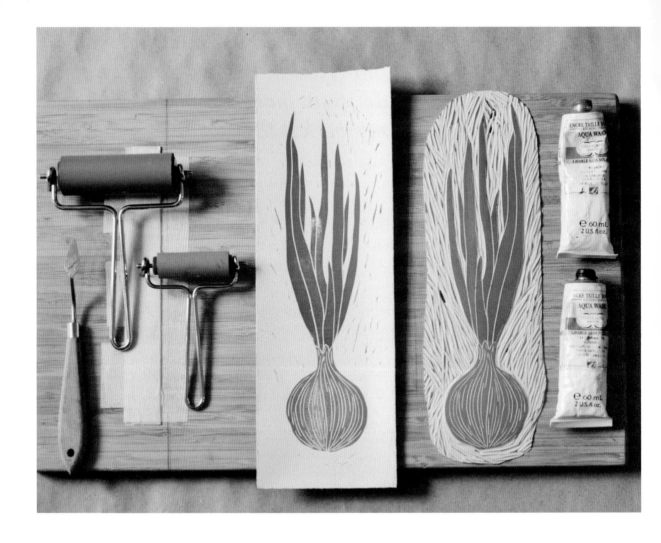

▴ *Onion*
▸ *Bear*

Chapter 3: Printmaking

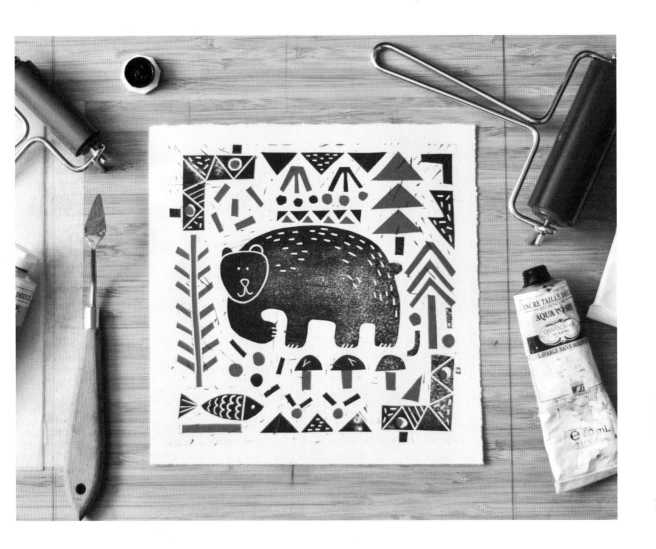

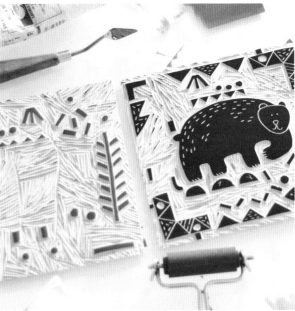

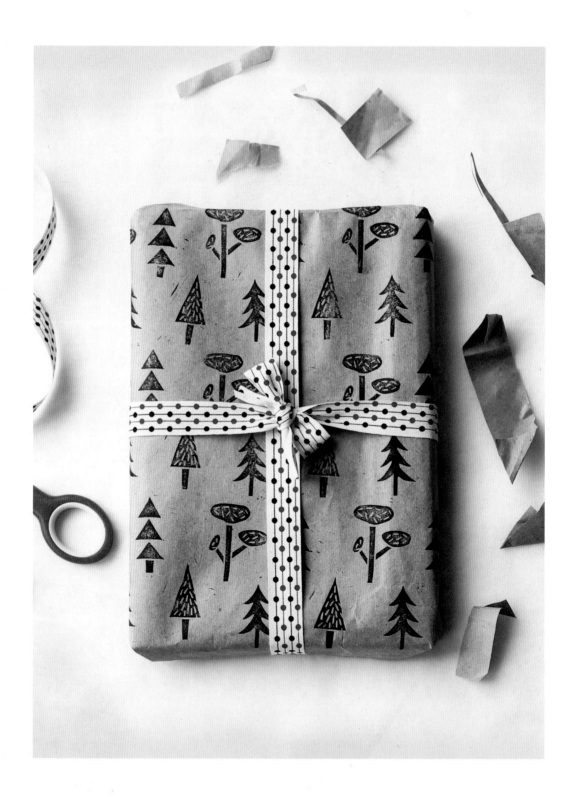

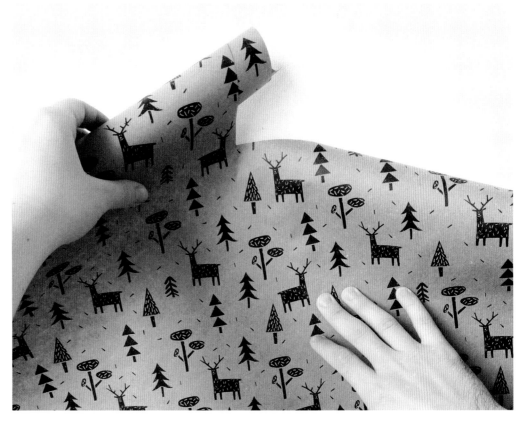

## *Wrapping Paper*

A collection of drawings and linocut prints for wrapping paper and cards.

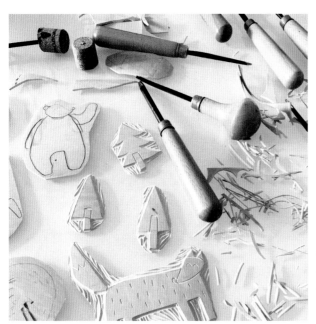

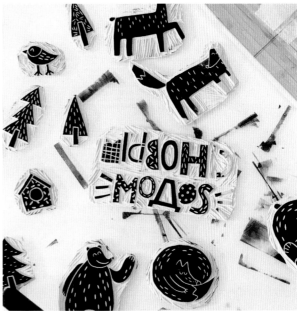

# ICHTHYOLOGY

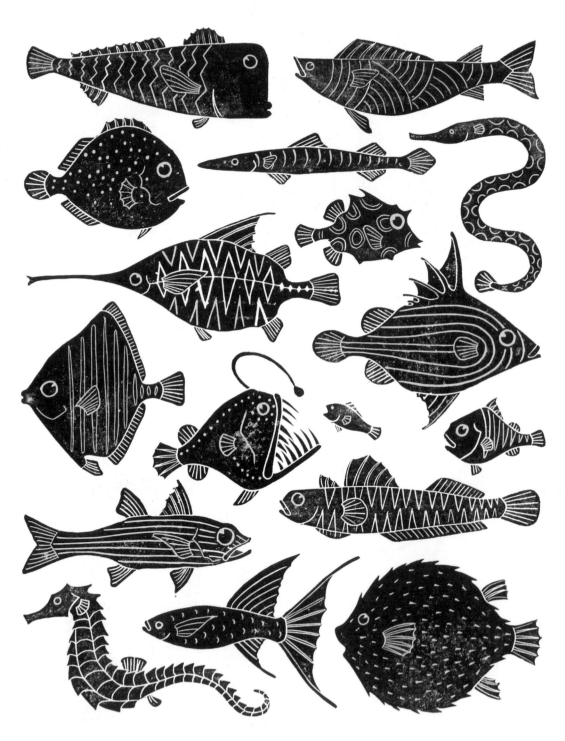

*Ichthyology*

*"My work is predominantly inspired by early printmaking, in particular, antique woodcuts, heraldry, and natural history illustration."*

# Jessica Benhar

Jessica Benhar is an illustrator and printmaker with a background in design. In an effort to work more with her hands, she rediscovered printmaking in 2010 and has been incorporating it into her practice ever since. She creates illustrations using a combination of digital techniques and traditional printmaking techniques such as linocutting.

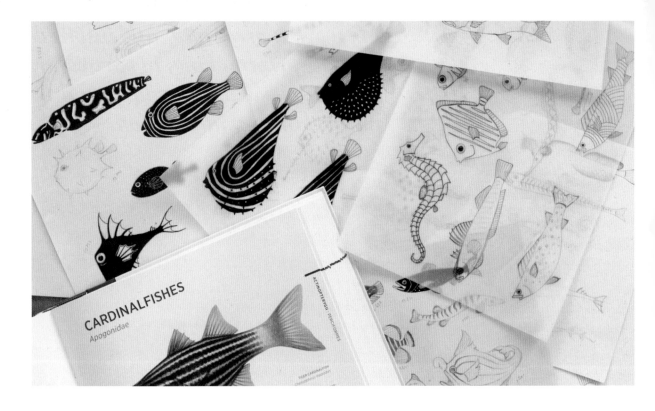

### ▴ *Ichthyology*

Inspired by the illustrations of fish in the 19th century's natural history texts, Jessica wanted to create something similar in her style. She enjoys giving character to the fishes and picking the patterns to go with each one.

### ▸ *Animals: Tortoise*

The Animals project is a continuing series of animal prints, which Jessica started as a design challenge for herself to illustrate animals that she had never drawn before.

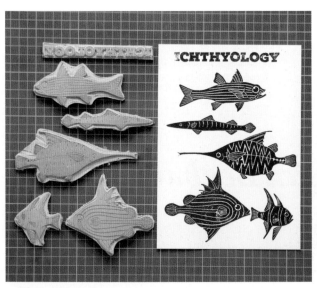

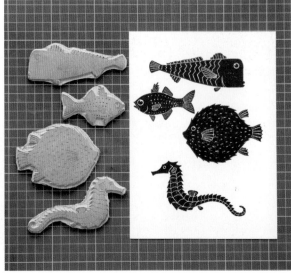

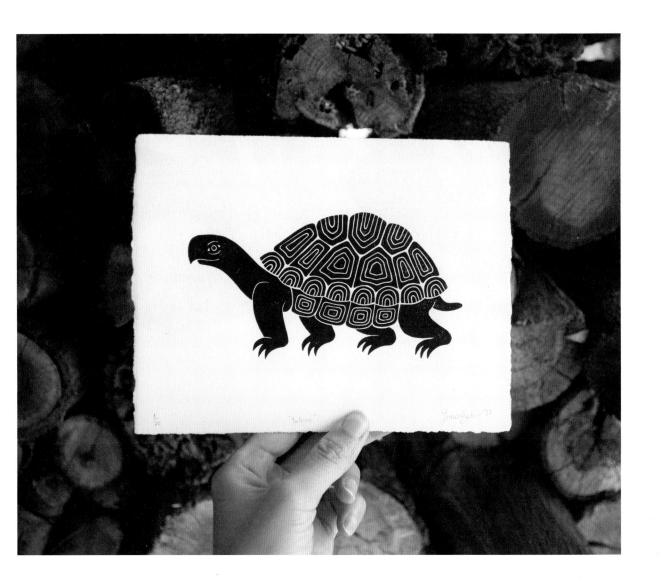

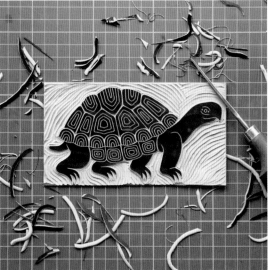

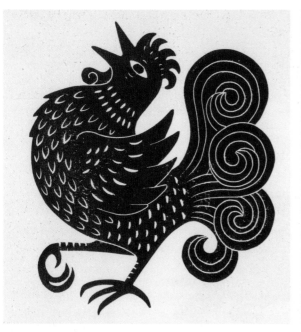 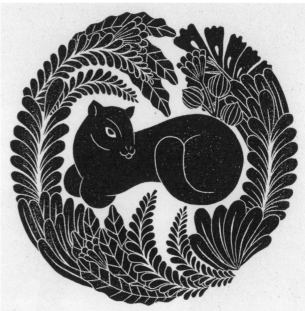

▴ *Animals: Rooster*
▴ *Nature Cat*
▾ *Animals: Owl*

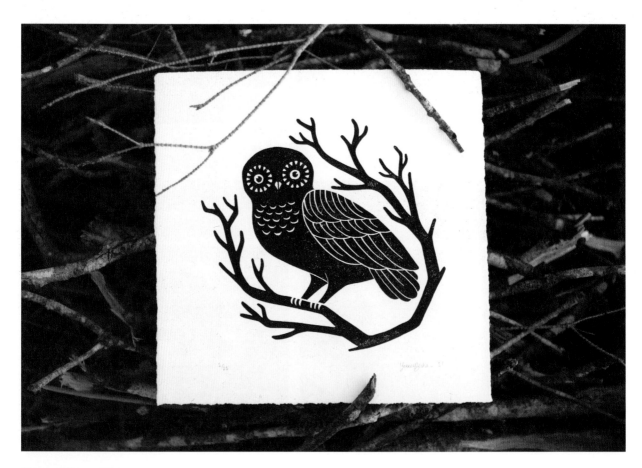

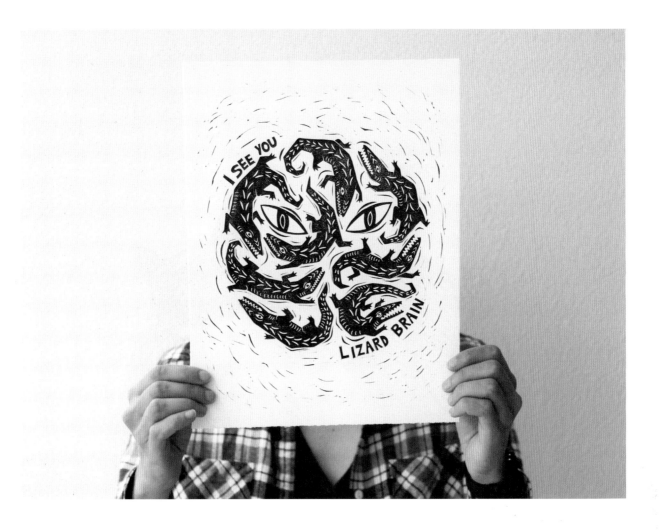

## ◭ Lizard Brain

The "lizard brain" is a primitive part of our brain that is in control of our fight-or-flight reflexes. It sets off all sorts of irrational fear alarms. The author Seth Godin describes it as one of the biggest reasons that people do not follow their passions—the lizard brain tries to keep us safe by limiting our risk. The poster is a reminder for viewers to acknowledge the lizard brain and accept the feelings that come with it.

5/13    'HEIDI THAI CAT'

*"By using traditional printmaking techniques, I draw attention to the slow, artisanal, and handmade process of creating images, which is in opposition to fast digital techniques."*

# *Zuza Miśko*

Zuza Miśko is a printmaker and illustrator with a background in animated film. Her current work focuses on nature, folklore, and spiritual symbols. Zuza works mainly with the linocut technique, a traditional relief printing technique. Her work stands out with its limited color palette and details juxtaposed with bold shapes.

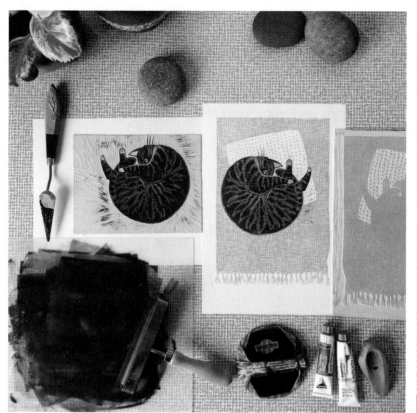
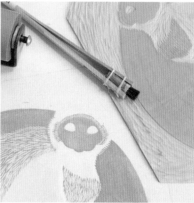

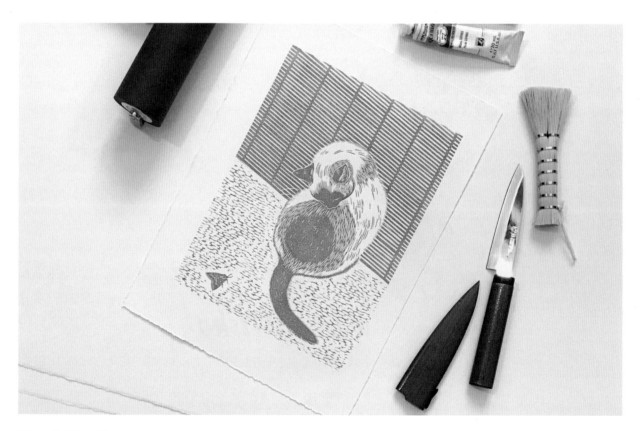

Chapter 3: Printmaking

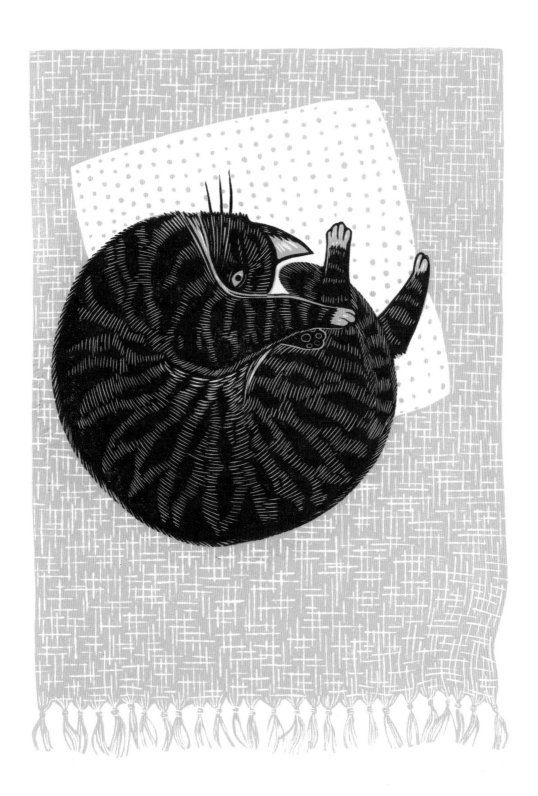

***Curled-Up Cat (Kot Kulka)***
A hand-pulled linocut print in limited edition.

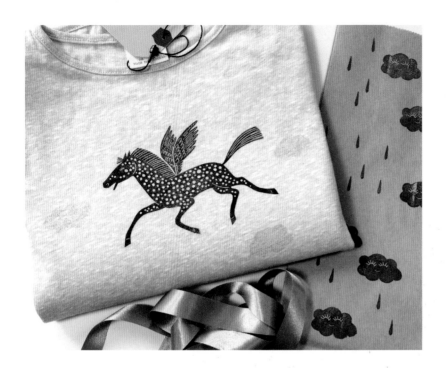

### ◂ Pegasus

Pegasus is generally depicted as a mythical winged divine stallion. It is also one of the most recognized creatures in Greek mythology.

### ▸ Sleeping Boars
### ▸ Bear

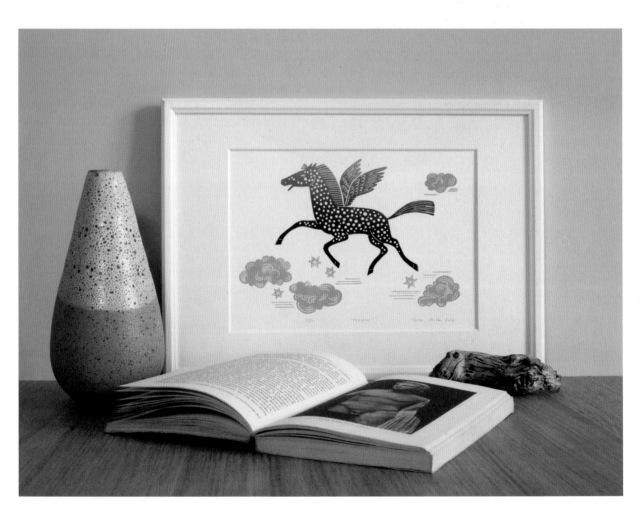

Chapter 3: Printmaking

*"One of my biggest passions is rubber carving. I use these stamps mainly to create art, printing cards, and other decorations."*

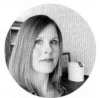

# *Viktoria Åström*

Viktoria Åström is an artist, illustrator, and animator who works and lives on an island outside Gothenburg, Sweden. She creates printed artworks and sometimes sells them from an online shop. She likes painting with ink, watercolors, or digital tools.

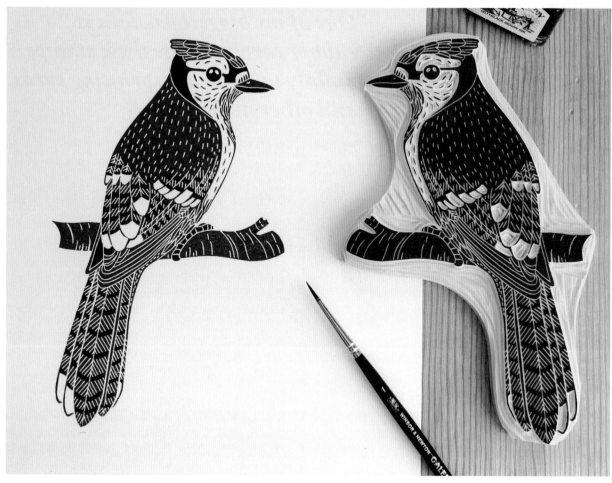

## Feathers & Birds

Birds are one of Viktoria's favorite themes when it comes to carving. She finds it interesting to carve the birds' shapes and patterns using rubber carving blocks and linoleum cutting tools.

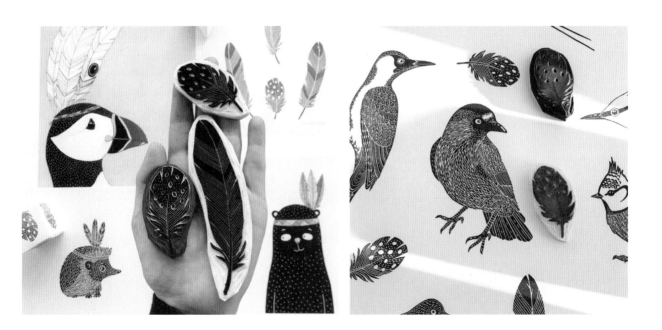

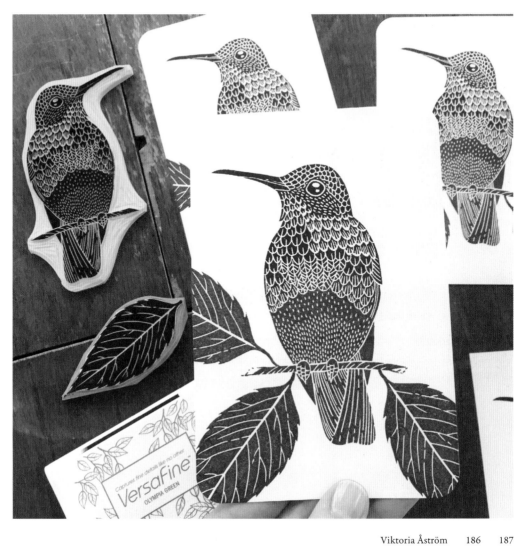

## *Plants & Insects*

Viktoria draws inspiration from the plants and insects that she comes across in
her surroundings.

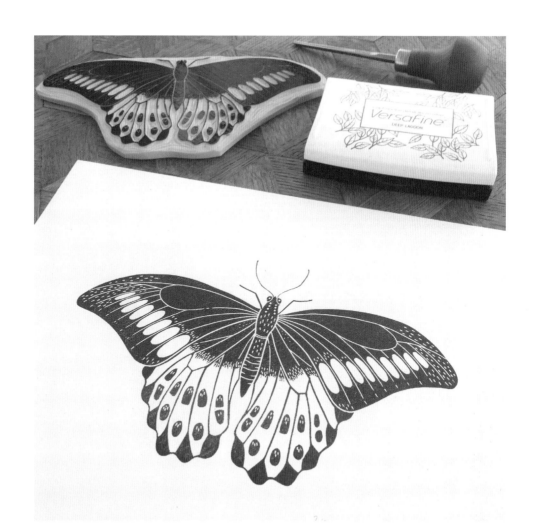

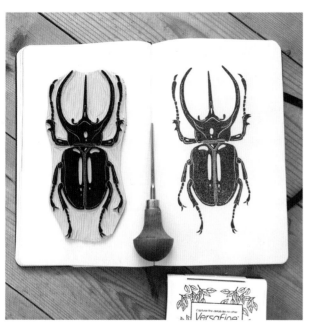

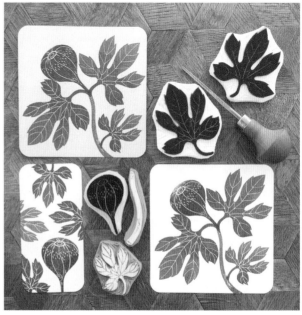

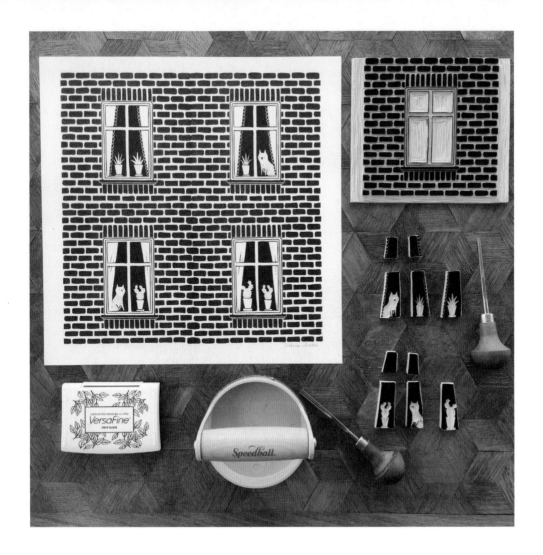

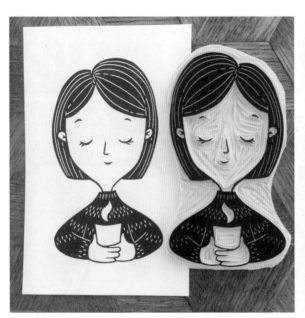

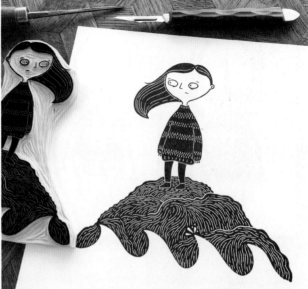

Chapter 3: Printmaking

# Creatures

Viktoria often refers to her previous designs, photographs, illustrations, and sketches for inspiration. She usually creates an illustration using watercolor or ink, and then she interprets the illustration again by carving to give it a completely different look and feel.

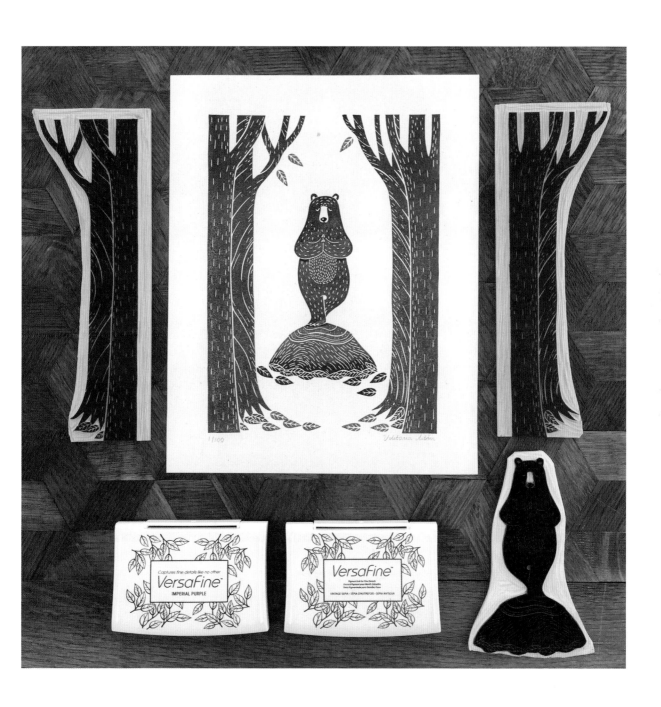

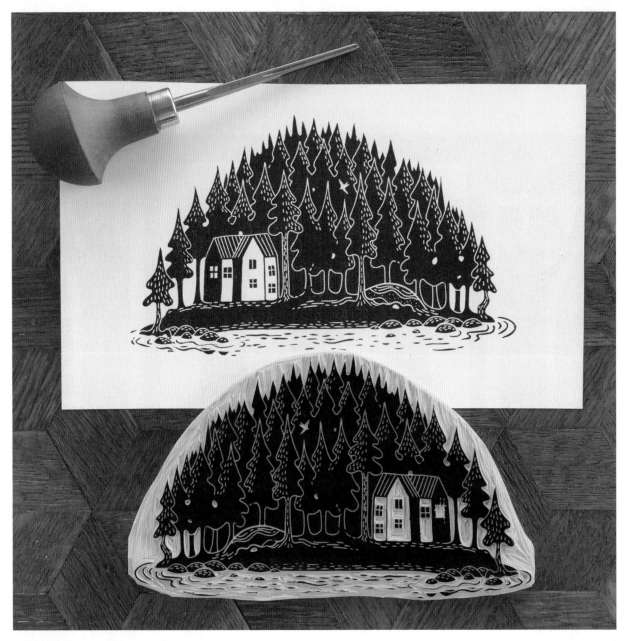

When creating a print, Viktoria usually prepares a design on paper. Then she transfers the design to a piece of rubber carving block using tracing paper. After that, she carves the design with linoleum cutting tools until the whole piece is finished. The print can usually be applied to paper or fabric.

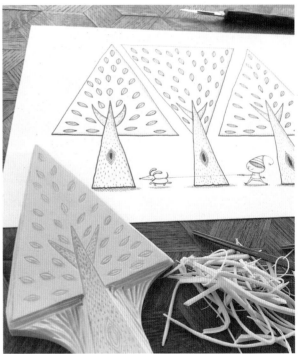

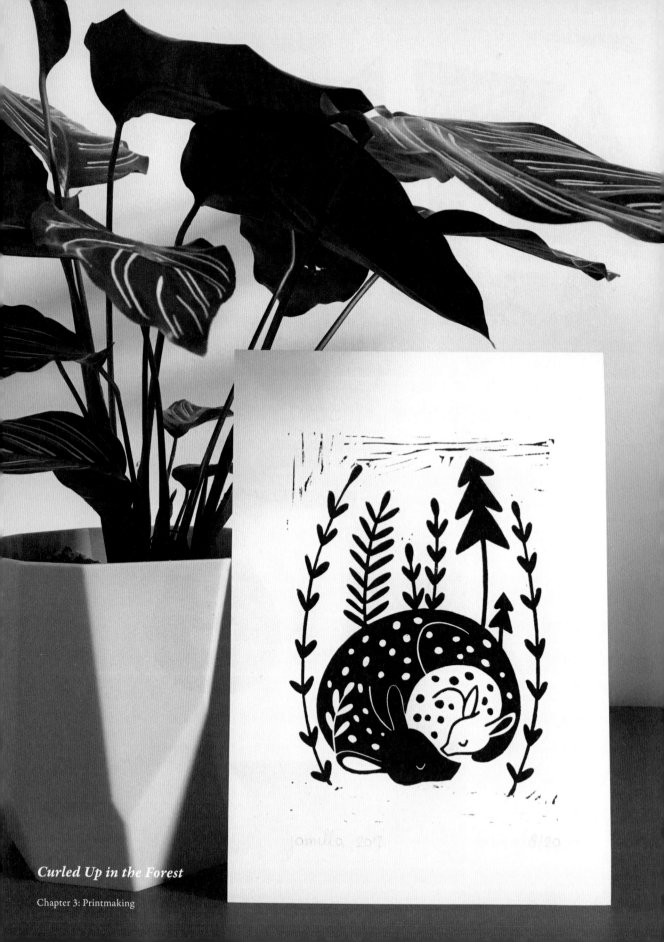

*Curled Up in the Forest*

Chapter 3: Printmaking

*"I love to work with different materials and techniques and combine them in my work. I just love the textures and feel of authenticity of analog work."*

# *Jamilla Beukema*

Jamilla Beukema has been drawing since her childhood. She currently works as an illustrator and art teacher. She loves animals and raises two cats, Hugo and Gerard. Animals and nature are always the themes of her art.

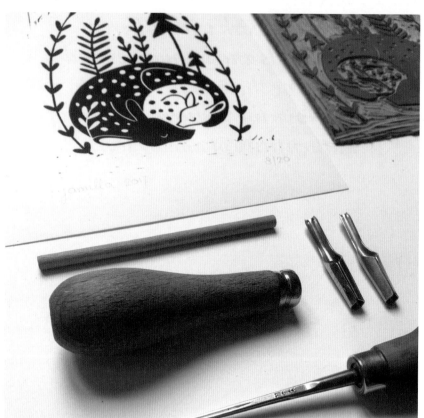

### ◄ *Curled Up in the Forest*

This project is very personal to Jamilla because she printed it before her mother passed away suddenly. She made the original illustration in 2014, but when she saw it again, she decided to turn it into a linoleum print. She added a small fawn curling up cozily beside the mother deer and some trees to the background as forest. In the final print, the fawn is made white and the mother black to sharpen the contrast.

### ▶ *Autumn Stamp*

This stamp featuring acorns and oak leaves is one of Jamilla's delicate rubber stamp carvings. It shows a lot of detail and it took her a while to carve. Jamilla made this stamp in autumn when she was inspired by leaves, acorns, and other items she gathered in the forest.

### ▶ *Mini Linoleum Animals: Badger*

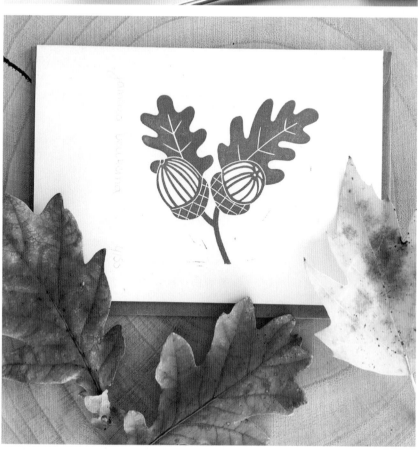

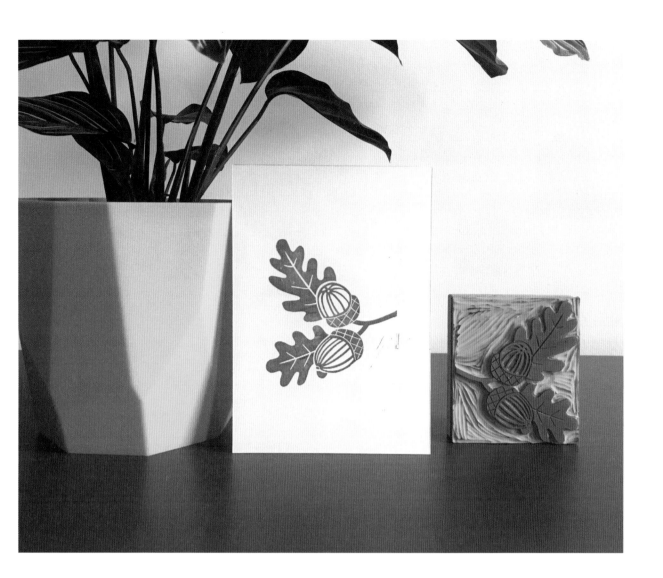

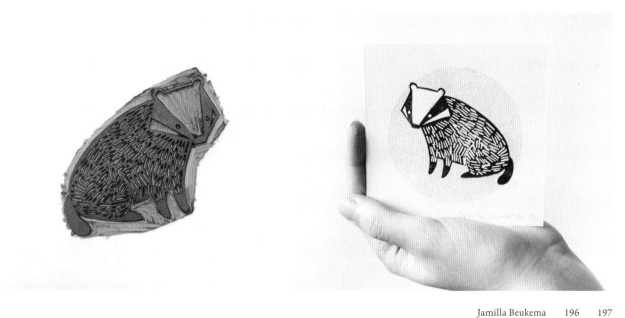

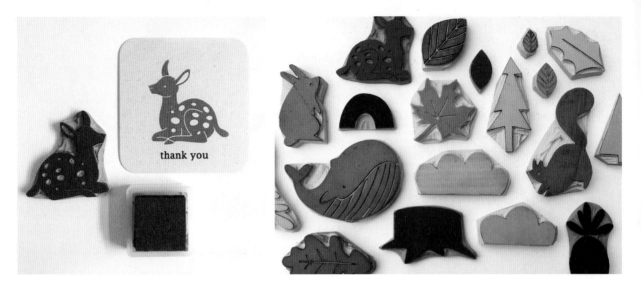

## Mini Linoleum Animals

This series of small animal linoleum prints started with the fox and badger. In 2014, Jamilla was experimenting with geometric shapes, so the shapes of the animals are very simple. Jamilla carved the fur with tiny strokes to make the animals vivid. She drew a rough circle around each animal with color pencils to add extra texture and a final touch to the print. All the prints measure 10cm × 10cm.

# Chapter 4: Paper Art

# City of Dreams: Manila

This was a commissioned project composed of four artworks for the spa area of a new hotel in Manila. Inspired by the sea, Claire used maps of Southeast Asia for this project.

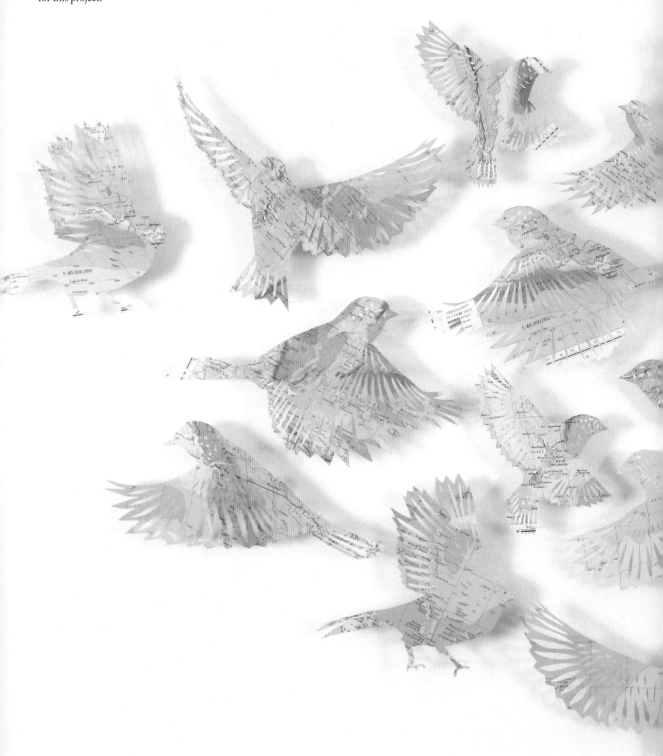

Photos of pages 200–209 by Paul Minyo.

*"I'd describe my style as inspired by the magic of everyday life."*

# Claire Brewster

Claire Brewster is an artist who lives and works in London. She creates intricate, ethereal, and detailed paper sculptures. Her work has been exhibited all over the world in major museums and galleries. She takes inspiration from nature and creates her art from vintage maps and atlases.

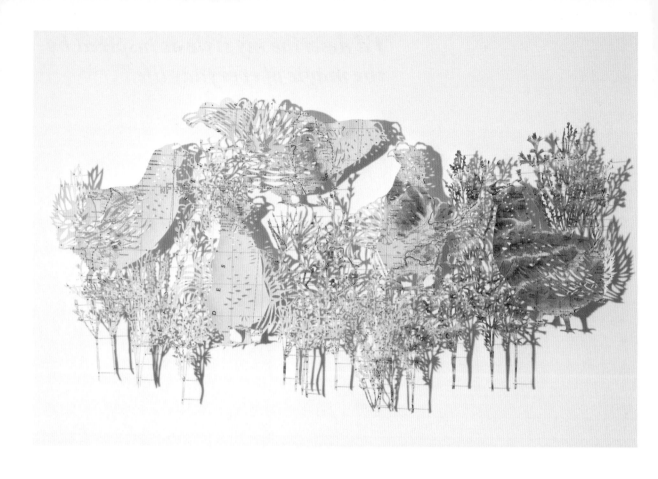

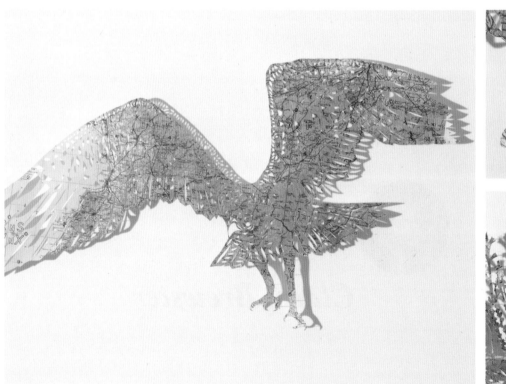

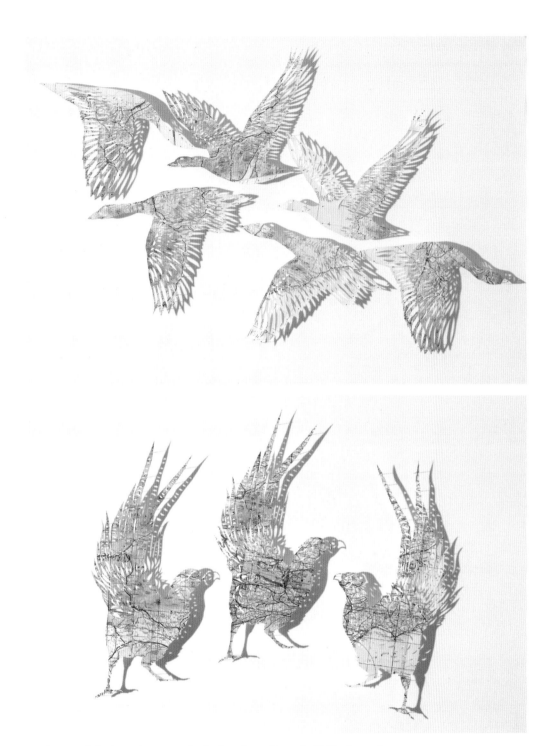

## *Private Dining Room: Caledonian Hotel, Edinburgh*

Claire was commissioned to make four artworks based on the theme of seasons. She used maps of Scotland and took native birds as inspiration for this project.

# *Hey We're Here*

This was a commissioned project for a home office.

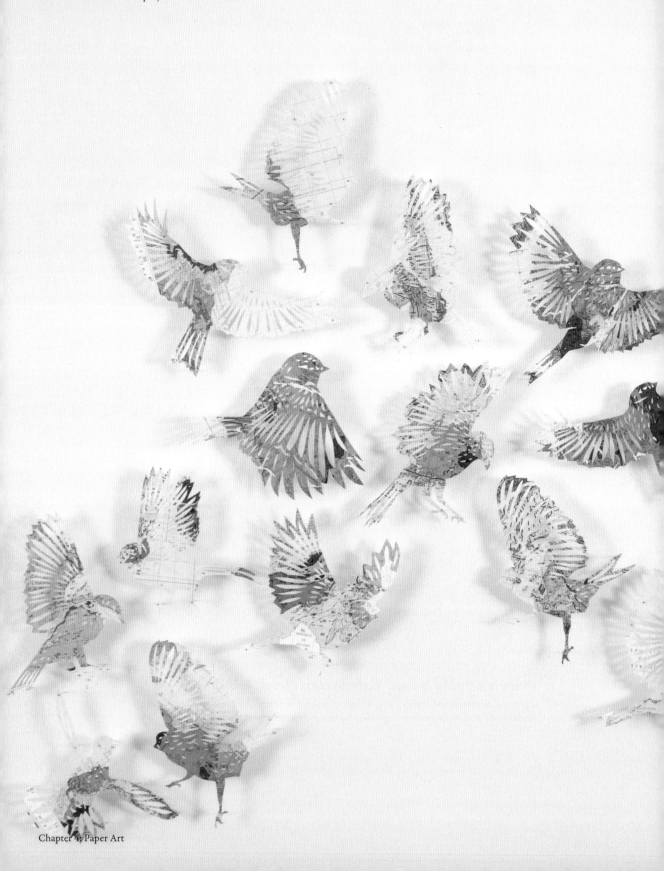

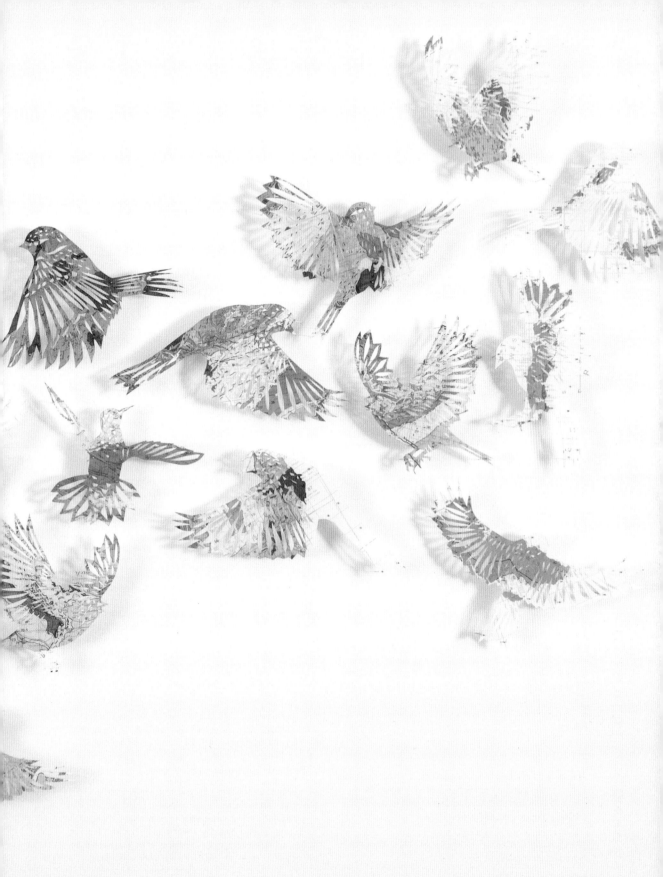

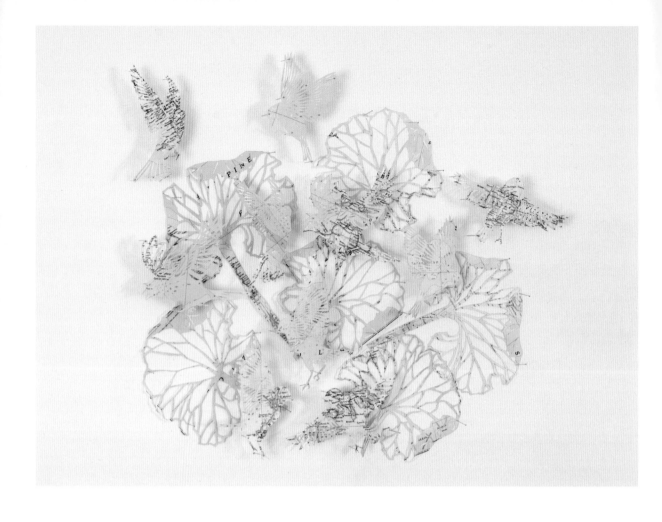

*1. Tell us something about your background. How did you discover paper art?*

I have a BA in Textiles/Fashion, specializing in tapestry weaving, but I was always more drawn to Fine Arts. For many years I worked in collage and painting, using maps as the background, until one day, I decided to cut out the maps instead of painting on them. That was my first foray into paper art. I've always enjoyed the process and working with processes (hence the tapestry weaving), so it felt natural for me to make work that was very process-based.

*2. For you, what defines a good paper art piece?*

The same as what defines any good art. For me, there has to be a feeling and a connection with the work. There needs to be something beyond technique—a depth that creates emotion and makes you think.

*3. You often use maps as the material—why? What other materials do you like to use?*

Maps are beautiful objects in their own right and the

paper versions have become somewhat obsolete in these days because of Google maps. So for me, it's a joy to give them a new lease on life and transform them into something different. It's like I'm setting my birds free from the confines of the map. I also work with metal and have recently started making paintings and collages.

*4. What is the best comment you have received so far?*

The best comments I receive are when people tell me that it's beautiful. But what is even better than that is when I look into their eyes, I can see they've connected to the work beyond words. That for me is a success.

*5. Where do you usually get inspiration?*

I find inspiration when I'm traveling, visiting old buildings, art galleries, and museums. I also get inspiration from nature, mostly from physical things. I try to take at least one day a week to go out and look at things, whether it's a walk in nature or to a museum. It's important to keep my creativity fed with new ideas.

*6. Do you remember the first paper art piece you made? What was it about?*

Paper has always been my favorite material, so before I was making my paper sculptures I was working on paper and making collages. My first paper sculptures were very detailed patterns cut from pages from atlases. They were about the joy of repetition and the closeness of details and how objects can be transformed by small interventions.

*7. What is the most challenging part of a project? What about the most refreshing part?*

The most challenging part is always the project in process. I love the thrill of a new project and find it very easy to get started but somehow, somewhere in the middle of the process, I get a bit lost and lose energy and focus, in a stage where I have to push myself to finish the artwork. I never have any trouble knowing when my work is finished and always love the end as it means I can start something new.

*8. How does the city of London shape who you are and influence your creations?*

I've been living in London for over 30 years, so it has shaped me as an adult. I can't imagine living anywhere else now. London is a big brute of a city and can easily be distracting and consuming, so it's important to find your part of it. I love how nature lives in conjunction with humans in London. Visitors are often surprised at how much wildlife is thriving there. I find it very inspiring.

*9. In today's world, people can get ready-made stuff easily from physical shops and online. What does craft mean to you?*

Craft means being made by hand, an element of skill, something that connects beyond the physical. People always appreciate the skill and hard work when they see it and that's why handmade stuff has the edge over manufactured things. I like the idea of buying less but buying better, so what you have is built to last rather than needing to be replaced in six months.

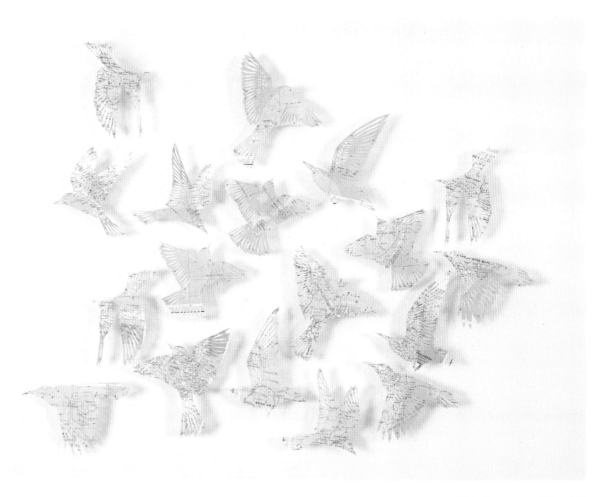

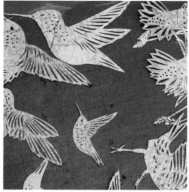

## Materials & Tools

- Various vintage maps

- Pencils

- Scissors and craft knife

- Pins

## Tutorial

1. Select your desired maps and birds; draw the birds on tracing paper and apply them to the back of the maps.

2. Cut out the birds using a craft knife.

3. Arrange the birds on a foam board and pin in place.

4. Finish and frame the work.

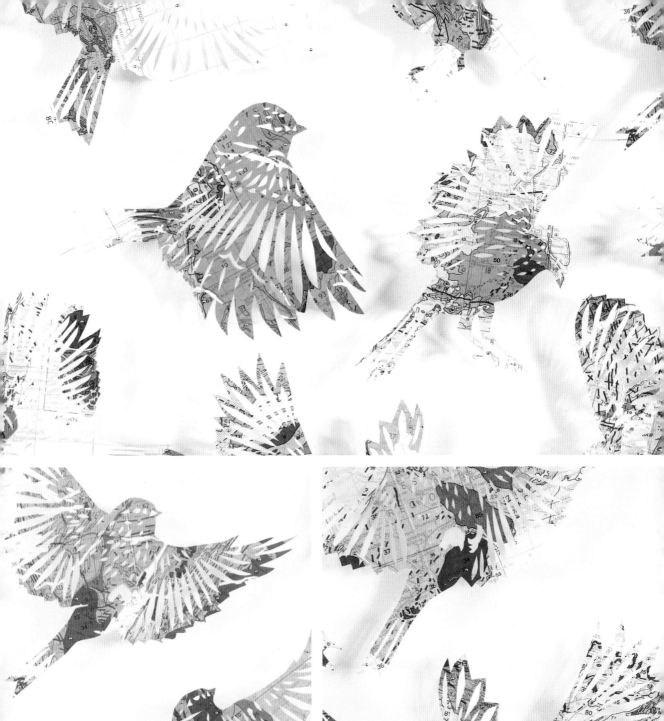
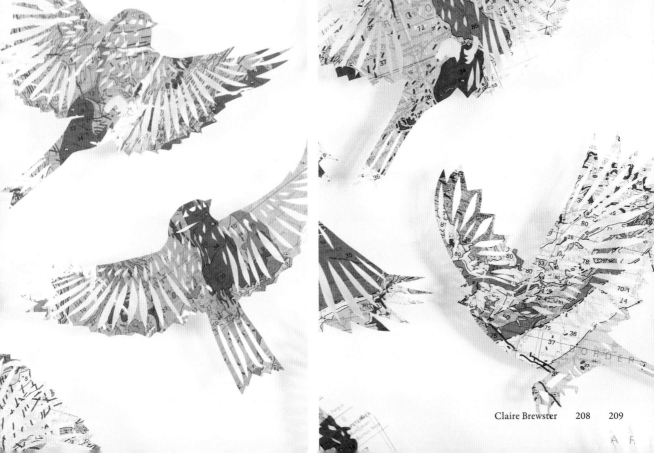

# Squirrel

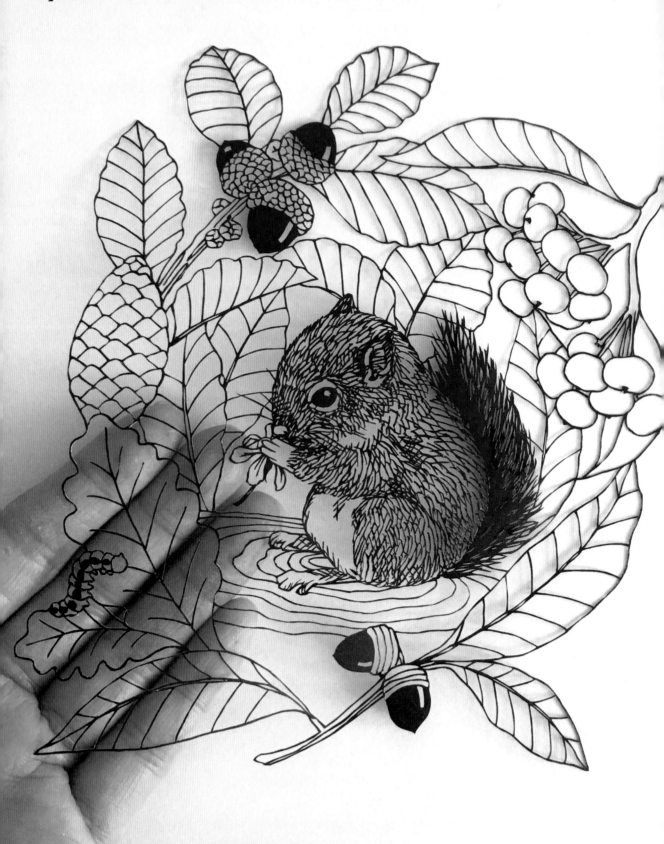

*"The black color creates beautiful contrast, and I really like the duality of a powerful design created by the highly fragile material."*

# Kanako Abe

Kanako Abe is a Japanese papercut artist. She cuts a design out of a single sheet of paper by hand. Her artworks are inspired by nature, wildlife, and Ise-katagami, the art of traditional Japanese papercut kimono stenciling. She likes using black paper for her art, which she finds beautiful, as if the artworks are floating ink drawings.

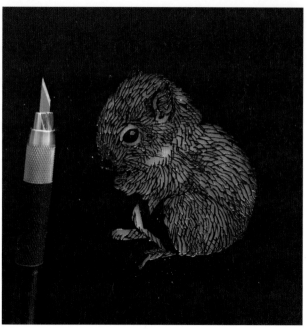

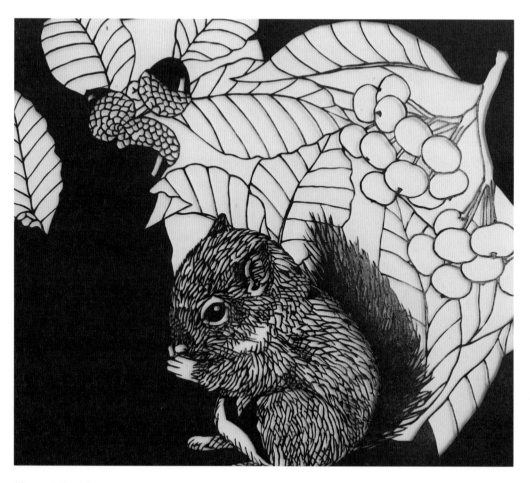

Chapter 4: Paper Art

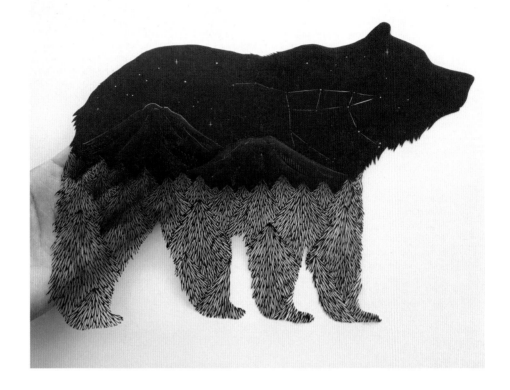

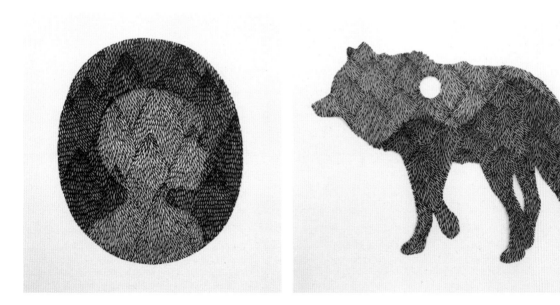

**1. Tell us something about your background. How did you discover paper art?**

I have enjoyed drawing and making crafts with my hands since I was little, so naturally, I wanted to pursue it as my career. I studied theatre arts at San Francisco State University and learned the art of costume and prop design. After graduating from the university, I worked for some local performing groups and theatres in San Francisco as a costume and prop designer for three years. However, I did not enjoy designing and making things for theatres because I always love working with small details, but designs for theatres do not necessarily require tiny details. I wanted to make art that was more challenging—something that would represent "me," without directors telling me what to make.

One day, while I was exploring a different style of art, I started making paper-cutting art for fun—and it clicked. I just loved doing it and loved the challenge of creating something from one sheet of paper, and the delicate nature of the art-making. I started researching Japanese traditional art and craft and came across Ise-katagami, the traditional art of kimono stenciling, which is highly intricate hand-cut paper stencil patterns for kimono fabric and considered one of the dying traditional art

forms in Japan. I was enchanted by the beauty of Ise-katagami, so I decided to learn this art for one year in Japan.

My goal was always to create my own art, so instead of going for an apprenticeship in the kimono industry, I decided to come back to the US and make contemporary papercut art using the techniques I learned from my Ise-katagami teachers. My goal is to bring the art of Ise-katagami to life and introduce it to the world, but in my own way.

**2. For you, what defines a good paper-cutting piece?**

Even if you are good and precise at cutting paper, that is not enough to make good paper-cut art. I think it's very important to conceptualize and make a good sketch first while considering negative space and composition. My Ise-katagami teacher once taught me so much about controlling the subtle details—the size of the lines, sharp edges versus rounded edges, etc. A difference between 0.5mm can affect the overall impression of the image. So, here are the keys to making a great paper-cut piece: good concept, sketches, precision, and attention to detail.

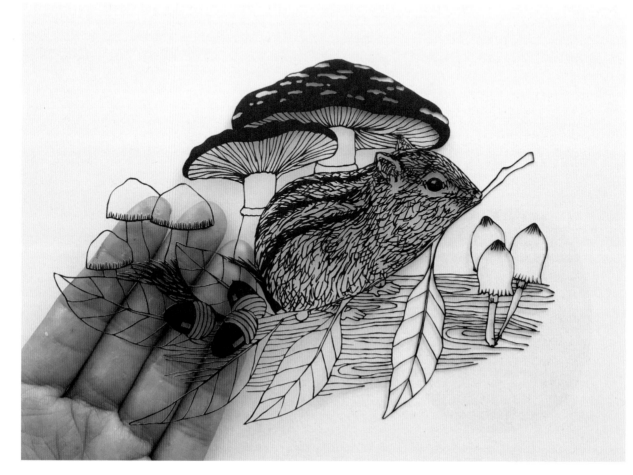

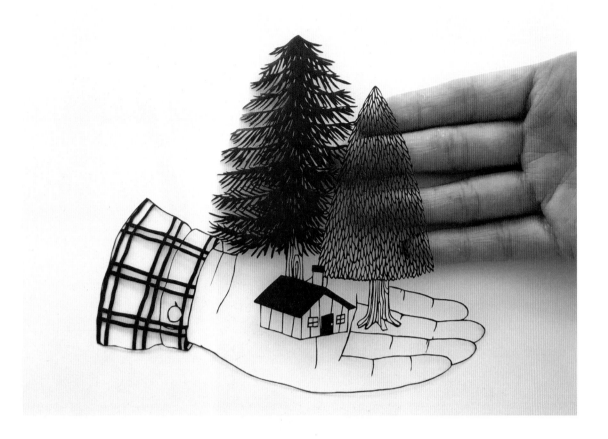

*3. Do you always use black for your paper art? Why?*

Paper-cut art is known as *kirie* in Japan, and people commonly use black paper or colored paper. Black cut-paper art is common in other cultures as well as popular folk art, but not many artists have tried making black paper-cut art with a contemporary approach. I only know a few artists who are doing that. Therefore, when I use black paper, I find there is so much more room to explore and discover, and I enjoy the challenge and process of evolving this art form from folk art into something new and more contemporary. It also goes perfectly with my intricate drawing style.

*4. What is the best comment you have received so far?*

People typically get amazed to find out that my art is cut out of a single sheet of paper. They would say something like: "Wow! This is made of paper?" Such comments make me happy and make me feel valued, but I especially feel happy when people find a special connection to the design itself because it's also an important part of my art. The design of each piece is very special to me. For example, I once made a piece which is a palm holding a cabin and trees. This piece inspired a girl and reminded her of her best friend right away, and she said: "Wow, this piece is so perfect for me!" It made me so happy to know that she found a very special, personal connection to the design.

*5. How has Japan shaped who you are and influenced your creations?*

Living in the US, especially in a culturally diverse city like San Francisco, leads me to view my country more objectively, discover many things about my culture, roots, and heritage, and makes me more "Japanese." I care more about who I am and what my culture is about than when I was living in Japan. The idea of bringing what I find so beautiful in my culture into a new world is very natural to me.

*6. In today's world, people can get ready-made stuff easily from physical shops and online. What does craft mean to you?*

I consider art and crafts as heart-to-heart communication between the artist and people. Artists or craftsmen spend so much time coming up with the concept, visualizing the idea, applying the techniques, and repeating the trials and errors. When one purchases the artwork, he/she is not only getting a pretty object but also an artist's time, philosophy, and love. When someone purchases my art, I feel as if I'm giving the person a fragment of me and my life because handmade art involves deep emotion and vulnerability. My art will keep on living with the person as if it is starting its second phase of life. One can have a special attachment to any object, whether handmade or not, but I believe that only handmade objects can inspire people to see the world differently.

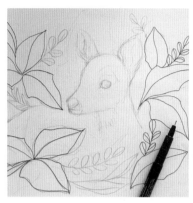
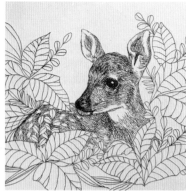
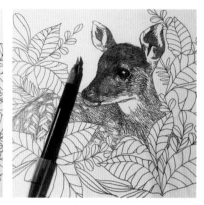

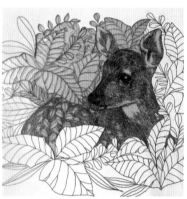
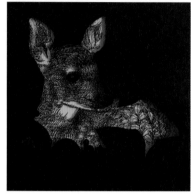
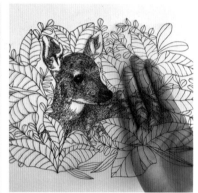

## Materials & Tools

- Paper for *kirie* (black on one side and white on the other)

- Pencils

- Ink pens (0.3mm)

- Cutting mat

- Craft knife

## Tutorial

1. Make a sketch in pencil first and trace it with an ink pen. Make sure all the lines are connected. It is important that the guidelines are clear so that they can guide you when you are cutting.

2. Be patient and make sure you are in good lighting conditions and start cutting. The key to creating flawless curvy lines is to switch the blades frequently and cut gently like moving a pen without pushing the paper too hard. It can take many hours of cutting.

3. After hours of work, it is finally done and ready to be framed! Lift up very gently.

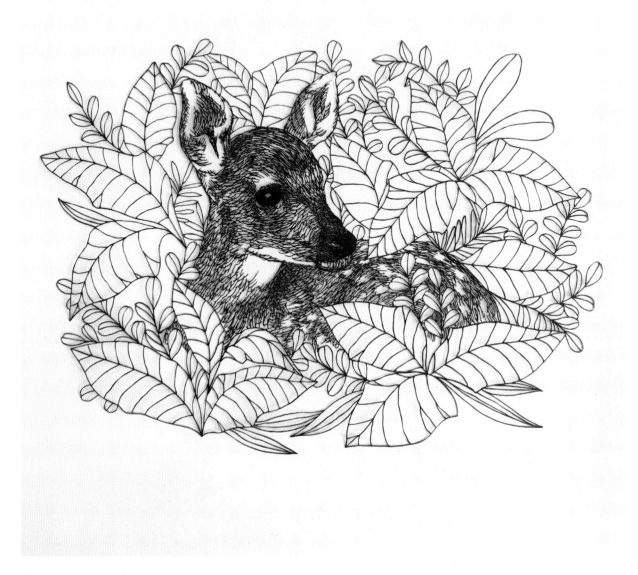

## *Fawn*

Kanako had a solo show in San Francisco which was inspired by wildlife and people's spiritual connection to nature. She created delicate papercut artworks of wild animals she loves. She feels deeply connected to deer and fawns, as she knows that deer are often deemed to be spiritual animals with magical powers.

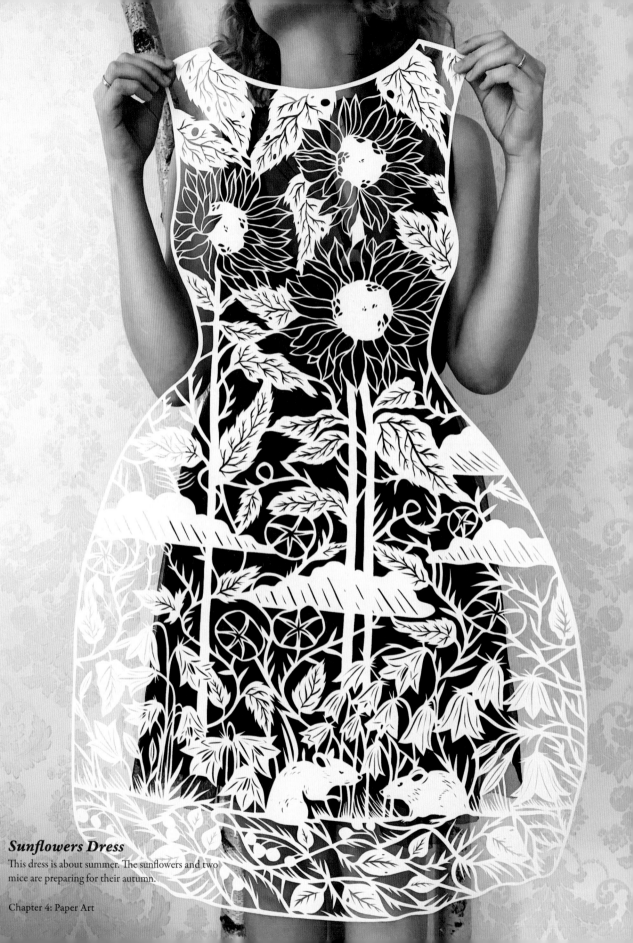

## Sunflowers Dress

This dress is about summer. The sunflowers and two
mice are preparing for their autumn.

> *"I prefer to work with paper because it has a lot of interesting qualities."*

# *Eugenia Zoloto*

Eugenia Zoloto is a paper artist from Kiev, Ukraine. Her work can be plain, laced, or sculptured in 2D or 3D. Eugenia started creating paper art in 2013, and this art form still amazes her. Eugenia loves cutting and playing with different forms and patterns.

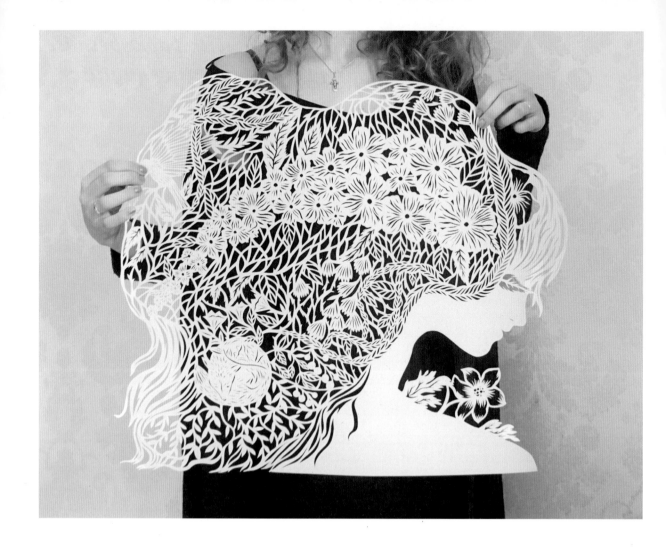

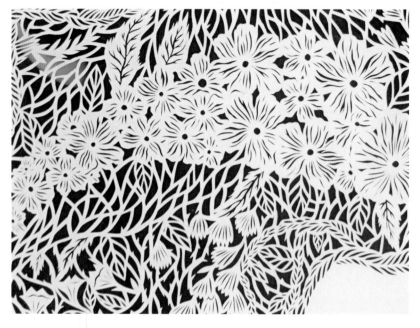

### ▲ Spring Wreath

This girl is dreaming about spring. The work is full of small floral details—Eugenia spent a week cutting it out.

### ▸ Owl and Blossoms

### ▸ Birds Made a Nest in My Hair

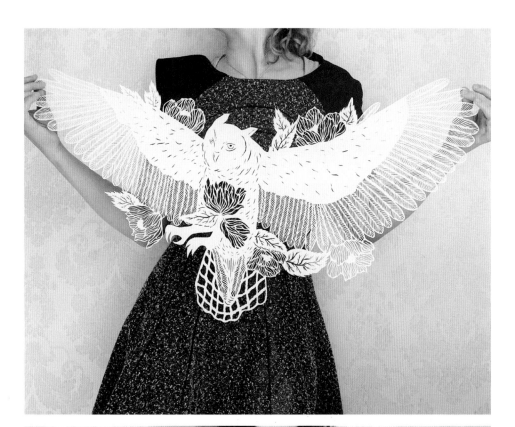

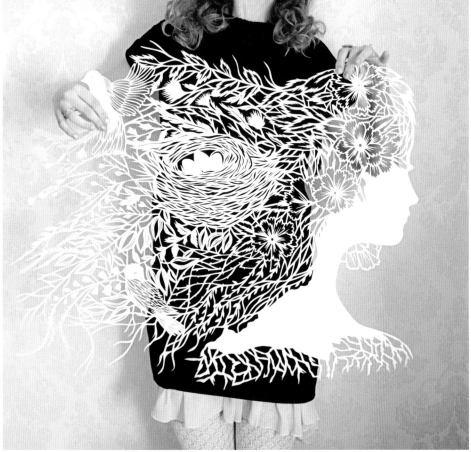

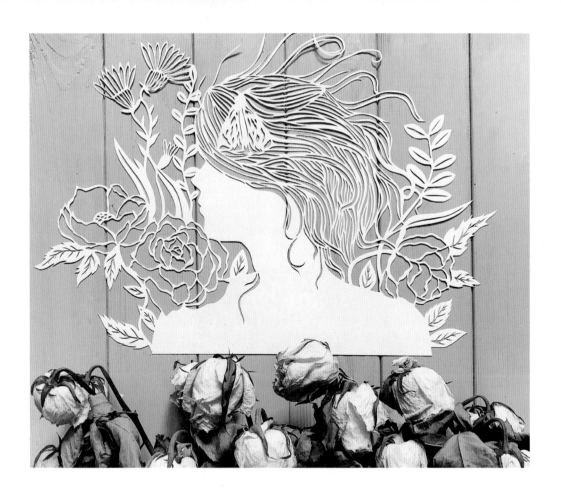

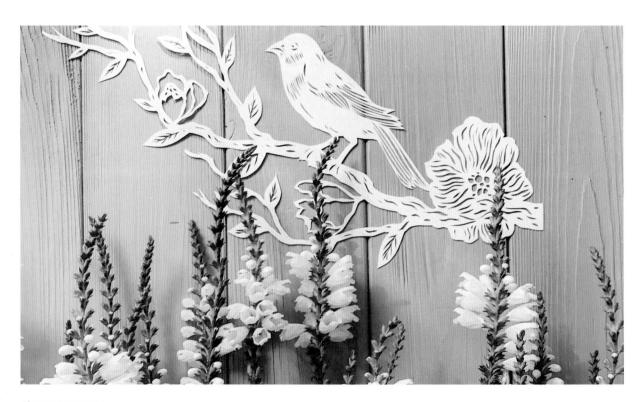

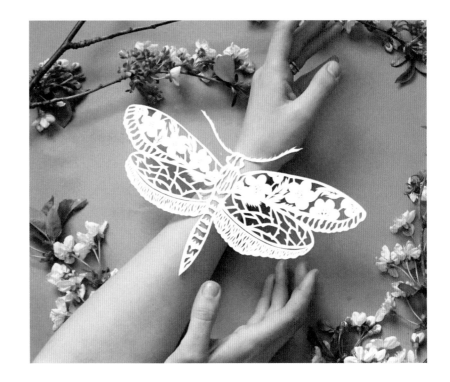

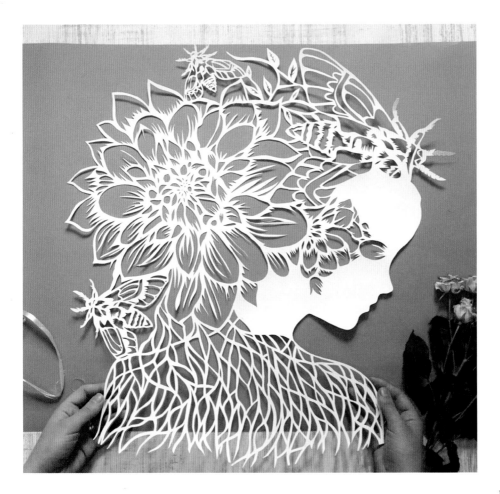

# Origami Balls

*"My art highlights harmony, balance, and simplicity. I get inspiration from nature and Eastern cultures."*

# *Valeria Riabtschenko*

Valeria Riabtschenko, originally from Argentina, loves art, design, and stationery. Her passion for paper craftwork has led her to origami and later to new paper folding techniques, which allow her to make three-dimensional objects and figures. She strives to give life to paper art and has developed an origami studio in Argentina called Papel Diamante.

## Origami Balls

Paper balls are made with one or more pieces of rectangular paper, folded by hand, which are later joined by tape or glue. Each piece of paper is printed with Papel Diamante's exclusive patterns and designs. They can serve as decorative objects piled together or hung up with threads.

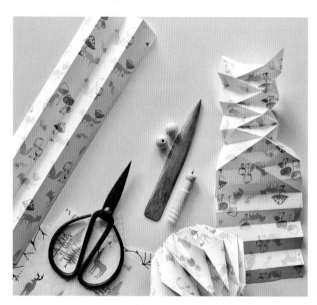

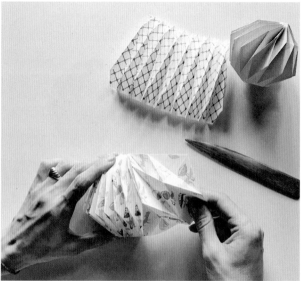

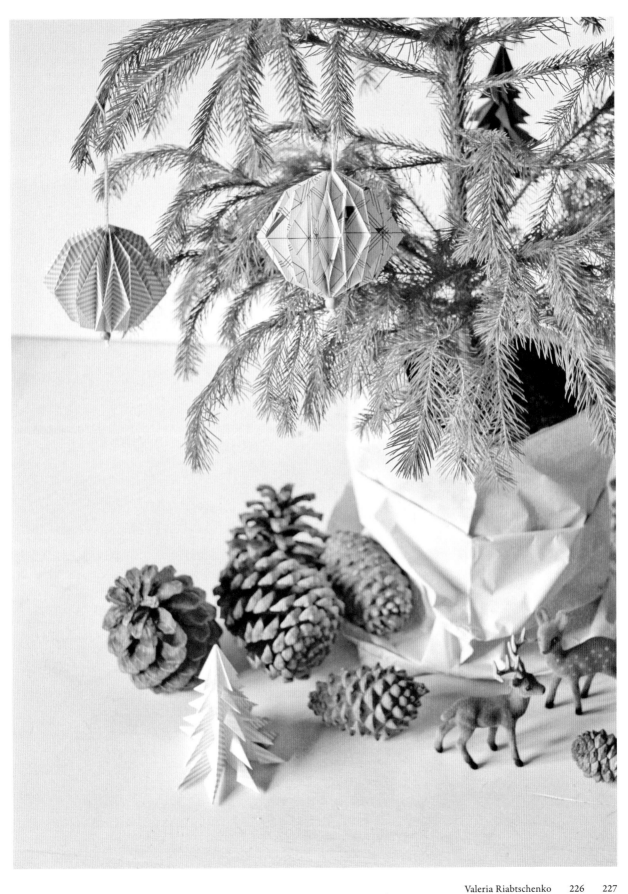

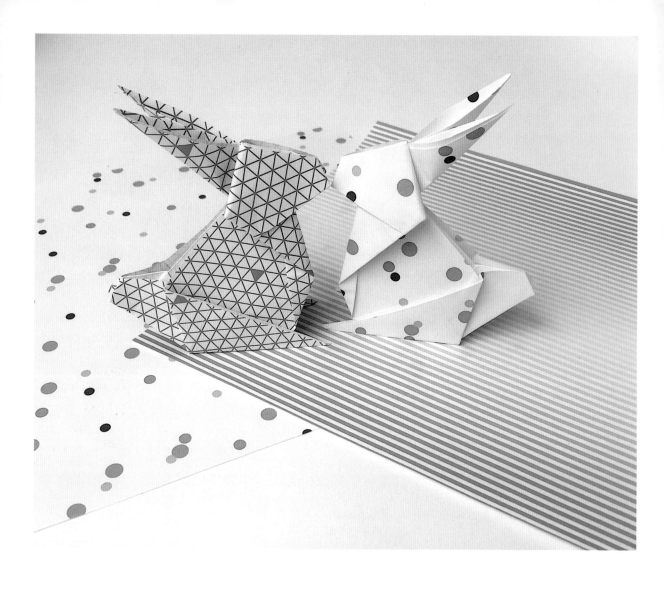

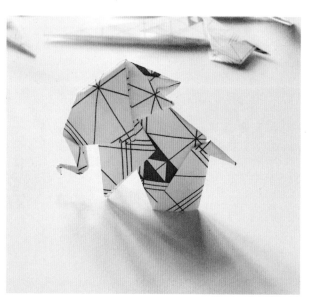

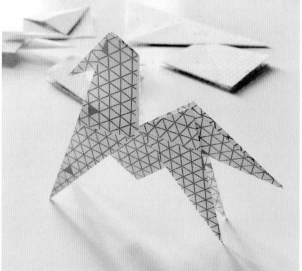

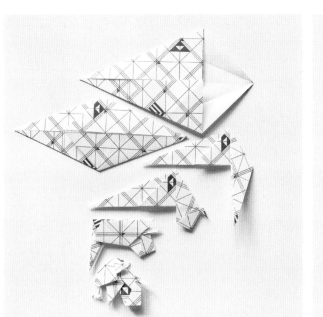

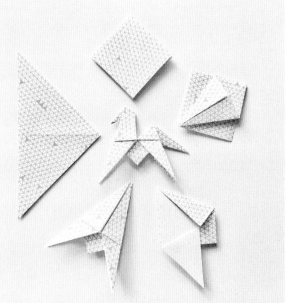

## *Traditional Origami*

In addition to the origami balls, Valeria also folds traditional origami figures
from the natural world like rabbits, elephants, horses, cranes, and so on.

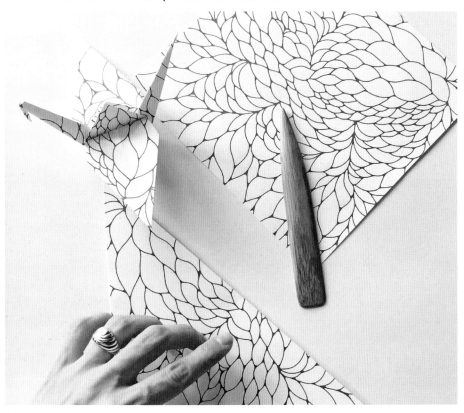

*"I delight in nature and all things about botany. My work is inspired by a childhood of woodland walks and countryside rambles."*

# Clover Robin

Clover Robin is a collage artist, illustrator, and designer. She grew up in glorious Devon. In 2007 she graduated from Leeds College of Art and Design and in 2009 she obtained her Master's degree from Central Saint Martins. Clover specializes in collage, creating colorful and vibrant hand-cut worlds using hand-painted, recycled and discarded papers. Due to the nature of this process, each artwork is completely unique and comes out with an unexpected look.

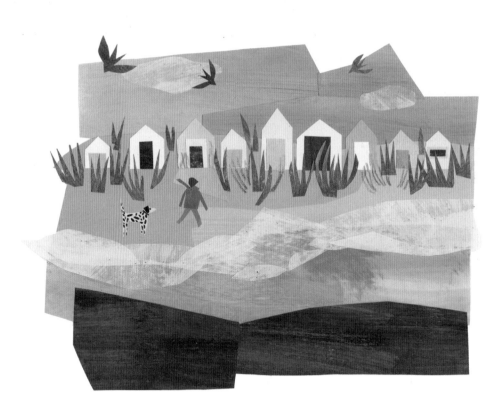

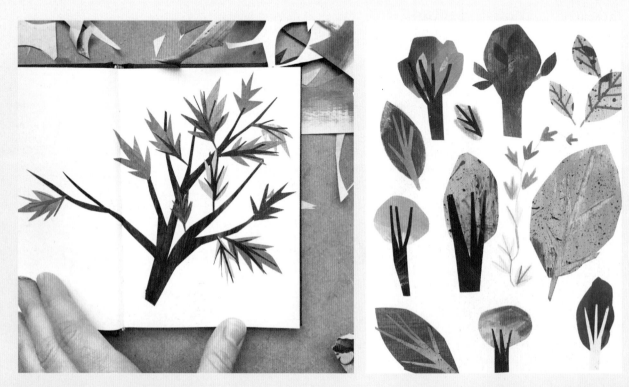

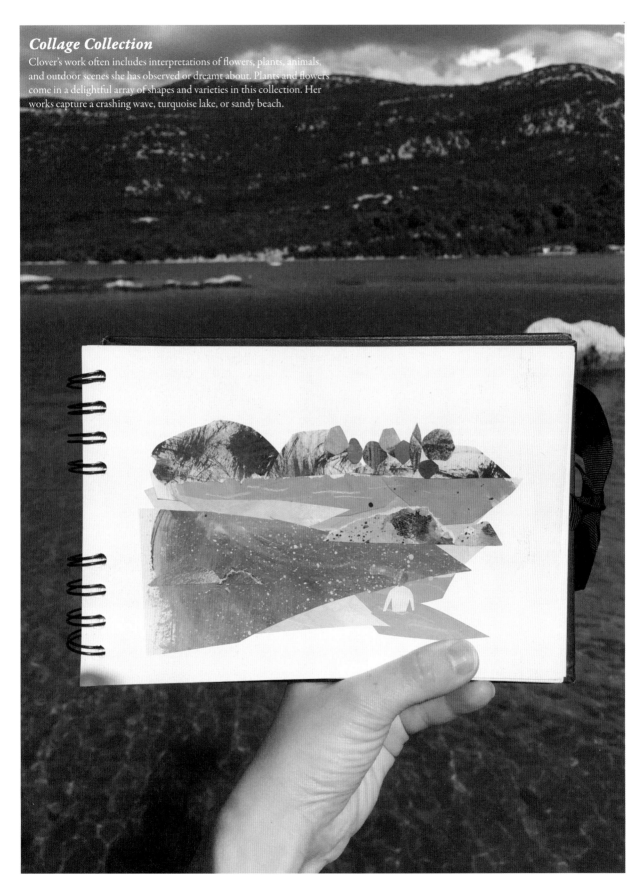

## Collage Collection

Clover's work often includes interpretations of flowers, plants, animals, and outdoor scenes she has observed or dreamt about. Plants and flowers come in a delightful array of shapes and varieties in this collection. Her works capture a crashing wave, turquoise lake, or sandy beach.

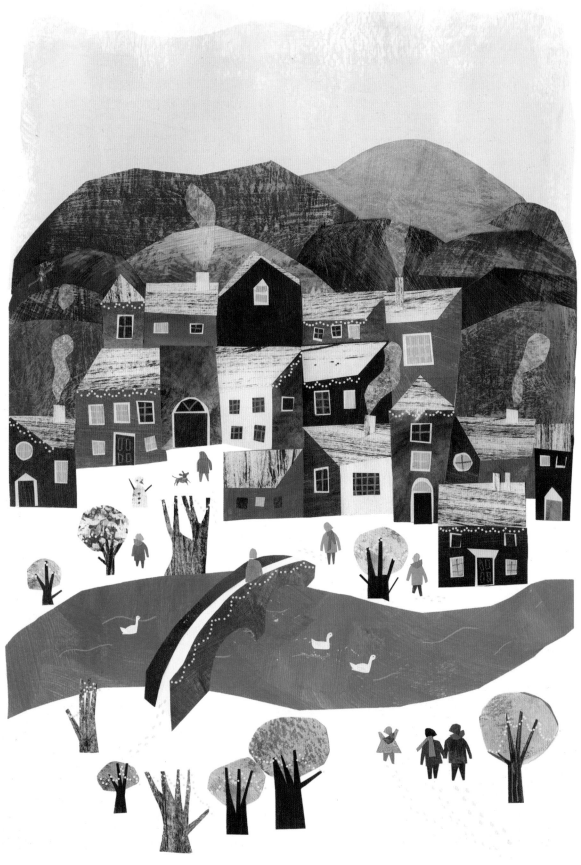

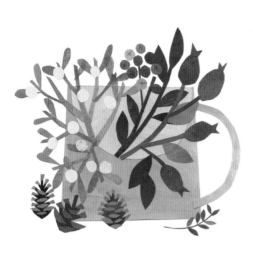

Rather than being purely nostalgic, these artworks also act as documentation of her surrounding environment, a bit like an explorer collecting visual specimens. Clover tries to capture the objects or scenes using distinct textures, shapes, and lines.

# Christmas Gift Tags

A set of Christmas gift tags featuring original folk-art-inspired festive papercuts.

*"My botany-themed papercut illustrations have a whimsical, contemporary style."*

# *Jessica Baldry*

Jessica Baldry is a British illustrator who makes beautiful handmade papercuts inspired by flora, fauna, and the outdoors. Each delicate silhouette starts as a sketch and is then cut out carefully by hand from a single sheet of paper, using a craft knife. Her incredibly intricate work is usually in small scale and celebrates the beauty of subtle details and patterns.

### ◂ Folk Christmas Tree Card

This card features a patterned Christmas tree inspired by Scandinavian folk art.

### ◂ Christmas Gift Wrap

Festive gift wrap featuring Scandinavian-style papercut patterns.

### ▸ Reindeer Card

The card features two prancing reindeers inspired by folk art.

### ▸ Animal Greeting Cards

A series of greeting cards featuring animals.

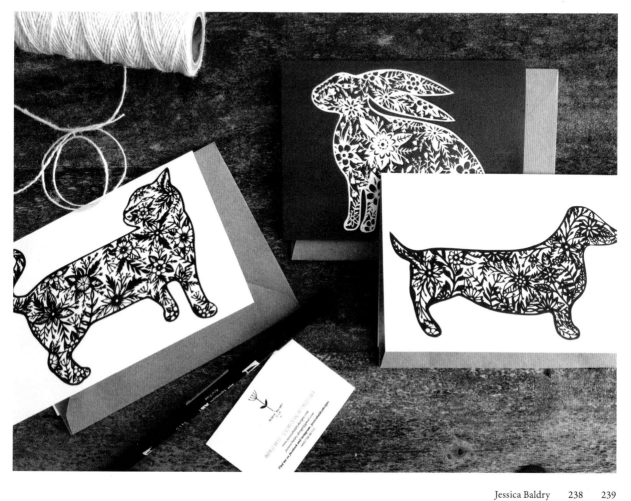

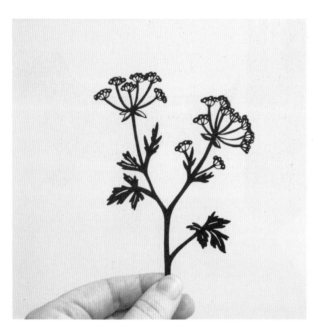

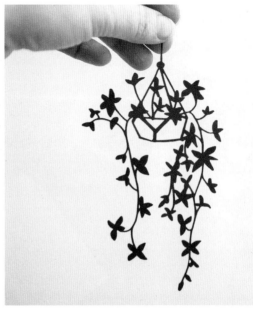

Chapter 4: Paper Art

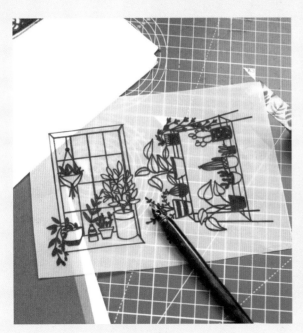

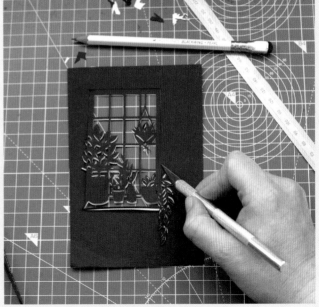

## ◂ *Houseplant Collection*

This is a collection of intricate papercut silhouettes of a plant lover's house. Jessica created the original sketches and cut the silhouettes entirely by hand.

## ◂ *Papercut Window with Houseplants*

This features an intricate papercut silhouette of a plant lover's leafy window.

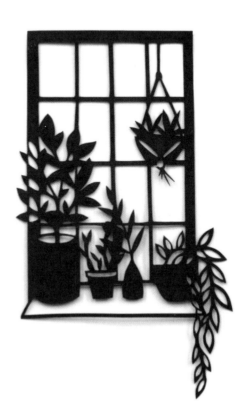

# *Greenhouses*

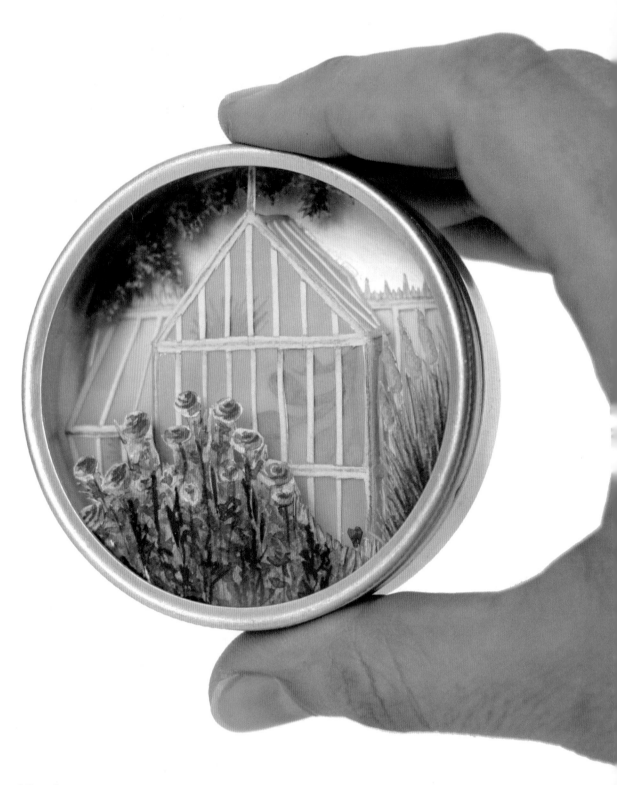

"*Made out of cut paper and watercolor, my dioramas are influenced by the architecture of my city, my travels, pop culture, and cinema. I often create spaces without people, as I think the space itself can represent its characters.*"

# *Mar Cerdà*

Mar Cerdà is an illustrator based in Barcelona, Spain. She has illustrated more than 20 books and has done work for Christian Louboutin, *The New York Times*, *Entertainment Weekly* and galleries around the world. She cannot live without creativity. The sense of theatre and the use of frontal view are some of the signature characteristics in her illustrations.

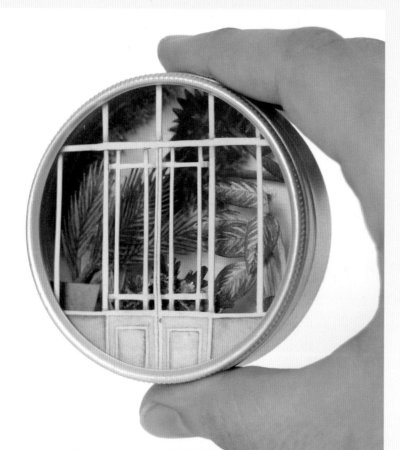

## Greenhouses

This project is made up of two types of greenhouse. The round ones were created for a group show called *Enormous Tiny Art* at Nahcotta Gallery (USA).

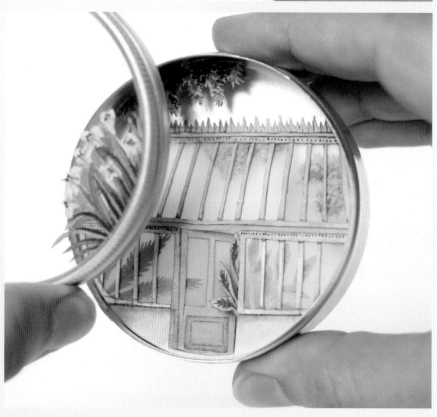

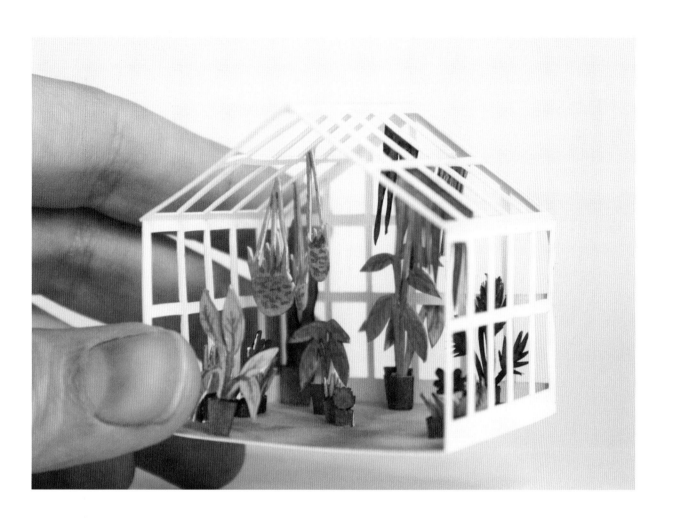

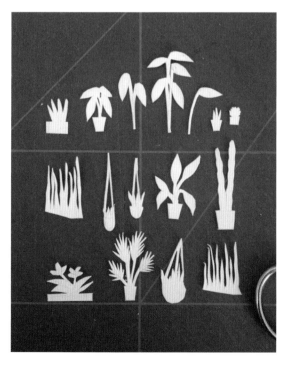

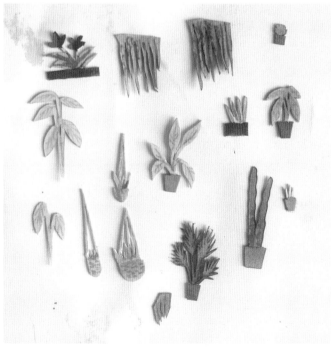

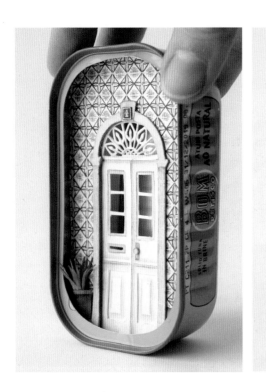

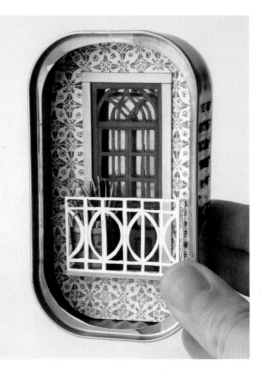

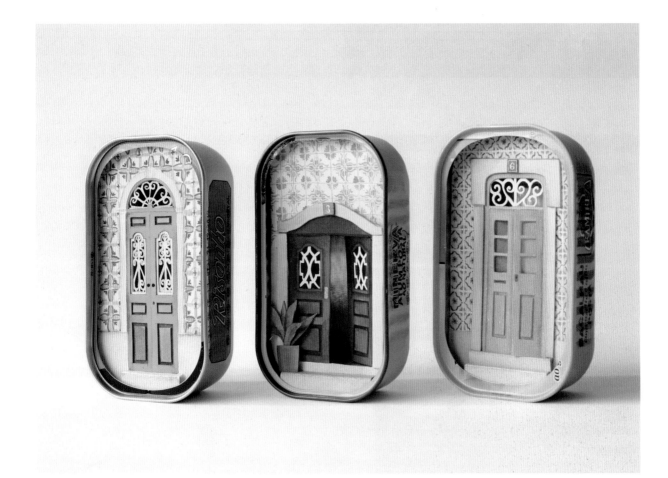

### ◂ Portugal

Inspired by the streets and the walls with tiles typical of Portugal, Mar did several little pieces inside cans—cans of tuna and sardines, which are very typical in Portugal.

### ▸ Menorca

After a trip to the island of Menorca in Spain, Mar made a house in memory of the local architecture.

## *Mendl's*

This is a commissioned work for a client inspired by the film *The Grand Budapest Hotel*, directed by Wes Anderson.

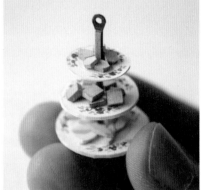

# Index

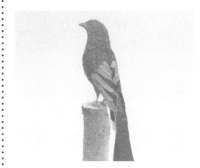

### *Atelier Hola*
*Korea*

www.instagram.com/atelier_hola

P096–105

### *Claire Brewster*
*UK*

clairebrewster.com

P200–209

### *Erika Barratt*
*USA*

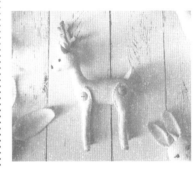

www.erikabarratt.com

P078–082

### *Atelier Pataplume*
*France*

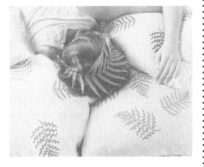

www.atelierpataplume.com

P158–165

### *Clover Robin*
*UK*

www.cloverrobin.com

P230–235

### *Erin Gardner*
*USA*

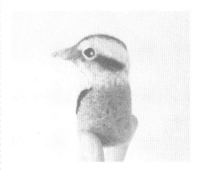

greyfoxfelting.com

P068–073

### Eugenia Zoloto
*Ukraine*

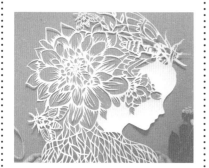

www.behance.net/Eugenia_Zoloto

### Iya Gaas
*Russia*

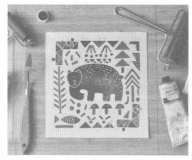

gaas-mi.com

### Jessica Baldry
*UK*

www.jessicabaldrydesigns.com

### Isti Home
*Ukraine*

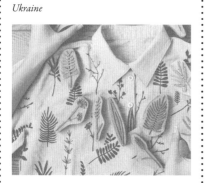

istihome.com

### Jamilla Beukema
*The Netherlands*

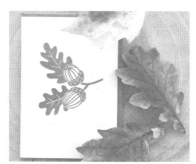

www.mila-made.nl

### Jessica Benhar
*Australia*

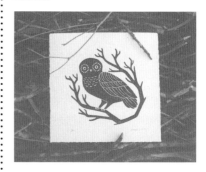

harkenback.com.au

### Justien van der Winkel
*The Netherlands*

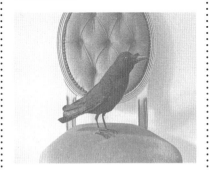

www.instagram.com/van_der_winkel

P074–077

### Karen Barbé
*Chile*

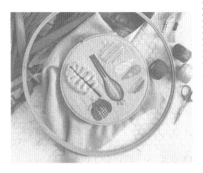

www.karenbarbe.com

P084–095

### Loly Ghirardi
*Argentina*

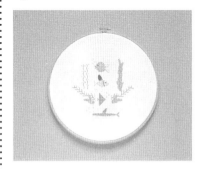

www.srtalylo.com

P138–141

### Kanako Abe
*Japan*

www.instagram.com/abemanatee

P210–217

### Lena Bekh
*Russia*

www.lenabekh.com

P030–035

### Mar Cerdà
*Spain*

marillustrations.com

P242–248

### Maria Danshin
*Russia*

mariadanshin.etsy.com

### Pani Pieska
*Poland*

panipieska.com

### Rita Pinheiro
*Portugal*

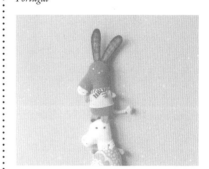

www.matildebeldroega.com

### MICAO
*Japan*

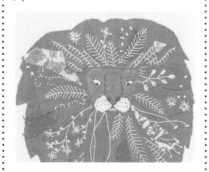

www.e-micao.com

### Phoebe Capelle
*Canada*

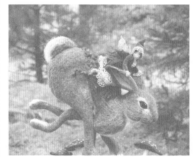

www.lavenderandlark.com

### Svetlana Kuznetsova
*Russia*

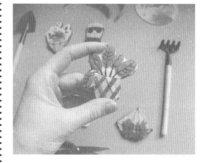

artmartblog.ru

## Valeria Riabtschenko
*Argentina*

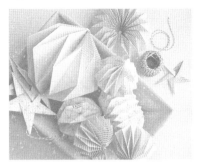

www.papeldiamante.com
P224–229

## Yuri Miyazaki
*Japan*

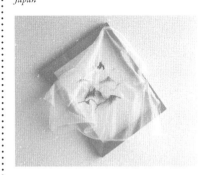

www.yurikero.com
P122–127

## Viktoria Åström
*Sweden*

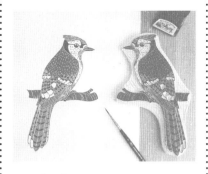

www.viktoriaastrom.se
P184–193

## Zuza Miśko
*Poland*

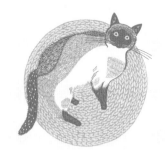

ateliermisko.com
P178–183

# Acknowledgements

We would like to thank all of the designers involved for granting us permission to publish their works, as well as all of the photographers who have generously allowed us to use their images. We are also very grateful to many other people whose names do not appear in the credits but who made specific contributions and provided support. Without these people, we would not have been able to share these beautiful works with readers around the world. Our editorial team includes editors Chen Yaqin and Jessie Tan and book designer Dingding Huo, to whom we are truly grateful.